THE **DIGITAL SLR** EXPERT
PORTRAITS
essential advice from top pros

THE **DIGITAL SLR** EXPERT

PORTRAITS

essential advice from top pros

MARK CLEGHORN • MATT HOYLE • EAMONN McCABE • STEVE SHIPMAN • BJORN THOMASSEN

Edited by Cathy Joseph

David and Charles

A DAVID & CHARLES BOOK
Copyright © David & Charles Limited 2009

David & Charles is an F+W Media Inc. company
4700 East Galbraith Road
Cincinnati, OH 45236

First published in the UK and USA in 2009

Text and photographs copyright © Mark Cleghorn, Matt Hoyle, Eamonn McCabe,
Steve Shipman and Bjorn Thomassen 2009

Mark Cleghorn, Matt Hoyle, Eamonn McCabe, Steve Shipman and Bjorn Thomassen
have asserted their right to be identified as authors of this work in accordance with
the Copyright, Designs and Patents Act, 1988.

A catalogue record for this book is available from the British Library.

ISBN-13: 978-0-7153-3200-9 hardback
ISBN-10: 0-7153-3200-7 hardback

ISBN-13: 978-0-7153-3201-6 paperback
ISBN-10: 0-7153-3201-5 paperback

Printed in China by RR Donnelley
for David & Charles
Brunel House Newton Abbot Devon

Commissioning Editor: Neil Baber
Editor: Emily Rae
Project Editor: Cathy Joseph
Copy Editor: Ame Verso
Designer: Joanna Ley
Production Controller: Beverley Richardson and Alison Smith

Visit our website at www.davidandcharles.co.uk

David & Charles books are available from all good bookshops; alternatively you
can contact our Orderline on 0870 9908222 or write to us at FREEPOST EX2 110,
D&C Direct, Newton Abbot, TQ12 4ZZ (no stamp required UK only); US customers
call 800-289-0963 and Canadian customers call 800-840-5220.

CONTENTS

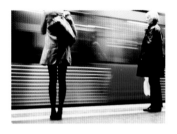
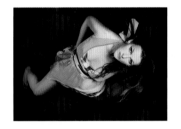
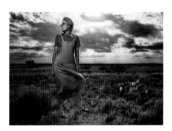
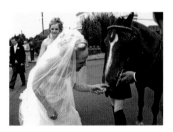

INTRODUCTION

MARK CLEGHORN

What I love about portrait photography is that every shot I take is different. Even though my lighting and other equipment may stay the same and be set up in a similar way, it is the subject in front of my lens that makes the difference to the portrait. This is exaggerated when I turn my camera away from the studio and point it at a wedding, as none of the elements are ever really in my control on the day.

When I prepare for a shoot, I have to take into account not only who the subjects are and what they are like, but also where the location is and the timing of the event. A winter wedding brings far more flash into the variety of images than a summer wedding does, due to lower light levels and darker nights, both inside a church and during the reception, as well as outside in the elements.

The great thing about shooting a wedding or a portrait with a DSLR is that there are no boundaries for creativity. I can see instantly if an idea has worked or not, allowing me to re-shoot or change the set-up dramatically for even more creative effect, or (more often than not) to bring the image back down to earth and shoot something more tame.

From the start of a wedding day, with all the chaos of the preparation, there is never a dull image, as around every corner there seems to be a better photograph to be taken. However, the most important part of my job is to make sure that I capture the wedding how the bride wants it to be captured and don't just shoot what I want to – that's the big difference between doing a wedding for fun or for profit.

There are some key secrets to posing and lighting a subject, however they are all preceded by familiarity with my equipment combined with my speed and efficiency during the shoot. Making best use of the location and its natural light, where possible, gives an instant variety to the images, not only through the background but also in the variety of the poses and the expression of the subjects.

A relaxed subject is always a happy subject and this, I promise you, always shows in the portrait. The secret to a natural expression is just keeping the portrait simple; by that I mean minimizing the complexity of the pose and the subject's animation. This also applies to the equipment – keep it simple to reduce the likelihood of technical problems and so that you can focus on the portrait instead of the chosen camera, lens or flash.

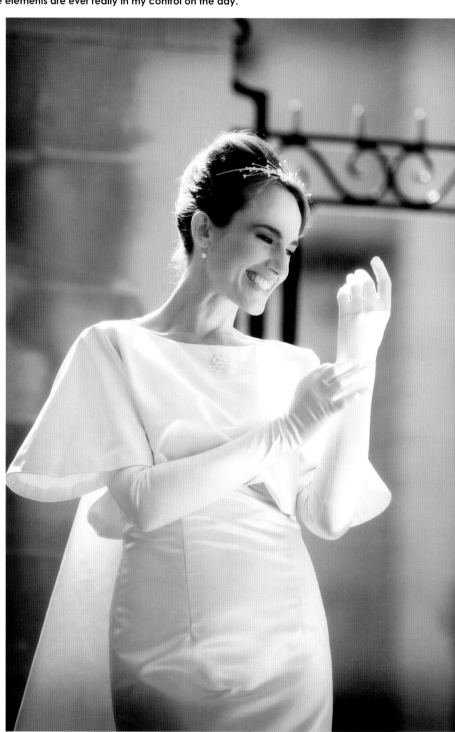

MATT HOYLE

I've been an observer of people and sensitive to my surroundings my whole life. I grew up in an artistic environment: painting, drawing, writing and making music. Creative people always want to share something of what they see with rest of the world and they'll find any tool to allow them to do that. For me, photography was never just about an aesthetic – a beautiful landscape or the way the light hits a piece of glass – it was always very much about an affinity with society. People have different ways of behaving and expressing themselves and these differences are visual.

Living in Australia for a period of my young adult life also had an effect on me. I was thrown into a different culture and then, coming back, I saw what I'd taken for granted in America. It was almost like beginning life anew. They say that to be a great photographer you have to start each day as if it's your first and observe things with a new eye. My creative side wanted to capture the people and society in a way that could tell this story.

To me, photography is not so much about the process. There are many fellow photographers out there who are into the equipment – the look of it, the bells and whistles of the most up-to-date camera or the old-school way of shooting film with a large-format camera, which is a production

just to set up. This is all cool – photography should be enjoyable or why get into it in the first place? But for me it's about the end result. I want a camera that is an extension of my creativity; something I can use to find, frame and capture my 'pages' of the story with little effort. And so the DSLR is my tool. It fits in one hand, can be snapped in a heartbeat, allows me to see its results and experiment or, if necessary, correct on the fly. It has changed the way I work and has given me the freedom to do more and better photography.

The DSLR has already digitized the image for convenient transfer into my computer, where the other aspect of my photography takes place. Post-production is a big part of photography today, whether you simply want to colour-correct, put a better version of a head on to a perfectly framed body, or, like myself, transform the image into a mood and feel that reality just can't deliver alone. The digital process has allowed me the best luxury a photographer can have: the freedom not to compromise a vision and to have full control over every shot from shutter to print.

The DSLR is not only my most valued tool, it is also now an extension of me. I can get it to act and react with minimal effort and, for me, this is where effortless storytelling and photography come in. I can spend less time thinking and fiddling and more time feeling and doing.

STEVE SHIPMAN

As a photographer, I have always been drawn to people rather than things, as I enjoy the creative collaboration they usually bring. Sometimes it's possible to achieve far more by sparking ideas off another person than you could on your own. Even a potentially dull situation with an unwilling subject can spur you on to produce dramatic work. I rarely go into a photo session with pre-conceived ideas. I have tried it in the past and I found that I became too focused on achieving the idea rather than allowing the session to develop with a flow of creativity, which can end with something far better than I had imagined.

My motivation is beauty and drama. I am only interested in making people look good. So, I look for the best light, the best locations and the best outcome. Sometimes it is a caught moment, anticipated in a split second and shot almost instinctively. Or, I might have seen a lovely location and directed my subject towards it to see what might happen.

I started my career as a magazine photographer. I shot portraits for all the Sunday supplements and many of the monthly magazines. I love magazines and used to spend a fortune on *The Face*, *Vogue*, *Paris Match*, *Life*, *Rolling Stone* and *Vanity Fair*. The latter two featured a major hero of mine, Annie Leibovitz, who, although she may not know it, has been my mentor for most of my career. Many of my magazine portraits were influenced by her production values – big format, big lights and big celebrities (with big hair!). It was great fun.

My subjects now are more varied and range from personalities and business people to families and wedding couples. I bring that same sense of beauty and drama to all of them. I use the same lighting and composition techniques, but there is one big difference now – I shoot digitally. And what a difference it has made.

Learning photography on film taught me a very good lesson – how to get the exposure right. I used to shoot on transparency film, where there is little room for error. I used Polaroids to check lighting settings before shooting and, invariably, the shot I wanted was the one on the Polaroid. I then had to try and recreate the moment on film.

Now, I shoot a test frame on the digital camera and, assuming all is well with the exposure, I still have the image to use if I wish. Everyone can see the images as I shoot, either on the camera or on the laptop, and so the collaboration between the photographer and the subject is enhanced.

Capturing images digitally has loosened up the shooting process; if I want to have more variations, try another angle – perhaps a wacky bird's eye view (or worm's eye view) – I can and all at very little expense. I have taken images without looking through the viewfinder, holding the camera paparazzi-style to get a shot over people's heads. A quick check on the back of the camera and adjustments are easily made. I can shoot dozens of frames, hundreds even, to get the variety and perfection I want. Later, in Photoshop, I can edit out the fire extinguisher, the paper bin or the proverbial telegraph pole. The one thing that is always underestimated in digital photography is exposure – it has to be right! Being able to change the ISO on the fly is brilliant, something that just wasn't possible with film.

The satisfaction gained in seeing a shoot right through to the finished image is enormous. I used to employ specialist printers to produce my final prints, beautifully dodged and burned, but they couldn't see through my eyes. Now I can play for as long as I like in my own digital darkroom, getting my images exactly as I want them. As a result, my images have a style that I am consciously developing.

For me, the DSLR is the ideal camera. It is so versatile with a fantastic range of lenses, the ability to photograph in any situation, with any amount of light (or lack of it, more crucially) and it is easily portable. It becomes an extension of one's eye and, with practice, adjusting the camera settings can become instinctive. As manufacturers continue to improve the technology, the image quality is becoming even better

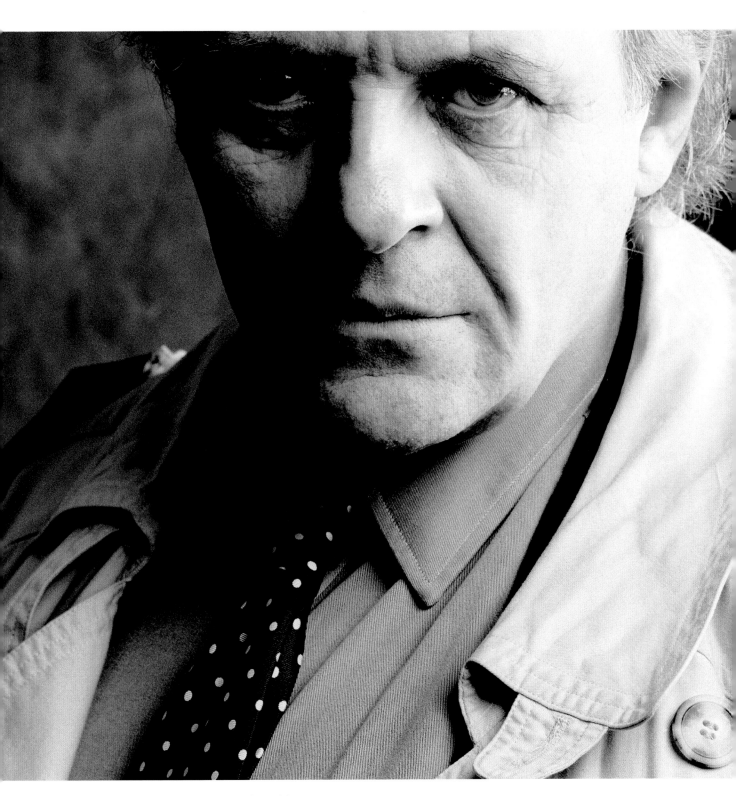

and shooting in a candle-lit church is no longer a grainy problem. Composing images made up of several separate images is easy, even producing 360-degree panoramas. Now, too, there is the convergence of still and video photography. I'm very excited about the future of digital photography, and I believe we are only just beginning to realize the potential the medium can offer.

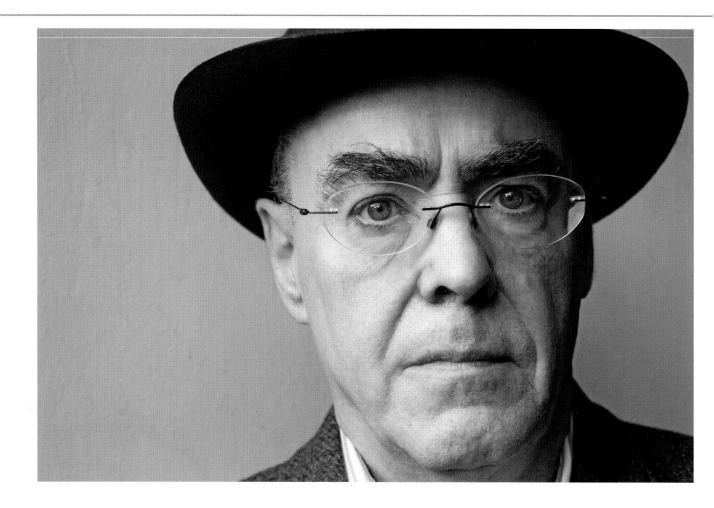

EAMONN McCABE

Looking back over my work for the last 40 years, I now realize that I've been a portrait photographer all my life. Even though I started out photographing rock and roll with bands like The Who and The Rolling Stones, followed by 20 years covering sport for *The Observer* newspaper, my best pictures, and the ones that really have lasting value, have been portraits.

When I was younger, I was an observer with a long lens looking in from the touchline. Now I'm older and more confident I have become a director and am able to organize photographs before I take them. It is very important to take control of a portrait. You must make the subject believe you know what you are doing. If you lose their respect you won't get anything. If you start with an idea and it doesn't work, you have at least bought yourself some time in order to look around and try something else.

Now that we all have digital cameras, it is really important not to take a machine-gun approach to a subject in the hope of finding a usable frame. If a composition, a pose, a prop or a location doesn't feel as though it is working to you, it won't get better simply by shooting hundreds of frames. All this does is give you a terrible editing problem later – time much better spent behind the camera than the computer.

Before you take a portrait, try to get the background right. Hunt around for the place to take your subject to; five minutes in the right place is worth an hour of wandering around. When I photograph somebody famous, I often do a deal with them. If I can get them into 'my space', I feel that I am in control and I can concentrate on getting right what Steve Pyke, who works for *The New Yorker* magazine, calls 'the landscape of the face'.

The choice of lens is very important for portraiture but you don't always have to play safe and stick with the obvious, as that may not be best for your subject. On a 35mm camera, 85mm and 105mm lenses have always been considered the most suitable for photographing faces, but recently I have been using a 50mm lens. It doesn't always work but when it does the results are stunning. Digital cameras are great for such experimentation as you can see the results immediately but if you have a new piece of kit, practise with it in your own time first, as confidence in your equipment is crucial when faced with an important assignment.

Another lesson I have learnt with digital photography is never to show the subject what you have just taken, no matter how tempting it is for them knowing that their picture can be viewed on the back of the camera. If they say they don't like a photograph, you will never be able to use it and that might be the best shot you have ever taken.

BJORN THOMASSEN

My photography has to fulfil me on an emotional level as well as a creative one. Social photography is a highly emotional area of photography and so a good understanding of psychology is essential for success. Honing your interpersonal skills is as important as refining your technical skills.

One of my objectives as a portrait photographer is to charge the atmosphere before and during the session. The pace and energy of a shoot is important to its success and my subjects must enjoy the whole experience. I favour the speed and portability of the DSLR because it allows me to work at a fast enough pace to energize the session. I seldom stop once in flow as I endeavour to engage and challenge my clients throughout the shoot.

I strive to create images that are as rewarding to me as they are to my subjects and clients, but I am rarely entirely satisfied with my shots.

As well as being a photographer, I am also a photographic judge and I therefore find myself constantly critiquing my own work and invariably finding fault with it.

I see post-production as an essential element to the evolution of the final image. The capture is in essence reality, albeit a creative perspective, but reality nonetheless. Post-production enables me to take an artistic departure from that reality. Coming from a traditional printing background, I have simply imported the concepts of how to heighten the aesthetics of an image into Photoshop.

I invest heavily in my own training and set aside an annual budget to expand my skills and knowledge. Too many photographers spend a fortune on equipment and software every year, but under invest in training. We should all continually strive to upgrade our skills to enable us to outpace our competitors and to explore new ways to satisfy our clients, our bank managers and ourselves.

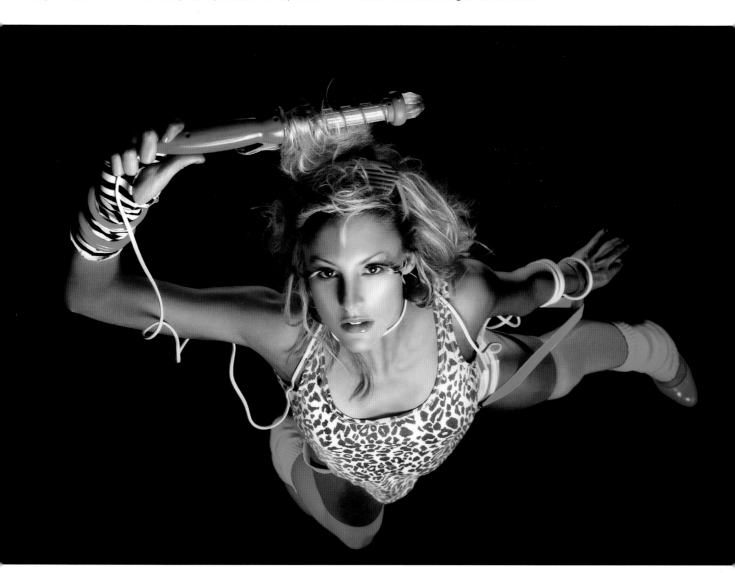

EQUIPMENT

MARK CLEGHORN

Cameras:	Canon EOS 5D; Canon EOS 5D Mark II
Lenses:	Canon 24–105mm f/4L; Canon 70–200mm f/2.8L; Canon 28–70mm f/2.8L; Sigma 12–24mm f/4
Lighting gear:	Canon Speedlite with radio triggers; Quantum T5-D portable flash; Bowens Esprit Studio Flash; Quantum Turbo batteries; softboxes
Accessories:	Lexar cards; Manfrotto tripod; Sekonic light meter; Lastolite reflectors and TriGrip reflectors; diffusion screens; backgrounds
Bags:	Lowepro; Billingham

The right equipment is essential if you want to simplify the task of shooting portraits and weddings. A fast lens is essential in low light otherwise every other shot may have to have flash applied just to capture something. The 24–105mm lens is wide enough for me to get in close to a group without being in their faces for both formal and candid shots and with the telephoto element at the long end, I can shoot three-quarter length shots at a reasonable distance. The 70–200mm lens allows me to work at a distance and for the depth of field to be crushed for a blurred background.

My camera needs to fire when I tell it to and without any delay if I don't want to miss the expression or moment. A range of ISO settings, especially at the high end, is invaluable to allow me to work in low light without flash. I upgraded to the Canon EOS 5D Mark II, which has an ISO of 6400, and the noise level at 1600 – the maximum of the 5D – is much less obvious. It also has 21 megapixels, giving me a much bigger file.

When I want to use flash it should, again, be instant with enough manual control to look subtle in the photograph without dominating the scene unless required to. When I use Speedlite flashguns, perhaps dotted around a reception room in winter, I have radio triggers, so the sensor sits on the camera's hot shoe and each of the receiver units is attached to the Speedlites. It doesn't make use of the through-the-lens (TTL) function of the flash; I set them on manual so they give an accurate output of flash each time.

Another valuable piece of kit is a double-sided silver/white reflector, which can completely change the look of an image with very little work. The Lastolite TriGrip is a great piece of kit designed to be held in one hand, with the camera in the other. When not in use, it folds neatly into the side of the bag.

MATT HOYLE

Cameras:	Canon EOS-1Ds Mark II; Fujifilm FinePix S2 Pro; Nikon D100
Lenses:	Canon 24–85mm f/1.8L; 50mm f/1.2; 85mm f/2.8
Lighting gear:	three Canon 580EX Speedlites; Canon infrared triggers
Accessories:	three 20in white satin reflective umbrellas; Manfrotto portable light stands; umbrella adaptors for the light stands; Epson card reader
Bags:	Lowepro backpack (with computer pouch)

When shooting on location I like to travel with the most portable yet effective kit. To me, the Canon stable of equipment works best. The zoom lens is my hero as it's crisp and gives me the freedom to zoom in or out quickly and frame the shot without having to move myself.

The 580EX Speedlites are quite powerful and allow me to shoot both a head-and-shoulders shot and a group of a few people without needing any extra lighting gear. The umbrellas I use are satin, which gives me a crisp yet soft skin quality so there are no harsh shadows but still lots of detail in the textures.

My Lowepro backpack manages to carry everything I need, including my computer, without me having to check it in at the airport as baggage. It saves me from hauling excess equipment while travelling. I have an Epson card reader, which I take on more remote location shoots when I don't want to risk bringing the computer along. This works nicely as a portable hard drive as well as a viewing device with an ample image area. The Manfrotto light stands are quite robust while being the most portable, collapsible stands in their range. They are also easy to pack on the side of my backpack.

EAMONN McCABE

Cameras:	Canon EOS 5D; Canon G10
Lenses:	50mm f/1.2; 35mm f/2.8; 85mm f/1.8; 100mm f/2.8 macro
Lighting gear:	Metz 54MZ-3; Broncolor Mobil with two heads and softbox; Quantum Turbo battery; Gary Fong Lightsphere
Accessories:	Gitzo G1348 Mark II tripod; Minolta 4F light meter; trolley
Bag:	Lowepro backpack

The bigger the job, the more kit I tend to bring with me because it doesn't leave anything to chance – and it looks like I'm a serious photographer! If I have five or ten minutes with a film star in a hotel room, for example, I will use the Broncolor set-up with two lights and a softbox. I don't like using the tripod much because it slows me down but I may start off with it, especially where the lighting is more complex. If I am photographing a rather boring businessman, on the other hand, I will use an interesting location to liven up the picture and shoot in a more photojournalistic style with just a camera, flashgun and lens.

I used to do more studio-style portraiture on the road but I found that my work was getting a little too formulaic. The newspapers also seem to prefer the feeling of 35mm and so I have been increasingly getting back to basics with the Canon EOS 5D and a couple of lenses. Shooting this way – which was how I started in my career – can give more urgency and edge to the shoot. My favourite lenses are an 85mm, which is a good portrait lens, and a 35mm for including more of the environment. When I was young, zoom lenses were considered cheap and nasty while prime lenses provided the quality. I know things have changed and I can explore zooms now, but I feel happy enough with what I have.

Recently, I have made two new discoveries. The Canon G10 compact camera with 14.5 megapixels is just brilliant. It has a solid-feeling metal body but is small enough to carry everywhere. It has helped me rediscover the joy of photography. The Lightsphere, invented by American photographer Gary Fong (www.garyfonginc.com), is an inverted cone that fits over your on-camera flashgun, diffusing and dispersing the light evenly. I have the cloudy version, which gives a lovely soft quality of light. I am still mastering using it but have been very impressed so far.

Probably my most useful item of equipment, though, is a two-wheel trolley. It is perfect for transporting all my kit when I have to park half a mile away from the location.

STEVE SHIPMAN

Cameras:	Canon EOS-1Ds Mark II; Canon EOS 20D; Canon EOS 5D
Lenses:	Canon 24–70mm f/2.8L; Canon 70–200mm f/2.8L; Canon 16–35mm f/2.8L; Canon 100mm f/2.8L macro; Canon 24–105mm f/4L
Lighting gear:	Quantum Qflash 5d-R flash head either on a camera bracket or a stand, powered by a Quantum Turbo 2x2 battery; Canon 580EX Speedlites
Accessories:	20 SanDisk memory cards, mostly 2GB some 4GB; polarizing filter; Lee colour-correction and graduated filters; batteries; lens cloth
Bags:	Lowepro backpacks

I use Canon digital cameras. I switched from Nikon film cameras because I wanted a full-frame camera so that the focal length of my lenses was true. At that time, only Canon produced a full-frame camera, the EOS-1Ds Mark II. At the same time I bought a second body, as a back-up, a Canon EOS 20D, which, although has a smaller chip than full frame, I use to my advantage with a long lens, making use of the increased focal length. I also now have a full-frame EOS 5D, which has replaced my 20D on some shoots.

My most frequently used lens is a Canon 24–70mm f/2.8L zoom. All my lenses are Canon's L series, which means they use the best-quality glass, and are often the fastest, with the widest aperture. This lens is a great workhorse and will comfortably cover a single portrait to a group of people in seconds. The 70–200mm f/2.8L is also a great portrait lens and has an image-stabilization feature, which helps to reduce camera shake. Portraits often look better when shot on longer lenses because there is less distortion to the face. A wide-angle portrait can be very unflattering, especially if the distortion is unintentional. A longer focal length will flatten the face, draw attention to the eyes with less depth of field and throw the background out of focus more easily.

Lighting, for me, has become more paired down over the years. Digital cameras need less light than their film ancestors and so I have a very versatile Quantum system from America, which fits somewhere on the portable side of a studio flash system, but with TTL and controls that trigger other flash lights wirelessly. I also have two Canon flash units that can be used separately or with the Quantum to light larger areas, or more creatively for highlights or backlight. For me it is important to be mobile, so lighting has to be set up easily and quickly. The Quantum battery pack also powers the Canon flashguns. I very rarely use my Elinchrom studio lights these days.

For anyone starting out now the minimum kit is really two camera bodies of a professional build quality and at least two lenses, notably a 24–70mm and 70–200mm. A hot shoe-mounted flashgun is essential too. The other crucial factors are a keen eye and masses of unbounded enthusiasm. It can take a while to establish a career in photography and it helps to have drive, as well as the love of a good woman or man.

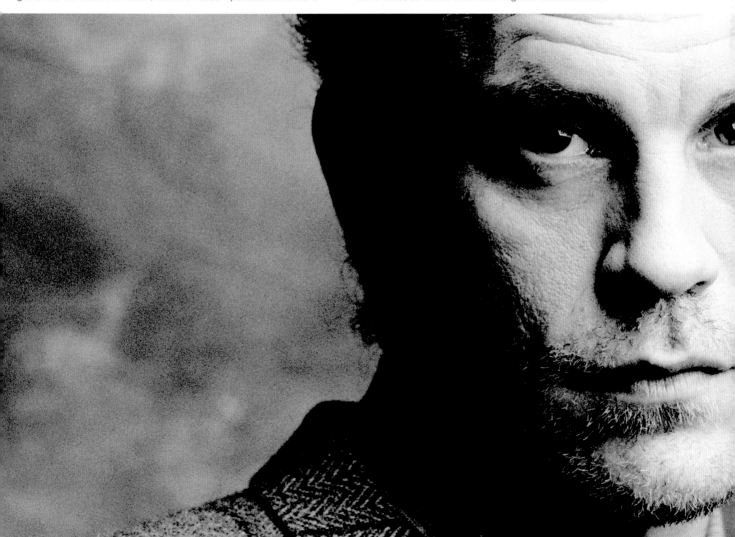

BJORN THOMASSEN

Cameras:	Canon EOS 5D Mark II; Canon EOS-1Ds; Canon EOS-1Ds Mark III
Lenses:	Canon 16–24mm f/2.8L; Canon 28–70mm f/2.8L; Canon 70–200mm f/2.8L
Lighting gear:	two Canon 550EX Speedlites; four Elinchrom RX Style monoblocs; Elinchrom Ranger portable power pack; Skyports radio trigger system; Elinchrom Rotalux softboxes in a range of styles and sizes
Accessories:	Lexar compact flash cards; Sekonic flash meters; California Sunbounce portable diffusers and reflectors
Bag:	Lowepro Stealth Reporter 650 AW

I love the versatility and practicality of the DSLR; it's such an intuitive and flowing system to work with – it is really like an extension of your arm. The Canon EOS 5D Mark II has had stunning reviews in the press and I can fully endorse it. It's a sensational camera for the price, with 21 million megapixels and great specifications.

My favourite lens for portraiture is the Canon 70–200mm f/2.8L. I like to compress perspective and the image-stabilization feature is a great benefit in enabling me to shoot sharp pictures without a tripod in low light. It's a most useful feature and certainly not a gimmick. At the other extreme, the 16–24mm lens is very good at rendering architecture with minimal distortion of the verticals but can also be used at acute angles for deliberate distortion. You get what you pay for with lenses and for edge-to-edge sharpness and high-quality optics, Canon is on top.

Among my lighting equipment, Elinchrom's Rotalux system is unique because it allows me to rotate the softbox or other accessory, which greatly expands its application and allows me to fine-tune the lighting as I please. I am also a fan of California Sunbounce reflectors and diffusers. They are extremely well-designed and versatile, coping well even in strong winds.

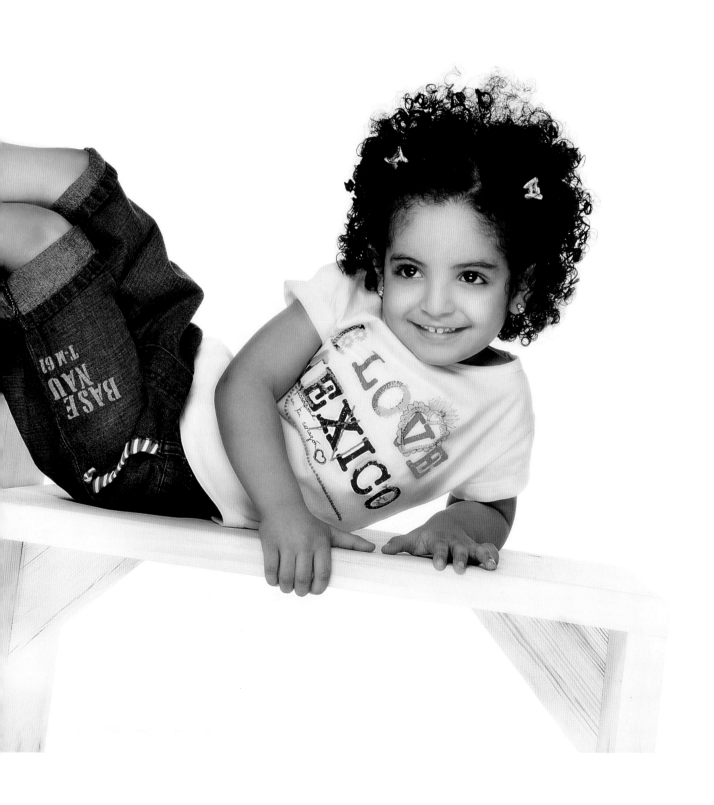

CHAPTER 1: WORKING WITH PEOPLE
Eamonn McCabe

To be a portrait photographer you need to have a natural affinity with people, otherwise you will neither enjoy your job nor be successful at it. Experience really does help in the ability to build a rapport with strangers and so enlist their interest and cooperation. You must also learn how to use your time with a subject, be it ten minutes or two hours, in the most efficient way possible to ensure you achieve that magical moment when expression, lighting and framing come together perfectly as you press the shutter.

Whenever possible, I scout around ≫ for a good location before meeting my subject so that I can take them straight there as a starting point. The writer David Peace lives in Japan and I felt the design on this pillar, which I spotted walking round Russell Square in London, had an Oriental feel. The geometry also worked well with his glasses. In available light, I used a wide aperture to blur the background.
Canon EOS 5D, 50mm lens, 1/400 sec at f/4, ISO 100

DEVELOPING A RAPPORT

Rapport is a word often used in the context of portrait photography and it certainly helps if you can find some kind of connection with your subject. For many people, having a portrait taken is an alien and stressful experience. Easing their anxiety will result in more relaxed facial expressions and body language, and a greater willingness to follow your direction. Inevitably, this will lead to better pictures.

The trouble is that building a rapport can be the hardest thing, especially if, like me, you're working for daily newspapers and often have very little time with your subject. A great friend of mine, the photographer Steve Pyke, likes to do themed projects on people who are linked by a common interest or profession. He will go round to someone's house and spend almost all afternoon talking to them before taking any pictures. I don't have the luxury of that time. I'm often given a slot at quarter past eleven in a hotel room. I get there at quarter to eleven, set up my gear and then, all of a sudden, the subject's there and then they've gone. How do you build up an intimacy in these circumstances?

⌃ I was photographing musicians at a newly built concert hall and these two, Iain Burnside and Roderick Williams, had just come off stage. In this case I was able to capitalize on the rapport my two subjects had with each other. They were in high spirits, chatting away and they reminded me a little of two detectives from a police movie. I set up a small room as a studio, using blue backing paper to go with their clothes and give an upbeat feel. The lighting came from a portable flash unit fitted with a softbox.
Canon EOS 5D, 85mm lens, 1/160 sec at f/11, ISO 400

⌃ Usually, I prefer a subject to be looking at the camera. However, the Irish playwright Frank McGuinness was a friendly, big bear of a man and I caught the moment he was laughing at something. I used fill-in flash to highlight his face.
Canon EOS 5D, 100mm lens, 1/200 sec at f/8, ISO 400

RESEARCH

There are some practical steps you can take to prepare the ground before a shoot. If the subject is someone in the public eye, it's easy enough to do some research on them. I did this recently when I had to photograph a professor of English that I'd never heard of. I had to 'mug up' to find that he'd written books on Shakespeare, teaches at a university and has two children. It didn't mean that I had to photograph him in Stratford upon Avon or take too literal an approach to him as a professor, but this kind of background information gives you the confidence to talk to people more easily.

Of course, there's no way I can quickly research the work of, say, a nuclear scientist but there are other ways of breaking the ice. Over time, you build up a mental stock of questions or comments that can be used to start a conversation with a stranger. For example, if people have just arrived in the country and are passing through, I ask them where they've come from, if they had a good flight and that type of thing. They will inevitably tell you how awful the airport was and you can relate to that.

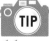 **TIP**

❝ If you are taking a portrait in your own home or studio, putting some music on will take the stillness out of the room and produce a more relaxed atmosphere. It can also give you and your subject something to talk about. ❞

Eamonn McCabe

BUILDING EXPERIENCE

I have a theory. I believe that photographers become better at portraits as they get older because they have greater experience and can talk to people more confidently. At 20, most of us are shy, awkward with strangers and are not even comfortable with making direct eye contact. I feel at an age now where I can photograph just about anyone because there are not many people who really faze me.

I've met people in just about every walk of life – rock and rollers to rappers. Actually, rappers do still unnerve me because I find it hard to understand what they are about. They seem to be playing some sort of game all the time, with their hats, rings, 'bling' and all that ultra-coolness. That fazes me a little bit because I realize I can't get anywhere near

them. But if you give me Keith Richards or Ray Davis, I can relate to them because I grew up with their music. I am their audience.

I think, as a photographer, you gravitate towards the people you feel most comfortable with and, for me, these are writers, poets and artists. I find politicians and business people very difficult because they never understand why you need a second picture. It's a 'you've got me, I'm going' sort of thing. I photographed Bill Gates once – I got 30 seconds with him. You can imagine how nerve-racking that was. At half past eight in the morning he was literally going from one room to another. What can you do? You're worried about whether your flash is going to go off, whether you're camera's going to work. Of course it does, but you can't create very much in 30 seconds.

≪ The actor Timothy Spall is the nicest man in Europe, as far as I'm concerned. I had photographed him before and he had told me he liked my work, so I knew that we would be fine. We met in a hotel in Soho in London and I had already scouted around the area and found a back alley that I thought would provide a little tension in the background, with the strong colour of the brick and the lines of the railings and bricks working with his shirt and jacket.
Canon EOS 5D, 50mm lens, 1/200 sec at f/6.3, ISO 400

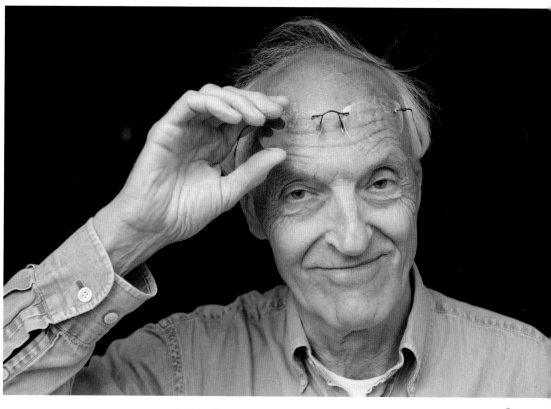

⌃ Michael Frayn, the writer, is an old friend of mine but is never very happy being photographed, as he is quite a shy person. I had already taken some pictures in his garden (see page 29) but I wanted one with a clean background. I stood him in the doorway of his French windows so that the room behind him would completely underexpose. I had noticed that he kept putting his glasses on his forehead then knocking them down again so I asked him to just hold them up like that, thinking it suited his highly academic nature. He didn't feel very comfortable with it, but we had warmed up to this point with previous, safe pictures and so he complied.
Canon EOS 5D, 50mm lens, 1/85 sec at f/5.6, ISO 400

When you are just starting out, it can help build your confidence to work with people you are at ease with and the most obvious subjects are members of your family, girlfriends or boyfriends. That doesn't mean to say that you shouldn't push yourself though. There are lots of people out there who love to be photographed. Look for flamboyant types – men who wear hats, people who enjoy showing off their bodies and anyone who dresses outrageously – and you'll often find they will oblige.

Market stallholders are another great group of people to photograph as they have lots of banter and self-confidence. Tell them that you're just starting out as a portrait photographer and ask whether they would mind if you took a few pictures. You might get a few knock-backs but you'll soon learn to overcome those.

Eamonn McCabe

DEALING WITH CELEBRITIES

It can be very difficult to take a good portrait of someone you are in awe of and that is a real danger with celebrities. Everyone else around them seems so frightened of them that it starts to affect you. You think, 'Why am I getting nervous? It's something I've done hundreds of times before,' and yet there is an aura around them because of their fame.

I have been lucky enough to photograph Al Pacino and Paul McCartney, arguably two of the most famous people in the world. When they come through the door, it's staggering. You have to deal with that, contain your excitement and keep the sense of what you're doing firmly in mind.

I remember when Al Pacino came in he had coffee stains on his lip and the hem of his trousers was hanging down. I said, 'Excuse me sir,' I often call them sir because I have forgotten their name, 'I hope you don't mind, but your hem …' He said, 'I don't mind, leave it.' And then I said to him, 'I like doing close-ups, do you like close-ups?' He said, 'I love close-ups,' and we were away. And there's perhaps the most famous person I've ever photographed, I'm doing the close-up I wanted of that rugged face and he loves it. Then I mentioned something about his recent film, *Insomnia*, and how I liked it and he said, 'Ah, that's my favourite too.' It definitely helps to have some knowledge of your subject but you can easily over do it. Going in there and knowing these people chapter and verse is not helpful – they're not interested. They just want you to be friendly to them.

The whole PR entourage is the main problem with celebrities. They get so wound up that they can swamp you with their nerves. They say, 'He's here, he's coming, he's coming!' and then you think, 'Oh my god, what am I going to do?' Then when someone like Paul McCartney sits down and says, 'Well, I hear you're a hot-shot photographer, what are you going to do with me?' if you're not careful, you crumble.

But experience gets you through. Photographing McCartney, I could see that he had some musical symbols on his sofa and so I started off with that. Then I was lucky – I pushed the door to his office open and there was his jukebox. I asked if I could take a picture of him by it and he said, 'Sure, what sort of music do you like?' and he put on some BB King. I took a good picture of him leaning on the jukebox but, looking back, I wish I'd had the calmness and coolness to sit him in front of it – it would have made a stronger image.

WINNERS AND LOSERS

Any portrait session with a stranger is about thinking on your feet. There is no telling whether you are going to come away with what you wanted or end up disappointed. This is especially true with celebrities when you have big egos to deal with too. Sometimes circumstances conspire against you before you even lift your camera and at other times, a chance remark you make will hit the spot and bring everything to life.

With the actress Juliette Binoche, I have had both experiences. The first time I photographed her was in a London theatre. The journalist and I had no choice but to take the lunchtime slot and she said I could photograph her while she was eating. So, I was trying to take a picture of one of the most beautiful women in the world in between mouthfuls of rocket salad. We didn't get on very well and it was awkward with knives and forks getting in the way. But, I managed to get a couple of pictures where there was no fork, plate or salad and it was OK.

Four or five years later, I photographed her again in a hotel room and I noticed she had great shoes on. I said, 'I just love those Camper shoes,' and she was delighted and told me that she had bought them the previous day. The result was some of the best portraits of a woman that I have ever taken – purely because I had admired her shoes and they were important to her. You could try that with someone else and they might just ignore you – you never know. All you can do is be respectful.

≪ I photographed the actress Nicola Burley in connection with a film she had starred in, *Donkey Punch*. We had been shooting with lights in a studio when I found some beautiful daylight in a stairwell and I asked if she would pose for me there for five minutes. She was charming about it, even though it wasn't the most glamorous of settings, and she gave off this lovely romantic, almost princess-like aura.
Canon EOS 5D, 100mm lens, 1/250 sec at f/8, ISO 400

I took some wider shots of Al Pacino sitting in a hotel room but I really wanted ≫ a close-up as he has such a distinctive, rugged face. I asked his permission to do this, as it's always better to have the person's full cooperation, and thankfully, he was enthusiastic. This would be a digital shot these days but it was taken in the days when film still ruled. The lighting came from a flash in a softbox, powered by my portable battery.
Hasselblad 500CM, 120mm lens, 1/250 sec at f/11, Kodak Portra 400VC

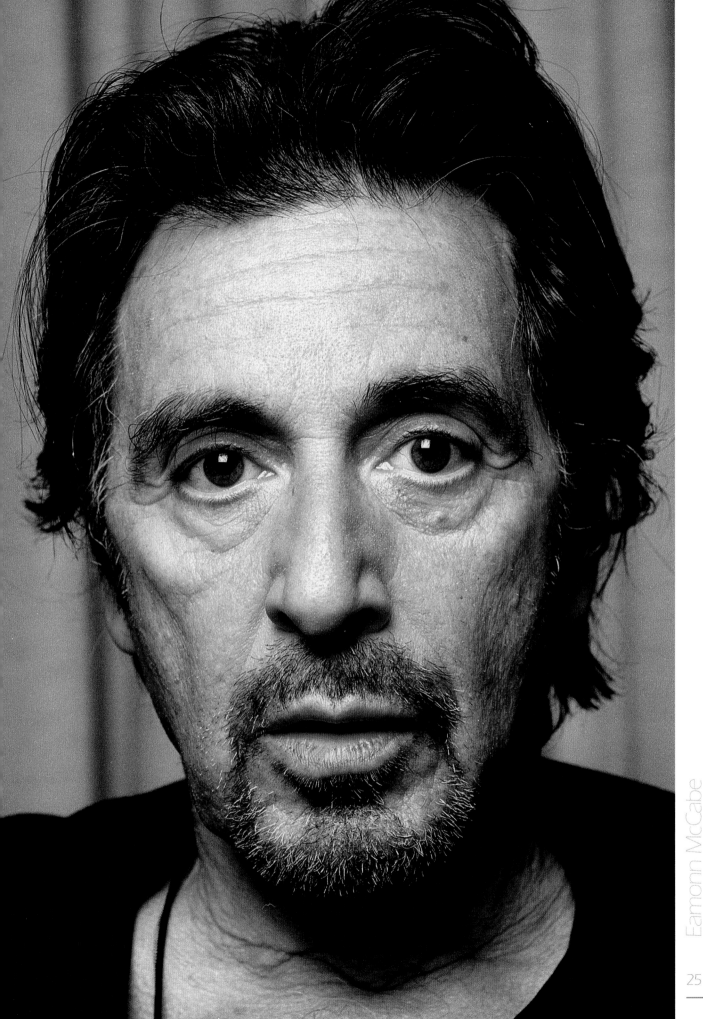

Eamonn McCabe

WORKING TO TIME

I'm a great believer that pictures should come early in a shoot. You wonder how long your subject will be there, they wonder what you are going to do – there is a real energy. I don't think that time equals great portraits. Good location, background and light are the things that you are after. Don't wear anyone out while you hunt for a picture because it's not going to get any better. With discipline and practice, it's amazing how quickly you can frame. When you have the shot, you know immediately, your heart pumps faster. Often, less is more.

I have a great friend, Kevin Cummins, who used to work in Manchester in the 1970s. He was so poor that he had to do three jobs on one roll of film. He uses digital cameras now and he still can't go beyond 35 frames at a given time because that is so ingrained in his work practice. It's a really great discipline but extremely hard to stick to when shooting digitally. The problem is, because it is possible to shoot so many pictures on the memory card, you do.

I know that I take far more images on a shoot with my DSLR than with my film camera. I find myself saying things like, 'I'm just doing this for a test.' I never used to say that before; I just used to take pictures. But because digital cameras allow an instant review, you do a test, check the exposure and, if you're not careful, you can shoot 60 pictures of the same head. The result is a terrible editing problem. Apart from the odd shot where the eyes are shut, how do you choose which to use?

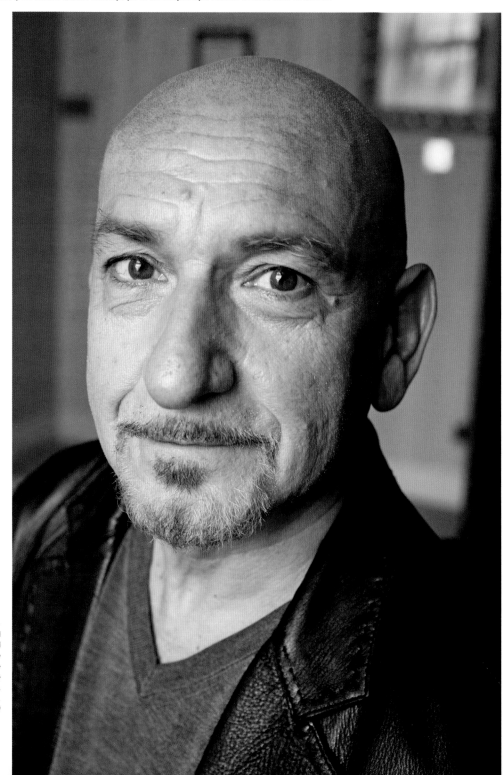

This portrait of the actor Ben Kingsley ≫ was taken in a hotel room where I had been working with my big softbox and Hasselblad camera. I had taken some good pictures but then I spotted some lovely window light and took advantage of it quickly with my Canon DSLR.
Canon EOS 5D, 50mm lens, 1/125 sec at f/5.7, ISO 400

While I sometimes think that a DSLR camera that could take only 12 frames would be a good thing, I wouldn't seriously recommend reducing the size of your memory card. It's a wonderful freedom not to worry about running out of film or changing rolls mid-shoot. However, all digital photographers should get into the habit of making every frame count. Try to make sure that the lighting, composition and exposure is as good as possible when you press the shutter so that you rely less on post-production editing and manipulation, which is not always a reliable safety net.

PLANNING

Working quickly and efficiently requires a degree of planning and quick thinking. If I only have ten minutes, I will decide in advance, if possible, whether the person has a really good face or if I need a wider picture. There are some people in the world, including celebrities whose looks have made them famous, where the face is the only shot worth taking. Other times, however, you can reveal something of their personality through the way they use their hands, their body shape or their clothes. You might walk into the room and be struck immediately by the jacket they are wearing and know that you want to use it in the picture.

I've met the author Alan Sillitoe many times and we get on well. When I saw ≫ that he had one of his trademark waistcoats on, I knew that I had to use it in my picture. He always puts his hands in his pockets so it was just a matter of getting him by the great light coming in from the window.
Canon EOS 5D, 50mm lens, 1/160 sec at f/2.3, ISO 400

Of course, as a professional, you should do both a close-up and a wider shot whenever you can, but prioritizing not only speeds up composition but also affects your choice of background, lens and lighting. If I go into a hotel room, I'll take a softbox and fully charged battery. I like to keep things simple, not only for speed but also because five lights can look overdone and kill the atmosphere stone dead. If I'm meeting someone at a location who I doubt will be 'a face', I'll carry a small flashgun in case I need it and I'll work with two or three short lenses, usually a 35mm, to capture a sense of the place.

≪ **Derek Walcott is a great man of poetry and is treated like a god wherever he goes so there tends to be some tension before he arrives. This was taken at the Globe Theatre in London. I had looked around beforehand and decided that one of the boxes would be the best place to take his photograph. I took some shots showing the stage below but was conscious that I wanted some new close-up portraits of him, as he seldom comes to Britain. There was some bounced light here from my Metz flashgun.**
Canon EOS 5D, 85mm lens, 1/60 sec at f/11, ISO 400

Eamonn McCabe

BACKGROUNDS AND PROPS

I'm very keen on backgrounds and atmosphere in portraits. The worst place in the world for me to work is a hotel room because it has nothing to do with the person – it's not their mirror, not their sofa. I love to photograph artists in their studios or writers where they work at home because you get something of the 'landscape' of their lives. I try to capture what drives these creative people and what they need around them. I don't set things up or rearrange anything and I like to use the same light as they use for their work.

You have to be careful in some circumstances though. You can knock on the door of someone's flat or office, walk in and be overwhelmed by so much stuff. You have to remind yourself that you're there to photograph the person, not take a lovely picture of the room with a tiny figure in it.

A similar thing can happen when you are working on location. Not long ago I had to photograph a writer, Sebastian Barry, at Canterbury Cathedral. He had a play on there, which would have finished by the time the picture was published in *The Guardian*. Walking around, I was overwhelmed by all that was there, gorging myself on the potential images. What I needed was a good portrait, not a picture of the cathedral so I had to strip that out altogether. I found a little seat set against some dark brickwork and knew that if I took him there I would have my picture.

≫ **Photographing the Irish writer Sebastian Barry at Canterbury Cathedral, I found that all the magnificent detail of the cathedral itself was giving me much more information than I needed to make a strong portrait. This alcove with its peeling surface had a sense of mystery, leaving something open for the viewer to interpret.**
Canon EOS 5D, 35mm lens, 1/60 sec at f/8, ISO 400

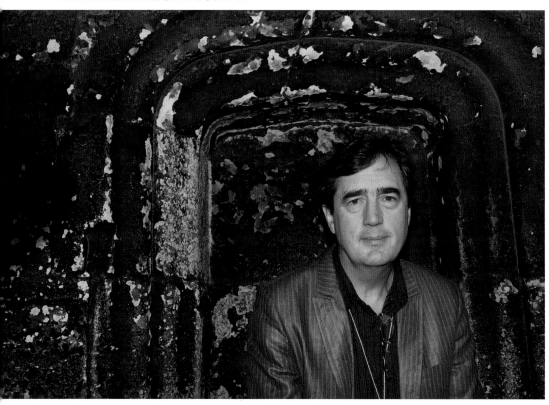

An alleyway or tunnel with a curved roof always makes a good background for a portrait as it provides a ready-made ≫ frame around the subject. I photographed Nicholas de Jongh, the *Evening Standard* theatre critic, because he had written his own play. We started off in his home but I wanted something with a little more drama. This was lit with on-camera flash, bounced off a wall to soften it a little.
Canon EOS 5D, 35mm lens, 1/160 sec at f/5.6, ISO 200

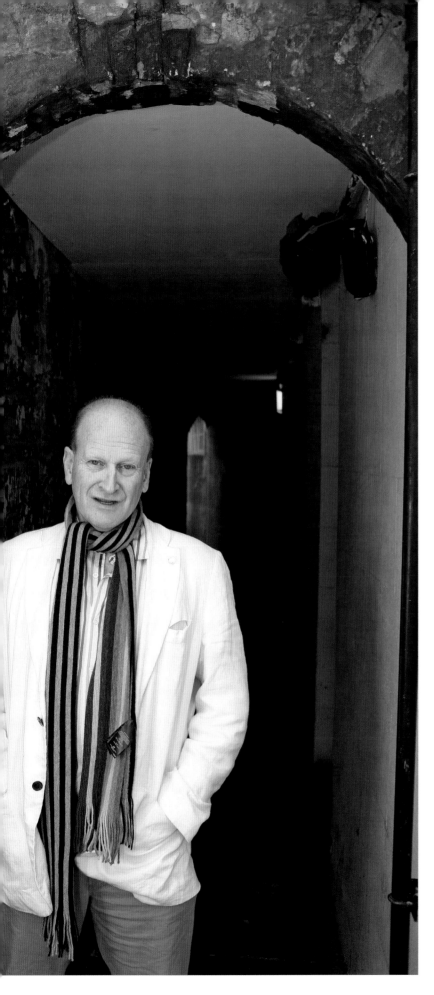

LATERAL THINKING

I try to avoid backgrounds that give information about the person in a too obvious or literal way. I had to photograph an author of a book about remembrance once. Again, we were in a cathedral where there was a plaque on the wall with the word 'remember' above it. The journalist who was doing the interview suggested I photograph the author underneath the plaque. I hated the idea. It was a writer's approach to a photographic problem. I prefer backgrounds that intrigue and challenge the viewer, rather than spell things out for them.

Working for newspapers and other publications, you are occasionally given a brief. Sometimes it is straightforward to follow but more often than not a brief will need to be adapted or ditched altogether. While you aim to find a background that will work with a particular subject, ideally it should also inspire you as the photographer. It's amazing how many people suggest I take their portrait in their local park, but I can't take a picture in a park to save my life. I quite like the hard structures of children's playgrounds but, for me, the idea of flowerbeds and trees just kills any thought of a picture. Of course, there have been some great portraits taken in parks but I'm definitely more of an urban photographer.

Often, as a professional, you simply have no choice but to make the best of the location you are given in the shortest possible time. Recently I photographed the presenter of the TV programme *Countdown* and the place we were given to do this was a dingy office with absolutely nothing going for it at all. Fortunately, I saw that the room had a balcony so I took her there and photographed her with the landscape in the background. You can usually find something that will work as a background and leave you satisfied, even though it would not have been your first choice.

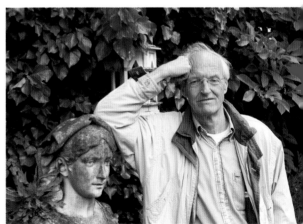

⌃ **This is the writer Michael Frayn from the same shoot as the portrait on page 23. I saw the statue in his garden and knew it would make a useful prop for him to lean against, with the foliage and birdhouse in the background providing interest without being distracting. He was a little self-conscious about this pose but agreed nonetheless and I think he looks comfortable enough in the picture.**
Canon EOS 5D, 50mm lens, 1/125 sec at f/5.6, ISO 400

If you are shooting in your local area, it's possible to build up a stock of places to take people. Perhaps you have a favourite alleyway, a cobbled street or some interesting architecture nearby. However, the most important factor in the photograph is the light. It is no good finding the perfect background if the light is too harsh. Time to adopt plan B and move on to a place where there is nice soft, reflected light.

USING PROPS

People often think that portrait photographers keep all kinds of items in the boots of their cars, ready to whisk out and hand to their subjects to give their pictures more interest. This is rarely true, though I can think of one very successful photographer who is well-known for pairing his subjects with bizarre appendages.

Props need to be treated with caution because they can look corny, predictable and gimmicky. Tea cups fall into that category – people eating and drinking do not look attractive. Good portraits are things that will last and tea cups and cigarettes don't have that solid feeling. Why do we love those Hollywood portraits from the 1930s and 40s? They are so striking because they are simple and don't rely on cheap props.

That said, props can be useful in revealing something about the person or their work. I have photographed a psychologist with a model head featuring labelled parts of the brain. I have also taken a picture of The Beatles' record producer, George Martin, among dozens of microphones in his studio, which seemed appropriate for a man of sound.

A prop doesn't have to have an obviously direct relevance to the person though. It may be that you walk into their room and something catches your eye that you would like to include. I try to put something extraordinary or exotic into a picture at times, perhaps a chair or part of a painting. I have photographed the academic and critic George Steiner three times and each time I have included a haunting picture of nuns that he has – I just can't resist it.

I prefer the kind of props that form part of the background rather than giving the person something to hold. There is a place for that on occasion, when they need something to do with their hands, but it would have to be something that felt natural to them to avoid awkward-looking self-consciousness.

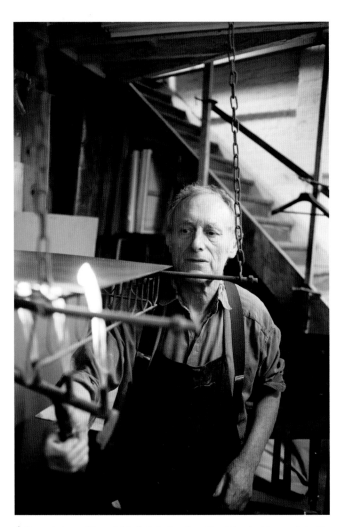

⋀ I love photographing artists in their studios. Here, the printmaker Norman Ackroid was showing me a technique as I was taking pictures. The background is a busy mixture of vertical and diagonal lines that help tell the story of his basement work environment. I didn't use flash here, taking a chance with an ISO of 1600, because I wanted to capture the warm colours and atmosphere of the room. The versatility of changing and experimenting with the ISO settings from frame to frame is one of the things I appreciate most about the DSLR camera.
Canon EOS 5D, 35mm lens, 1/60 sec at f/2.8, ISO 1600

⋀ A.C. Greyling, an academic and writer, photographed in his slightly chaotic, book-filled room. This provided a natural background for him as it tells the viewer something about his work and personality. It was late in the day so I used a portable flash unit with a softbox.
Canon EOS 5D, 35mm lens, 1/125 sec at f/8, ISO 400

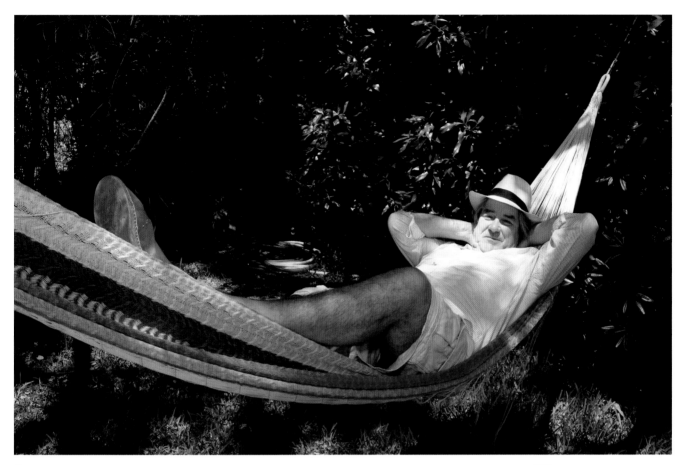

⋀ The writer Patrick McGrath is often photographed as someone miserable, so I thought it would be good to get him in a bright atmosphere, especially as we were in Ibiza in the summer. I knew the hammock would help me to get something different, but I didn't know whether I'd be able to persuade him to get into it, especially for a big profile piece in a national newspaper. But we had a few beers and a chat and he was quite happy to do it. The hammock gave me some different options. The full-length shot is quite moody, with the play of light and shade, and then I went close, taking some with flash and some without.

Canon EOS 5D, 35mm lens 1/60 sec at f/16, ISO 400

TIP

" Always think about how the image is going to look in the final medium. For most of my work I have to think about how it will look printed in a newspaper. Sometimes I will need to use a little flash to add sparkle. Pictures can often look flat in the paper if they are just shot with available light. "

WITH FLASH

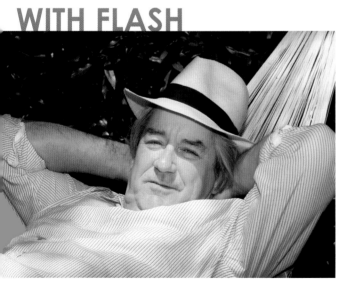

WITHOUT FLASH

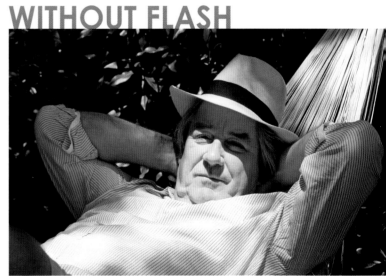

DIRECTOR OR OBSERVER?

When I was a 22-year-old sports photographer, I spent my days on the edge of a football pitch or tennis court, waiting for the moment. Even when I took portraits of famous athletes, I was grabbing the shot and glad of grabbing what I could. As I've got older, I feel like I've gone from being an observer to a director, in my own small way. I'm orchestrating events now, taking people where I want them and telling them what I want them to do.

As you gain experience, you learn that you have to make people believe you know what you're doing otherwise they will walk all over you. If your subject is someone halfway famous and you say, 'Do you think we should do this?' then they are going to murder you. If, however, you say, 'Look, I've had an idea for a picture,' then you are going to gain their interest and, hopefully, their respect.

Sometimes even the best-laid plans go wrong and you find that your idea doesn't work in practice. This is not a disaster though, because the important thing is to start with something that you can work on and then you can make it better. Stay calm and in control and hopefully your subject will not be aware of a second's hesitation.

With a group of people, like a rock band or a football team, it's easier to fall flat on your face. If one of the group picks up that you don't know what you're doing, you can lose ten vital minutes as they take advantage and mess about. Even with people you are close to – family members, boyfriends or girlfriends – it's important to have some structure to your time, perhaps especially so or you'll soon find them groaning every time you pick up your camera. Think of a couple of ideas before you begin and then if you manage to get some spontaneity, great.

POSING

They say in portraiture that 'the eyes have it' and I am certainly a great believer in the gaze to camera – I like people to look at me. People, in general, are not very good at looking each other in the eye so if you have a famous face staring straight at you from the pages of a book or magazine, it becomes very powerful. You have to take that person on.

In my view, if a person is looking off-camera it just makes the viewer want to see what they are looking at and I find it rather insulting. I see it so many times in newspapers, where you can tell the photographer has just asked the subject to look out of the window, usually to avoid that face-to-face confrontation. I think it's a cop out. If you look at all the great portraiture from Irving Penn to David Bailey, it always has the gaze to camera. Start with that and the rest will follow.

How you decide to photograph a person, whether close-up, full-length or seated, depends a great deal on your initial impression of them, as soon as the door is opened. If you see a great face, you can pretty much throw everything else away and just go for that. If they are not particularly striking looking but they have great flamboyant clothes, then you would shoot it full-length. Very tall people can be a problem full-length because they can appear distorted, so sitting or crouching

≫ When photographing the writer Orlando Figes, who had just published a book about Russia, I didn't have much to go on to give me a portrait of note. My solution was to use the directional light from a window at his home to inject a sense of drama and eeriness.
Canon EOS 5D, 85mm lens, 1/60 sec at f/22, ISO 1600

I photographed actor and director Ron Howard for a piece about film directors, in connection with his film *Nixon*. ≫
I only had ten minutes with him and as soon as I saw his skull-like domed head I knew I wanted to go for a close-up.
We were in a hotel room and I took my own paper background with me, which I taped to a wall. I often do this as
hotels tend to have awful wallpaper. The lighting was flash with a softbox.
Canon EOS 5D, 85mm lens, 1/160 sec at f/16, ISO 400

Eamonn McCabe

is often a better solution. Similarly, if someone is very short and plump you need to take care. Over the years you learn how to use a person's height to your advantage rather than their disadvantage.

You also have to fit the pose to their age and character. I've recently done a series of portraits of war veterans and they had trouble standing. I had to find a device to make the pictures work so I included their walking sticks as props, held in the centre of the picture almost like weapons. You do have to be careful when using chairs with backs because they can merge in with the portrait. If the chair is making a good shape, that's great, but otherwise it is better to find an angle where it doesn't intrude. If your subject is young and vibrant, you don't want then sitting tamely in a chair but need to look for more dynamic angles, perhaps through the use of their body, or through the background or a prop.

HANDS

Another signature style of the great Bailey is that he never uses hands. If you look at his pictures, the strength of many of them is just through the head and shoulders. I can see the benefits of this approach. Hands can be awkward, especially for people that are not used to being photographed. They don't look right just hanging straight down and if you're not careful, they look stuck on. I do a fashion shoot once a week with someone picked off the street for their dress style. It is always a full-length shot so hands and arms can't be avoided and I find that a handbag is a very useful prop in these circumstances.

Of course, some people are wonderful at using their hands and the expression they create with them can be integral to a portrait. If that is not the case and the hands are adding nothing to your shot, my advice would be to frame more tightly to leave them out.

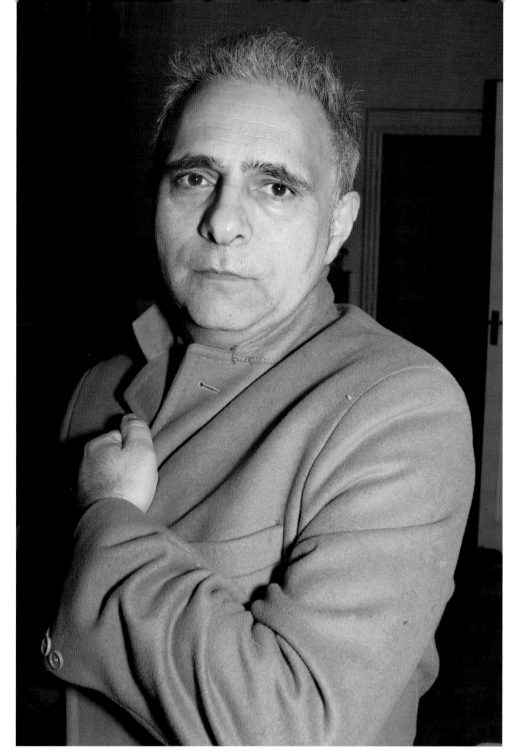

⚒ When you are constantly photographing people every day for a newspaper you have to think of devices to chop and change the mood. I took some photos of the writer Hanef Kareshi at his house and, here, used bounced flash off a wall on the right side to create a little drama. Depending on how you are getting on with someone, you can become more ambitious and, as he was an open, cheeky character, I was able to ask him to wrap himself in his coat to give some texture and a different sort of look.
Canon EOS 5D, 50mm lens, 1/200 sec at f/16, ISO 400

≪ Aravind Adiga had just won the Booker Prize when I went to photograph him in his publisher's office. I saw this amazing blue painting, sat him in front of it and then just played with the shapes of his head and hands. The lighting was on-camera, bounced flash.
Canon EOS 5D, 85mm lens, 1/160 sec at f/16, ISO 400

WORKING THE ANGLES

While you should always start a portrait session with a couple of ideas to get you going and instil confidence in your subject, observation is, of course, still an important part of the craft. As you put your eye to the viewfinder, keeping the person engaged all the time, watch for nuances in their facial expression, notice their body language and the shape of their clothing. When it all comes together, the person's hands are in the right place, the balance of their shape in the frame works, your heart skips a beat. You react to how something looks through the lens and you know you've got it.

This sequence of shots and those on the following pages give an idea of how I will work-up a picture. It is interesting to see how a slight turn of the head or a tilt of the eyes changes the way the character of the person comes across to the viewer. It is not something you notice during an everyday conversation with someone but it is so evident when that split second is frozen in time by the camera. For me, it is one of the fascinations of portrait photography.

JUDITH KERR

I photographed the children's author and illustrator, Judith Kerr, at her home for *The Guardian*'s Saturday interview. The paper asked me to get a cat in the picture because she is famous for her books about Mog the cat. I found some beautiful light downstairs with some sunflowers in the background so I shot a few portraits before we went looking for one of her cats. For this regular newspaper feature, the picture always needs to be a letterbox shape, so I use an 85mm lens, which is a 35mm shape. Although my angle of view is more or less the same in the three pictures without the cat, they are all very different portraits.

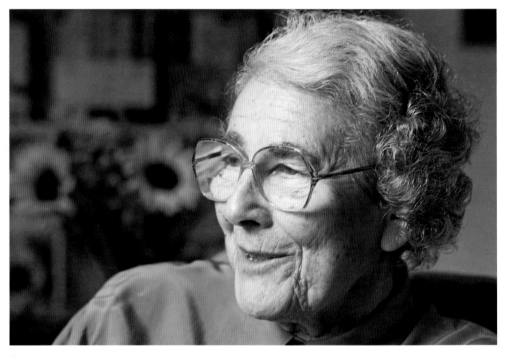

⌃ Finding the light and the situation is my first priority for a portrait. The lovely natural light from a window cast shadows on the right of the face, which added pleasing modelling. I framed with Judith's head off-centre and included the sunflowers to lift the background, using an aperture of f/4 to ensure that they would not be overly sharp.
Canon EOS 5D, 85mm lens, 1/60 sec at f/4, ISO 400

We were getting on well together ≫ and she threw her head back, laughing at something and so I grabbed the shot, just getting the one frame. It probably wouldn't be used as an individual portrait because, out of context, it's not clear what she is doing, but I always seize a moment like this anyway.
Canon EOS 5D, 85mm lens, 1/60 sec at f/4, ISO 400

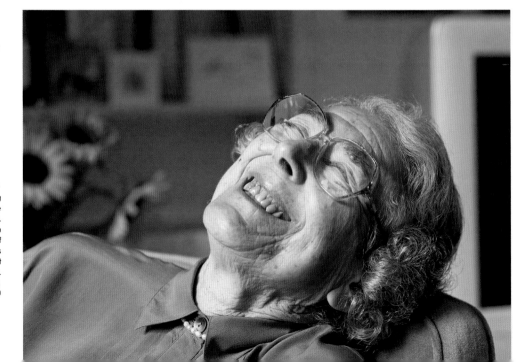

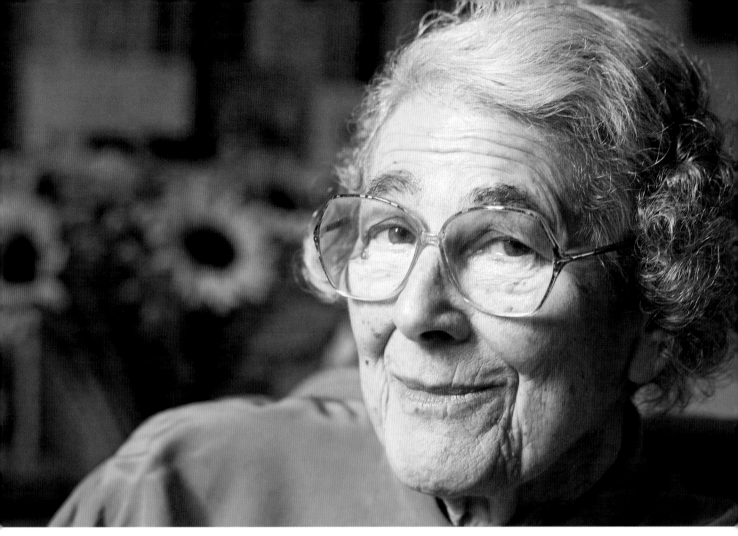

⌃ This is my favourite of all four pictures. She was just giving me a little sideways glance and I think her expression and her eyes really engage with the viewer.
Canon EOS 5D, 85mm lens, 1/60 sec at f/4, ISO 400

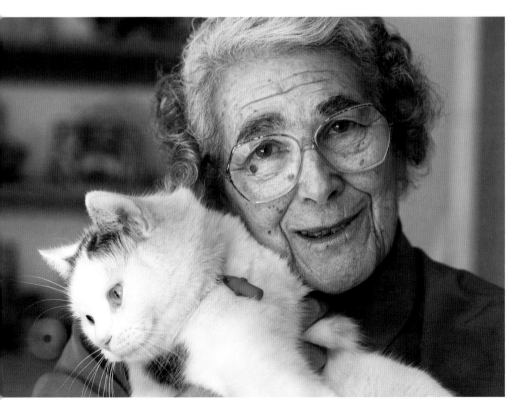

≪ After we had warmed up and I had taken the shot that I felt really happy with, we went for the picture the newspaper had particularly asked for, with Judith holding one of her cats. We tried out various poses and this was the most successful.
Canon EOS 5D, 85mm lens, 1/60 sec at f/4, ISO 400

Eamonn McCabe

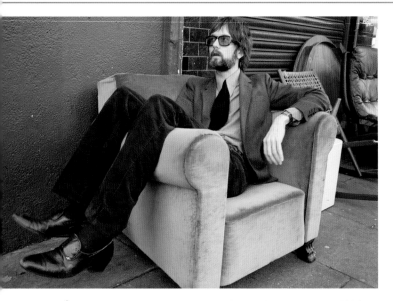

⋀ I began using the chair to help deal with his excessive height, but I still didn't feel it was working very well from this angle.
Canon EOS 5D, 35mm lens, 1/60 sec at f/6.3, ISO 400

JARVIS COCKER

For a photograph for *The Guardian* to celebrate 30 years of Rough Trade records, I went to see the rock musician Jarvis Cocker at his office in Portobello Road in London. Beforehand, I had spotted a junk shop over the road and the owner had given me permission to use it. All I had to do was take Cocker there, and he was very good about it. Musicians, writers and artists understand why you do these things as a photographer, but politicians don't – they wouldn't go across a corridor for you. I also tried photographing him standing up against a railway bridge but it didn't work; he was just too tall and thin. It would have looked very awkward in a newspaper. I knew I needed a chair, as a way of compacting him, while making interesting shapes and textures. We made four or five really nice pictures there, using the chair, going in close and turning the camera from horizontal to vertical.

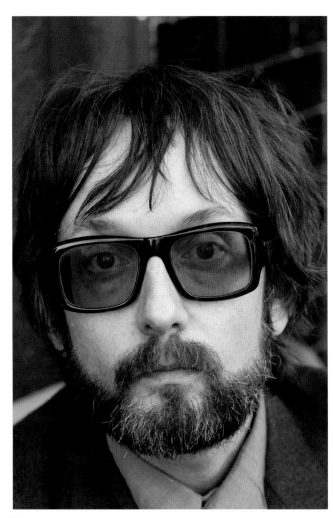

⋀ Looking into the camera with his big square glasses, it's a strong close-up, and the height awkwardness is not an issue, but I wanted something more interesting from this particular shoot.
Canon EOS 5D, 35mm lens, 1/60 sec at f/6.3, ISO 400

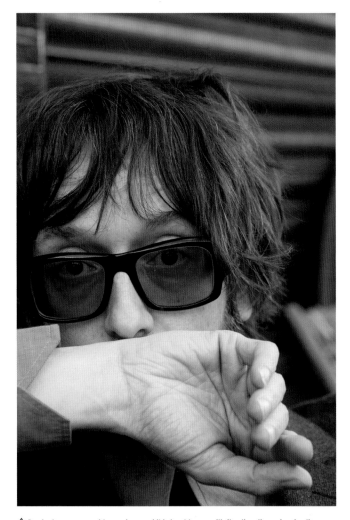

⋀ Rock stars are used to posing and it is best to go with it rather than dominating too forcefully. If they feel they have given you what they want, they are more likely to go along with your ideas.
Canon EOS 5D, 35mm lens, 1/60 sec at f/6.3, ISO 400

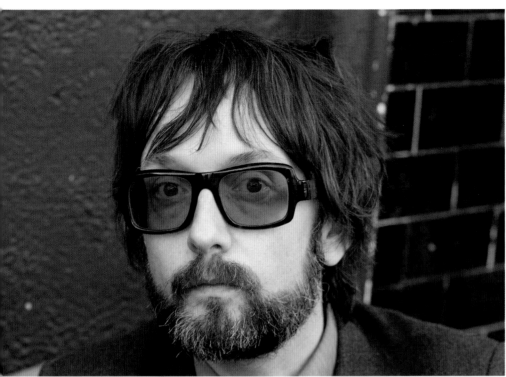

≪ Working a picture up, I will try both vertical and horizontal formats. Leaving some space around a face allows for cropping decisions to be made later on the computer.
Canon EOS 5D, 35mm lens, 1/60 sec at f/6.3, ISO 400

⩔ Leaning over the chair, I had my shot as I wanted it. He is making a good shape with the chair, his posture and folded arms are commanding and there's enough of the background in the frame to show the shabby, urban environment. Unless I change to a completely different set-up, I normally stick to the same lens for a shoot like this, changing my own viewpoint instead. I don't trust zoom lenses out of habit because the standard of them used to be inferior to prime lenses.
Canon EOS 5D, 35mm lens, 1/60 sec at f/6.3, ISO 400

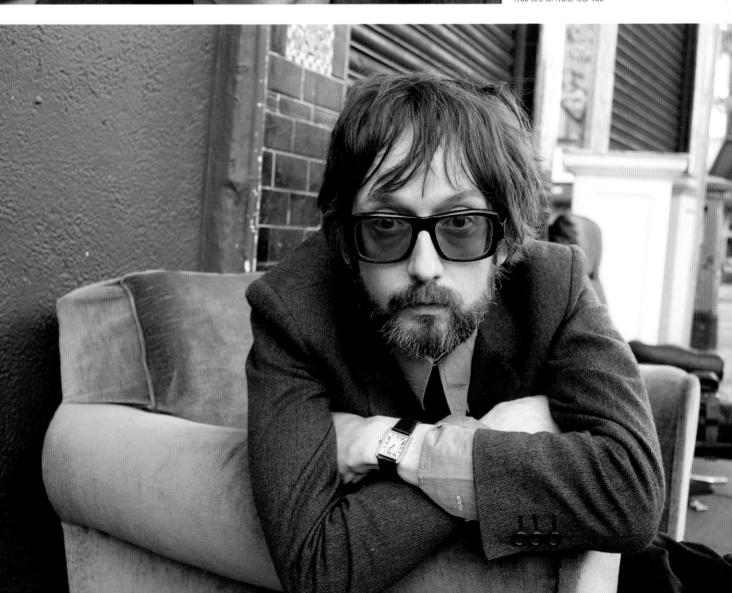

POST-PRODUCTION: CROPPING

As a general rule, I'm not an ardent cropper. My preferred way of working is to find a good space and put the person in it, having already visualized how they will fit. However, cropping has been an integral part of the photographic process ever since the medium was first invented and there are very few people who can get away without ever tweaking the dimensions of their pictures.

While it used to be down to the darkroom printers to instigate the crop, now you can take it into your own hands on the computer, using a very simple method in Photoshop. It takes no time at all to experiment with different crops, fine-tuning and adjusting on-screen while leaving the original picture file untouched should you want to return to it at a later date.

Sometimes cropping is essential to improve the picture: you may have the choice of framing carefully with the lens and missing a crucial moment or grabbing what you can and dealing with a distracting element by the side of the subject later. If you can't get it right at the time of shooting, it's always better to include more detail than you need than to go in too tight and regret it afterwards. There may be practical reasons for cropping too, such as the need to fit a photograph into the space it will be published or displayed in.

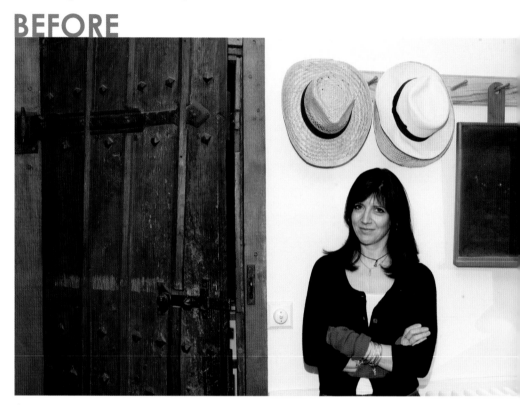

⌃ I photographed the television presenter Emma Freud in her kitchen, which has a Mexican theme to it. I like to show people in their own surroundings as it reveals something of their character, so I kept the shot fairly wide using a 35mm lens.

CROPPING IN PHOTOSHOP

- Select the Crop tool from the tool palette.
- If you want to crop to pre-set dimensions, perhaps to fit an album or frame, select from the drop-down menu by the Crop icon on the Options bar. Alternatively, you can key in your own measurements here. If you want to crop 'freehand' to no specific measurements, leave the width and height boxes blank. Enter the desired resolution in the Options bar.
- Drag over the part of the image you want to keep. This will create a marquee.
- To move the marquee to another position, place the cursor inside the box and drag. To change the size of the marquee, drag a handle. To constrain the proportions as you change the size, hold down the Shift key while you drag a corner handle.
- To stop the cropping action, press Esc or click the cancel button in the Options bar.
- To complete the crop, press Enter (Windows) or Return (Mac), click the tick box in the Options bar, or double-click inside the cropping marquee. If you feel you have made a mistake, go to Edit> Undo Crop.

⌃ With the image open in Photoshop, select the Crop tool. The 'marching ants' marquee comes up and you can make your selection, grabbing the handles at the sides and corners to adjust it.

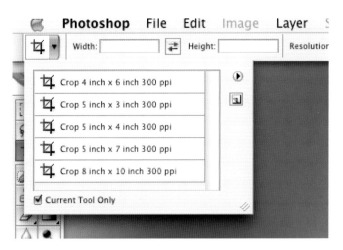

≫≫ This rather drastic crop isn't what I intended from the shoot at all and would not have been suitable for the newspaper commission, but it could be a useful shot for other applications.

≫ A drop-down menu allows you to pick specific dimensions if you want to fit an album or photo frame.

TIP

❝ It is easy to get carried away with the Crop tool in Photoshop. Take your time to see if you are really improving the composition or squeezing the life out of your subject ❞

⋎ I rather liked the blackboard on the wall in the original, but it did mean including part of the lamp and the radiator, which added nothing. This is certainly a 'cleaner' version.

AFTER

Eamonn McCabe

41

CHAPTER 2: COMPOSITION
Steve Shipman

Composing a portrait photograph is about putting in place the building blocks of a picture within the frame of the camera. It involves decisions on where to place your main subject, what other elements you are going to include or exclude and how they will relate to the subject in a way that will enhance it. Light, colour, movement and technical considerations, such as depth of field and lens focal length, also play a part.

Sometimes it is a quick and intuitive process, at other times it must be considered at length, but it is always highly subjective. By experimenting and studying your own pictures and those of others, you can work out your preferences and develop a personal style.

This image is of the VOP Crew, as they ≫ are known, and we had permission to use the rooftop of a tower block near to a large mural the crew were painting in Bermondsey, South London. The image is shot in sunlight but with flash as the main light source.
Canon EOS-1Ds Mark II, 16–35mm lens, 1/250 sec at f/10, ISO 200

POSITIONING THE SUBJECT

When setting up a portrait, my first consideration is how to position the subject within the available space, whether it be a clean white background, a blur of colour or a detailed environment. A lot of photographers talk about finding the light and putting the subject into it, as though the rest of the picture will somehow follow. I've never quite subscribed to that. For me, the priority is finding an interesting or unusual situation. Once this is established, you can make it work by experimenting with framing and composition to achieve a balance and harmony between the subject and the background.

The viewfinder is just like a rectangular window through which you need to capture a pleasing arrangement of elements. It's up to you to choose those elements that add up to a good composition and eliminate those that detract from it. To do this you can either move your subject or you can change your own viewpoint to find a position that gives you the shot you want. Whether using a zoom lens or a series of primes, choose the focal length that frames the shot in an ideal way, cropping out the superfluous and including elements that are meaningful in the photo. Turn the camera on its side to decide if a horizontal or vertical position works best. Work out what you are trying to express through the picture and how to contain it within the rectangle.

THE RULE OF THIRDS

A good starting point for deciding where to place your subject within the frame is the rule of thirds. This is a classic technique that has been used by artists and photographers for centuries where the main subject or focal point of a picture is one-third of the way into it and there is space in the other two-thirds of the frame. This can work in three ways: vertically, where the key element is one-third or two-thirds of the way up or down the picture; laterally, where it is one-third or two-thirds of the way across a picture; or at an angle, where you have a diagonal line that reveals your subject in a 'thirds' position in the frame.

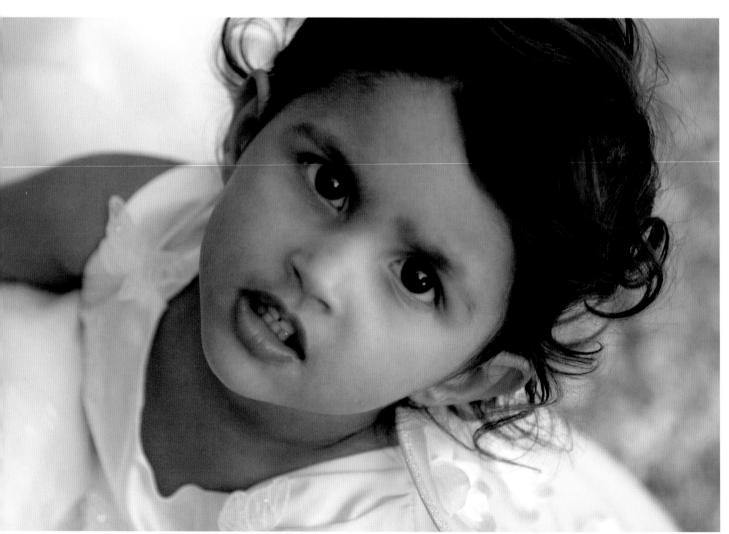

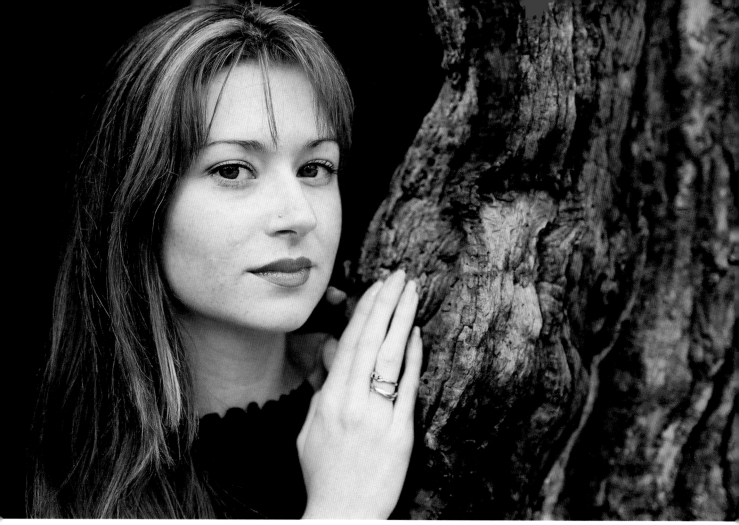

⋀ Props can be used in close-ups where they complement the subject through colour or texture. I saw this tree and put the girl next to it because the colours in her hair matched the colours in the tree and the gnarly bark makes her skin seem even clearer by contrast. The tree was hollow, which meant I could place my subject in the darkened tree trunk and expose the image for the light falling on her face. Note that her eyes are on the top horizontal third of the picture.
Canon EOS 20D, 24–70mm lens, 1/250 sec at f/4, ISO 400

It is surprising how many photographers adhere to this rule, although many do so almost unconsciously, simply because they find it a naturally pleasing arrangement. It is quite easy to train your eye into seeing this way by imagining a 'noughts and crosses' grid over the viewfinder and placing the subject on one of the intersections between the vertical and horizontal lines.

Composition is largely a matter of personal taste, however, and photographers need to find out what they find visually pleasing or challenging. You don't have to create a traditionally composed picture with the subject one-third or two-thirds of the way in. You could try putting the subject at the extreme right-hand side of the image, for example, with unusual and effective results. Similarly, putting the subject in the very centre of the image can sometimes make a strong picture. Take some time to browse photography books and art galleries to find images that you admire. Consider carefully what it is you like about the composition and what makes it work in your eyes.

GOING CLOSE

Often it's the person's face alone that will inspire you to take their portrait and in this case you will want to use a longer lens to frame fairly tightly around it. The eyes will be the part of the picture that draws the viewer in so these must be in sharp focus, as any hint of blur will immediately detract from the picture. The rule of thirds is a useful guideline for positioning the eyes within the frame to achieve pleasing results. Try having the eyes two-thirds of the way across the frame, and two-thirds down from the top. Lighting is important too, as side light will have a different effect on the face to front-on light.

Even with close-ups, the background needs attention as it should not compete with the subject but complement it if possible. If the background is too cluttered or distracting, use a wide aperture to throw it out of focus, while ensuring you have enough focus on the eyes. Converting the image to black and white in post-production is a good option if the background colour detracts from the subject.

≪ This was a spontaneous shot, lit by daylight and grabbed in one frame. The picture was converted to black and white and the blacks darkened because the child's beautiful brown eyes are the central element of the picture. There is a triangle of movement around her eyes, mouth, shoulders and dress behind her that leads your eye around the picture.
Canon EOS 20D, 24–70mm lens, 1/640 sec at f/2.8, ISO 1600

Steve Shipman

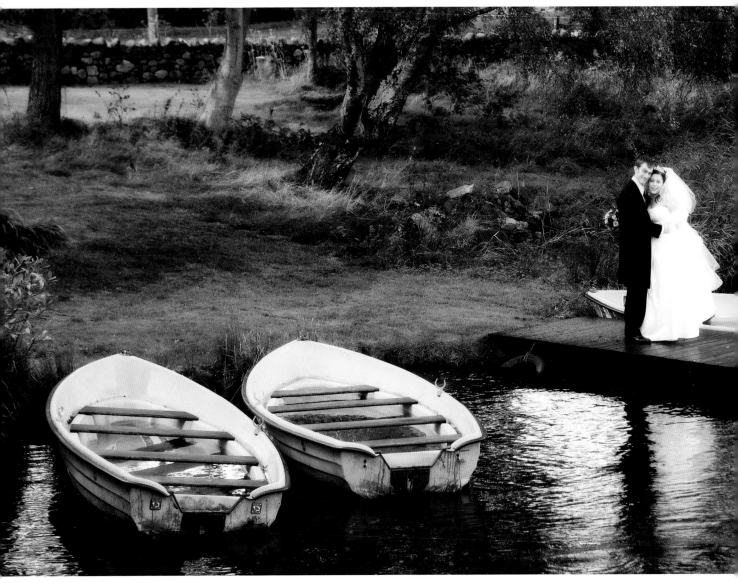

STEPPING BACK

I love finding good backgrounds and situations into which I can put my subjects because, for me, they so often provide the inspiration for the picture. Sometimes just a small part of the background is needed to construct the composition but at other times you need to stand back and allow some space around the subject. This may be because the environment tells a story about the subject or is relevant to them in some way, or it can be a compositional device to draw the viewer's eye towards them. It could be that the setting is particularly beautiful and almost a landscape in its own right, but I also love more unlikely environments that challenge the viewer a little and enhance the subject through contrast.

Whatever your setting, make sure that it has a reason for being there and that it works in harmony with your subject. Be selective with your vision and change your viewpoint or your lens to include what is necessary. Experiment with different crops in-camera and be aware that you can always crop again afterwards in post-production. It is often better to err on the side of generosity with the space around your subject rather than go in too tight only to decide the composition is unbalanced later. Don't forget to look up to see what is above your subject – you might get a strong vertical composition using the space above your subject's head.

⌃ This was shot with a long lens from a bridge, which gave me the height I needed to include the boats in the frame. The heads of the couple are roughly two-thirds up but not quite two-thirds across the picture, which is cropped to a letterbox format. The single lateral boat leads the eye to the right and then the eye moves round through the couple's reflection on the water to the boats on the left and back, through the wooden slats on the boats to the couple. The light elements of the boats, the bride's dress and the reflection are important to the composition and the warm-coloured grass on the right also helps the balance.
Canon EOS-1Ds Mark II, 70–200mm lens, 1/200 sec at f/4.5, ISO 400

I was driving to a location in North Wales with this couple when I spotted this ≫ disused petrol station and knew I wanted to stop. I was immediately drawn to the weathered rust, the peeling paint and signs of age, which contrast with the pristine dress of the bride and the fact that they are starting on a new life together. I struggled to make the composition work because it was not an easy one to balance. There are the uprights of the pumps and corrugated iron and yet it had to be a horizontal composition because of the wide spread of the pumps. I experimented a lot with it and cropped the shot radically from the original. I think it works, with the bride being the brightest part of the shot, framed by the pumps that look out to the edges, almost like people.
Canon EOS-1Ds Mark II, 24–70mm lens, 1/250 sec at f/8, ISO 400

⚞ This is a corporate shot of two men in Reykjavik, whose business is to do with the building behind them. Usually, if you put people on a white background, you crop to the edges around it. In this case the whole set, including the battery-powered lighting, is part of the composition. The flat, even lighting matches that of the snowy day with the black, shiny buildings behind looking quite ominous. The shot was composed and carefully framed in-camera on a tripod with no cropping afterwards.
Canon EOS-1Ds Mark II, 24–70mm lens, 1/40 sec at f/8, ISO 200

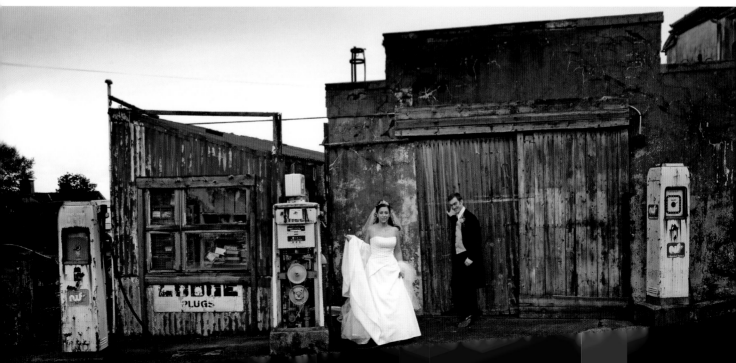

PRECISION FRAMING

Sometimes composition and framing are quick and intuitive – you are capturing a moment and you instantly know you have got it right. At other times it may be a longer, even painstaking, process to ensure that every single element you have included is in exactly the right position.

Corporate and advertising portraiture often falls into the latter category. There may be an art director involved who has an overall vision of what is required from the image and together you will build it up, examining the back of the camera or computer screen at every stage to ensure everything is in place. For this kind of work, it is essential to have the camera on a tripod and to use a zoom lens because even tiny adjustments to the framing can radically change the effect.

The shot of the businessman in his office (below left) was a highly controlled composition that took a great deal of time. He is sitting exactly halfway up the frame and everything else is divided vertically, up and down the picture, with a couple of crucial horizontals. Even the carpet had to be moved to line up exactly so that the right-hand edge leads up to the man's hand and face. The out-of-focus door handle balances the right side of the picture and gives the picture depth because your eye naturally looks past it to the subject in the middle.

The man with the newspaper (opposite) was another corporate shot, photographed in a pub. Again, the camera was on a tripod and we found that small movements of the camera and zoom lens changed the composition entirely. For example, when we tried cropping the mirror, we found it didn't work; it was important to include the whole frame. The window on the left, however, didn't need to be shown in its entirety to contain the image. The camera was set up with the digital sensor exactly upright so there are no converging verticals – all the vertical lines are parallel to the edge of the frame. The chairs were lined up and carefully placed so that the light on the seats and wooden backs leads the eye to the subject.

When working on images such as these, the finished product should look natural and realistic. If the viewer can sense just how contrived it actually was, you have not done your job correctly. It is a very difficult balance to get right.

≪ I photographed the CEO of a company in the waiting area of his office using studio lighting to give a very natural effect. The sky outside was slightly underexposed to make it more dramatic. Although it looks spontaneous, it was a complex composition to set up because all the elements within it had to be carefully balanced. It would have made a good horizontal shot but I was commissioned to produce an upright and so the picture had to be composed accordingly.
Canon EOS-1Ds Mark II, 24–70mm lens, 1/40 sec at f/4, ISO 100

This corporate commission was set up in a pub. The businessman was lit entirely ≫ by window light and there's an enormous amount of dynamism with converging horizontal lines that lead to the subject and beyond him to his reflection in the mirror. Because the camera was on a tripod, I could use a long exposure to add interest to the picture by showing some movement in the newspaper.
Canon EOS-1Ds Mark II, 24–70mm lens, 1/8 sec at f/5, ISO 200

⌃ A classically posed businessman, grinning and looking powerful but within a carefully structured composition. His head is in the top quarter of the frame after the crop at the top and his body is exactly two-thirds of the way across it. The river, which is negative space, plays a small but important part and the bridge beyond is more or less level with his shoulders. Within the stonework embankment there is an oval element that balances the man's face; both are about equal distance from the edges of the frame. The embankment comes down at an angle from his shoulder to the bottom left of the frame, then turns into the stonework he is leaning on at a similar angle to his elbow. The light and shade within the image are also crucial. On a dull day, he was lit very gently with flash to lift the shadows round his eyes. I burned-in the picture digitally to darken the edges to make his face one of the brightest parts of the shot. His thumb holds interest at the bottom of the frame, preventing it being too dark and heavy and it also forms a triangle with the two ovals in the shot.
Canon EOS-1Ds Mark II, 24–70mm lens, 1/250 sec at f/8, ISO 800

LINES AND SHAPES

Understanding the power of lines and shapes within the frame is, for me, the key to creative and interesting compositions. Of course, every form around us is made up of lines and shapes but it takes some training of the eye to be able to harness them within a picture. If successful, you can create great dynamism or something much more subtle – a visual harmony that the viewer can appreciate almost subconsciously.

Horizontal, diagonal and vertical lines can lead the eye towards the subject and from one part of the image to another. They can suggest power and energy or calmness and tranquillity. Geometric shapes like circles, squares and triangles can be used to give a three-dimensional solidity and graphic design to an image. Negative space, the empty space around a person or object, needs consideration too. It links different parts of the composition together and can reveal shapes of its own that perhaps can be found to echo other shapes within the positive part of the image.

With portrait photography, you have the lines and shapes the people's bodies are making to play with, as well as those of their surroundings. You can do this with the posing and the angle you choose to shoot them from. Find a willing subject and take them to an interesting space. It might be an architectural background or a natural one with rocks or trees. Experiment with shapes, verticals and horizontals. Set up the camera so that you are looking at the subject from an angle, sideways and up and down. With a wide-angle lens, especially, you'll get some dynamic lines within your pictures that will enhance your compositions.

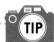

TIP

❝ When photographing business people, spend some time arranging the pose. Ideally, you don't want them to be square on to the camera so you may need to physically turn their shoulders. Try telling them that you want them to look tall. This always makes people stand or sit up straight, which gives them the status they want and lets them know you understand how they want to look. ❞

This woman was photographed against a white background in an office with ≫ studio lighting. I did a series of portraits of people using chairs as a prop and I encouraged them to fidget as much as possible. The idea was that they would make shapes with their bodies on the chairs and also find the experience amusing and so loosen up for me. They were real office workers and not used to being photographed but once they realized they could sprawl and slouch how they wanted, I was able to get really interesting shapes. This woman had her arm over the back of the chair, which gives it a strong horizontal shape. There's a lovely angle between her left and right arm that goes through her face. Your eye naturally looks along her extended arm, down her hand and back up through the other arm to her face, giving a lovely circular motion within a rectangle shape.
Canon EOS-1Ds Mark II, 100mm macro lens, 1/400 sec at f/10, ISO 400

⌃ I love the frailty and gentleness of this bride in contrast with the weight of the massive stone pillars behind her on the steps of St Paul's Cathedral in London. It is cropped so that she is looking out of the frame with little space in front of her. It could also have been cropped to form a perfect square because there's a diagonal that goes from her feet, right across the middle of the shot through her head. There's also a subtle convergence of the horizontal lines of the steps. The colour is almost monochrome and I darkened areas in Photoshop so that she is sitting almost in her own pool of daylight. Burning-in is a technique I use a lot (see pages 62–65) because the eye is always drawn to the lightest part of the picture first.

Canon EOS-1Ds Mark II, 24–70mm lens, 1/400 sec at f/10, ISO 400

DEPTH OF FIELD

Depth of field is the range of distances in a line from the camera that appear to be sharp in an image. This area of sharpness, from foreground to background, can be controlled using the aperture in the lens. An f-stop of say f/2.8 will give a shallower depth of field than an f-stop of f/16.

Looking through the viewfinder of a DSLR, the lens is automatically wide open at its maximum aperture, allowing you to see your subject as clearly as possible. The moment the shutter release is pressed, the aperture diaphragm in the lens is closed down to the f-stop chosen, either by you or the camera, and the image is captured. You can check the change in depth of field by pressing your depth of field preview button (if you have one) on the camera body, or you can check the LCD screen to see how much of the image, from foreground to background, is in focus. 'Stopping down' the lens, in other words turning the control wheel to make the aperture smaller, will give you greater depth of field and more of your subject will be in sharp focus. Larger apertures (smaller f-stop numbers) and placing your subject closer to the lens will give you shallower depth of field.

> **TIP**
>
> " You can use a shallow depth of field to give depth to an image by featuring out of focus elements in the foreground. Try moving your camera as you view your subject through leaves, or the bars on the back of a chair, or items on a table. "

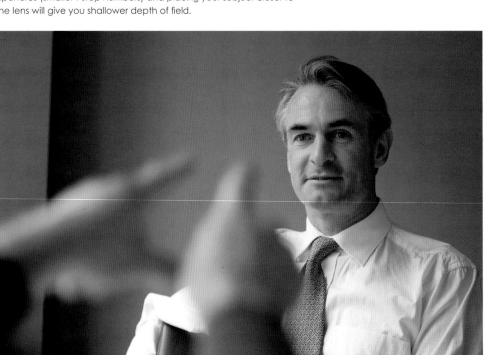

⌃ This shot was controlled through the camera and framed very deliberately, although hand-held. For this set of portraits I had people talking to the subjects – I didn't want them looking to camera. I tried all sorts of props like teapots, glasses and pots of pencils to add foreground interest, though they were put out of focus so there was merely a suggestion of the objects. Here, I had someone using his hands as if to demonstrate something as part of the conversation. The composition works because, although his hands are not actually pointing to the man's eyes, your eye goes straight to his face. There's a strong diagonal from the left side to the right that increases the dynamism of the shot. I probably shot 40 or 50 frames and every one was different. Once I started shooting, it became apparent, through the viewfinder, what worked and what didn't. It is unusual for more than half a picture to be out of focus, but it can work in a powerful way.
Canon EOS-1Ds Mark II, 100mm macro lens, 1/40 sec at f/4, ISO 400

The French setting in the evening sun contributes to the atmosphere of this portrait and although it could easily have ≫ been cropped to make a square, I liked the space around her. There are two triangles, one made by her dress, face and the wall behind and the other an inverted triangle between the tree branches. A square crop would mean losing both triangles. The light was so strong here that I had no choice but to stop the aperture down, resulting in a wide depth of field and sharpness in the background.
Canon EOS-1Ds Mark II, 24–70mm lens, 1/160 sec at f/6.3, ISO 400

It is a myth that wide-angle lenses have greater depth of field than long lenses. In fact, if your subject stays the same size in the frame, then at any given aperture all lenses have the same depth of field. Longer lenses appear to have less depth of field, mainly because the subject is bigger in the frame. However, when standing in the same place and focusing on your subject at the same distance, a longer lens will have less depth of field than a wide-angle lens, as an effect of lens magnification.

A longer lens will also flatten perspective and produce a result with a more obviously blurred background. The blurriness in the background of an image is called 'bokeh'. This can greatly affect the look of your final photo, and is governed by factors including lens design, quality, focal length and the construction of the aperture blades within the lens itself. One other element that has an effect on depth of field is the sensor size in your camera. With all other factors being equal, the larger the sensor, the less depth of field there will be. A compact digital camera will generally produce images with more depth of field then a professional-level DSLR.

Controlling depth of field is managed by balancing two other factors – the shutter speed and the ISO – in order to expose your image correctly. You may want to increase the depth of field by choosing a small aperture, say f/11. But there might not be enough light on your subject, so you need to choose a slower shutter speed or raise the ISO setting. You may also need a tripod. Conversely, you might want very shallow depth of field and so with the aperture wide open at a low number, say f/2.8, you will need to choose a faster shutter speed, or higher ISO setting to balance your exposure.

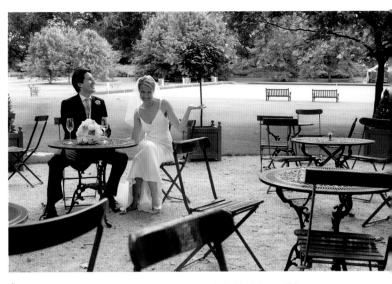

⌃ I like the higgledy-piggledy nature of the elements within this picture, with the tables, chairs and benches all at different angles. The stability of the image comes from the couple firmly seated in the left third of the frame but there's a lovely jumble of visual clutter all around them. I converted the picture to black and white to strengthen the graphic elements of the tables and chairs. There's great sense of depth to the image, with foreground, middle and background interest and the streak of light running across the top third of the frame highlights their heads perfectly.
Canon EOS-1Ds Mark II, 24–70mm lens, 1/160 sec at f/5.6, ISO 400

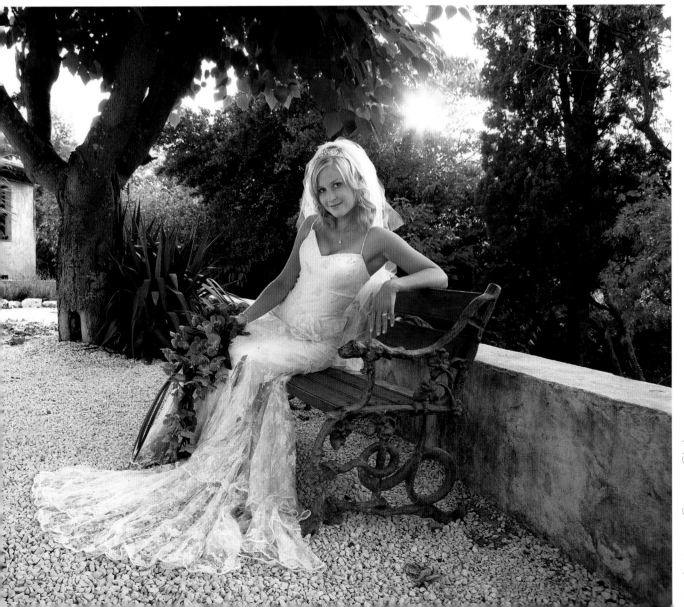

Steve Shipman

COLOUR

We all shoot photos in colour these days. While you can switch your DSLR to a black-and-white setting, it's far better to take colour pictures and convert them into black and white with your post-processing software if desired. That way you are leaving your options open if you want to rework the original file.

Colour can make or break a picture. It can become a crucial part of the composition, balancing elements within it. You could, for example, have a portrait of a man wearing a yellow shirt with another small touch of yellow somewhere else in the frame that will just lift the image and make an enormous difference. It is worth remembering that red and yellow are colours that appear to advance towards the viewer, while blue recedes. A red pillar box or traffic signal behind a person in neutral clothing will immediately distract the eye, so always scan the viewfinder carefully and make sure that any dominant colours are related to your subject.

Lighting plays a large part in the way colours are registered by the camera. A shaft of sunlight can pick out a bright colour against a shadowed background in a dramatic way. In fact, unless the light is uniformly overcast, colours will change constantly throughout the day. Moving around your subject, changing the angle of view, can have a noticeable effect in the way that colours are rendered.

Boldly contrasting colours can create great drama and impact in a portrait photograph but usually one colour should outweigh the rest. Too many colours of a similar size and shape crammed into a picture will often result in confusion. Colours don't have to be vivid to make a statement either. You could have a very strong portrait made up almost entirely of white and cream. Think of the mood and emotion you are trying to convey in a portrait and how you can use colour most effectively to portray that.

⋁ I used a long lens and a tight crop on this Indian bride. The pink and orange colours in the background really make the picture work and evoke India for me. Had the colour elements been in sharp focus though, they would have been a distraction from the portrait.
Canon EOS 20D, 70–200mm lens, 1/250 sec at f/3.5, ISO 400

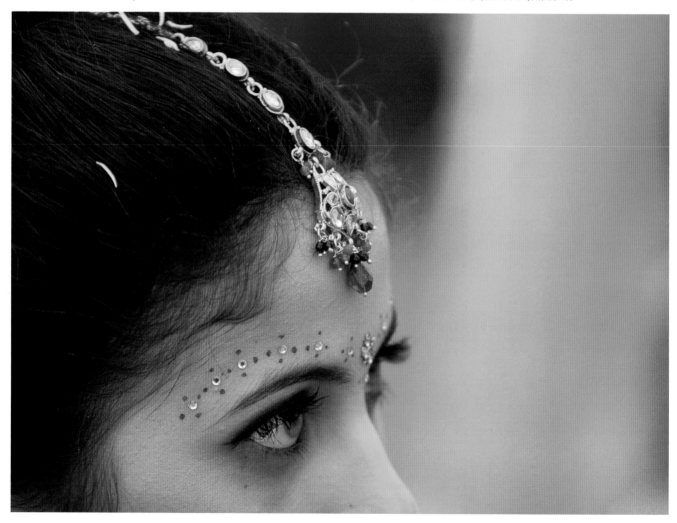

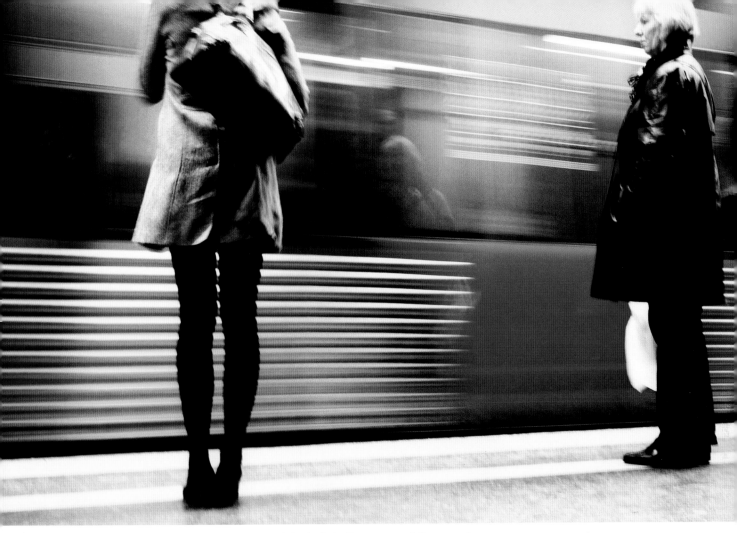

⌃ On a station plaform in Stockholm, I took this without looking through the viewfinder. The camera was in Program mode because I wasn't sure what I was going to get but I wanted to capture the train as it moved past me and I liked the shapes the waiting people were making. The picture is entirely about colour and is almost made of two halves, one gold and black and one blue and black. In the artificial light of the station, the camera made the colour balance decision for me on Auto White Balance.
Canon EOS 20D, 24–70mm lens, 1/5 sec at f/8, ISO 800

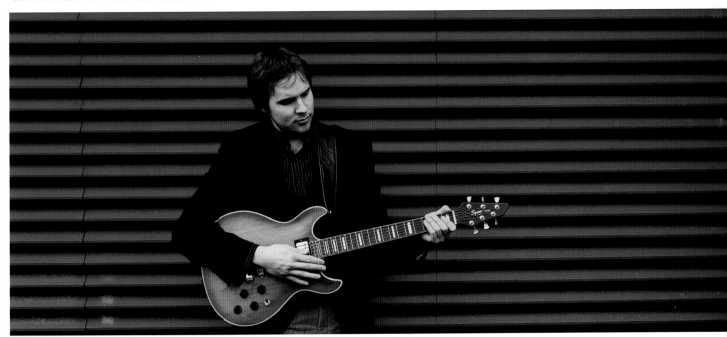

⌃ The background here is the ventilation panel on the side of a sports centre and I liked the strong contrast between the blue and the orange guitar. The horizontal lines of the background also match the lines of the guitar strings while the arms and head make a triangular shape. I cropped it to emphasize the horizontal lines but it could also work as a square.
Canon EOS-1Ds Mark II, 24–70mm lens, 1/125 sec at f/6.3, ISO 200

UNUSUAL ANGLES

You can take some wonderful, unexpected pictures by playing with unusual angles. Look at things in as many different ways as possible from as many different viewpoints. This doesn't necessarily mean tilting the camera but rather looking up from ground level or looking down on something. Explore your subject visually while taking pictures all the time. Take the safe shot first and then go for something more experimental and unpredictable.

I remember the great photographer Lord Snowdon once came into a studio where I was working and I've never seen anyone look more intently around them at even the most mundane things in the room. He is a great example of someone who looks hard at everything and you can see how this is reflected in his work. Sometime later, I wrote to him and asked if he would critique my work. He agreed to meet me at his studio and while looking at my photographs he noticed all sorts of things I hadn't seen, which taught me to look harder.

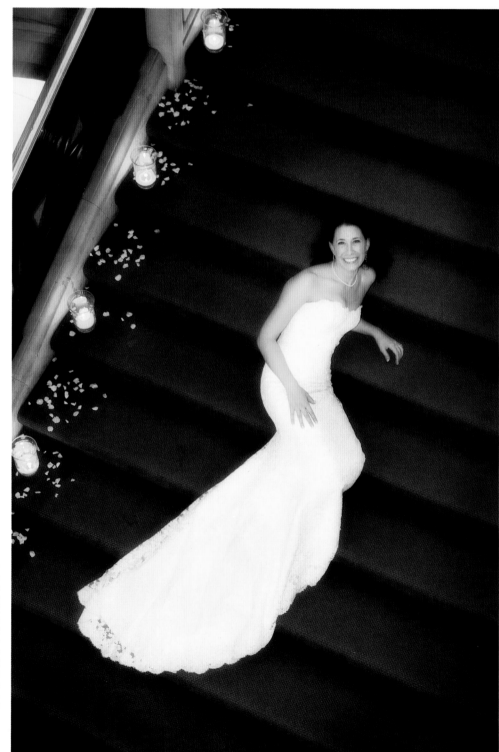

This was a case of seeing the potential ≫ of the dramatic red stairs and putting the bride in that situation while I shot from a balcony above. She made a lovely shape and looks almost like a mermaid. I moved around and took several shots from different angles but this worked the best because of the diagonals going across the stairs with her shape forming lines in the opposite direction. The pinpoints of light from the candles add atmosphere to the overall effect.

Canon EOS-1Ds Mark II, 24–70mm lens, 1/30 sec at f/4, ISO 800

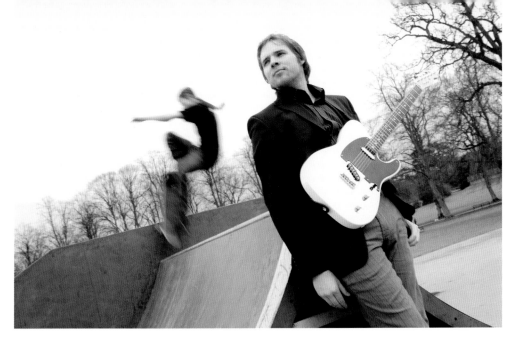

≪ My subject and I went for a walk to find some different locations and we came across some skateboarders in a park. With the camera held below waist level, there's a lot of space above the subject that I wanted to leave clear for the skateboarders to appear in as they whizzed up and down their ramp. Using a slow shutter speed to capture a sense of movement, there's an element of chance with shots like this and I took a whole series of pictures to ensure one good one.
Canon EOS-1Ds Mark II, 24–70mm lens, 1/30 sec at f/11, ISO 200

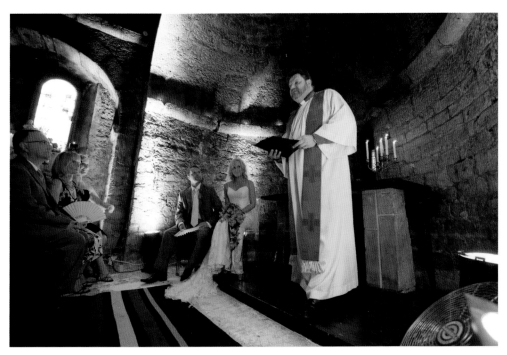

≪ This was taken at a wedding ceremony in a tiny, ancient chapel. I crouched down as close to floor level as I could get and used an extreme wide-angle lens to give a lovely sense of both the place, with its beautiful old stonework, and the occasion. The converging verticals make every line seem to swoop into the picture and back out again. Most conventional church pictures are taken at eye level but it is always interesting to explore other options and try out different lenses.
Canon EOS-1Ds Mark II, 16–35mm lens, 1/80 sec at f/4.5, ISO 3200

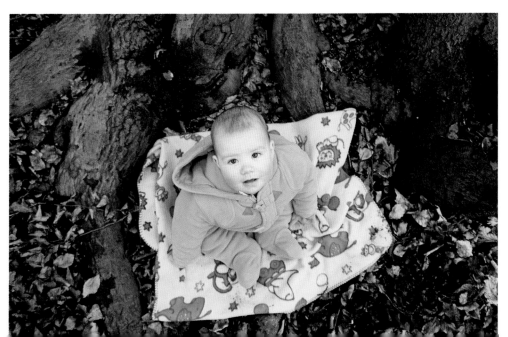

≪ This was taken on a family picnic and wasn't arranged in any way. I had taken some pictures at the baby's eye level, but then realized I could take this from above, looking directly down at him as he, amazingly, held my gaze. His face is the brightest part of the image and everything else seems to rotate around him. I like the contrast between the gnarly old tree roots and this new life, with his lovely clear skin.
Canon EOS 20D, 24–70mm lens, 1/125 sec at f/4, ISO 400

Steve Shipman

57

MOVEMENT

Movement in a photo engages the viewer by emphasizing the caught moment that is about to change. It draws you in with the knowledge that the next moment will be completely different, everything will have changed, and the moment you are viewing is truly special.

In my photos here I can see three types of movement – the subject is moving, the subject is static but elements in the shot are moving and the subject is static but looks as if it's moving. The bride's veil on the steps (opposite, top) is moving in the wind, and although the veil is frozen by a fast shutter speed, the movement of the veil is in line with the diagonal shape of the steps and creates a strong and fluid composition. The same is true of the veil in the landscape (opposite, centre). There is a lovely movement of the veil from right to left, and as you read the image your eye moves back from left to right. The tilted horizon adds to the movement.

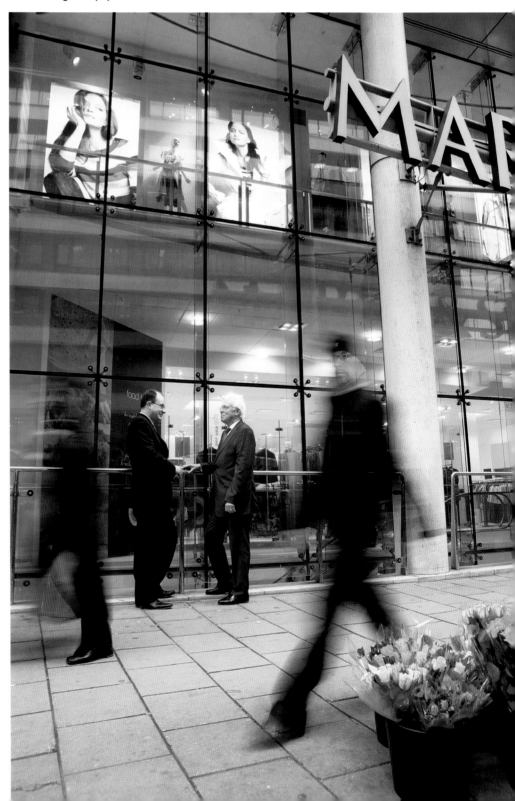

This corporate shot was taken very ⟫ early in the morning with the lights on in the shop behind, which was crucial because the warm glow is repeated in the warmth of the flowers in the foreground. There's a strong vertical theme to the picture from the people, the pillar and the shop windows. It's a classical 'thirds' composition where the two men talking are one-third in from the left and two-thirds down from the top. Added interest comes from the blurred figures. With the camera mounted on a tripod, I mixed flash and daylight to half freeze the movement but leave some blur. To do this, you need to work out a shutter speed that is fairly slow but not so slow that your main subject is going to move during the exposure. Once you have established the shutter speed, you have to adjust the aperture. The flash was balanced for daylight – I didn't want it to be dominant, just give a subtle edge to the person walking in foreground. The men in the background are lit purely by daylight. It was crucial that no passers-by were crossing the men, so I just had to look through the viewfinder and watch. It's a hit and miss technique, so you have to establish your exposure and composition and take lots of shots. *Canon EOS-1Ds Mark II, 24–70mm lens, 1/8 sec at f/7.1, ISO 200*

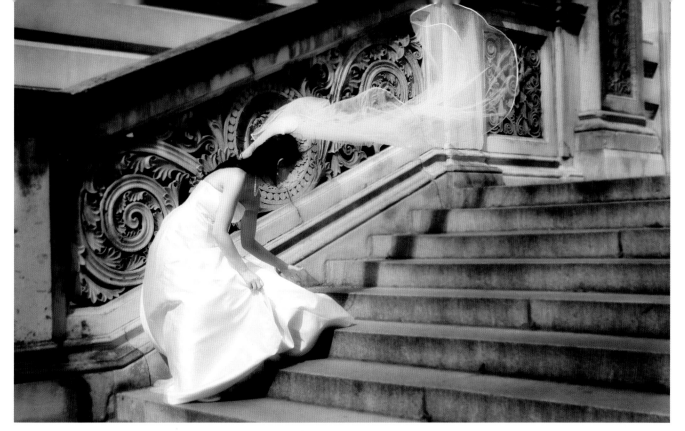

The three images in this chapter with movement blur are the woman on the train platform with the train moving (page 55), the guitarist with the skateboarder moving (page 57), and the walkers on the pavement in front of the shops (opposite). In each case movement is created with the use of a slow shutter speed, to allow elements within the frame to move while the shutter is open. This creates interest by recording shapes that you would not normally see. Of course, there is no real movement in a photograph, it is an illusion, but you receive the impression of movement.

It can be fun to experiment with long shutter speeds. It is possible to photograph a busy traffic junction, for example, and by using a shutter speed of several minutes, it can look as if it is completely empty, with no people or vehicles. Or you could ask someone to sit in front of your camera, and again with a long shutter speed, say ten seconds, ask your subject to keep shaking their head, preferably without moving their shoulders. Ask them to start shaking their head steadily, before you release the shutter, and to continue until the shutter closes. It is possible that their head will have disappeared completely in your final image. Try it with a family group and have some fun.

⊼ Taken not far from her wedding near Parliament Square in London, I knew this was a good location for some pictures. This was an unexpected moment as we were walking down the steps where the wind caught the bride's veil as she turned to adjust her dress. It works because the floral design in the stonework exactly matches the shape that her dress and veil are making – a perfect 'S'. She's one-third of the way in from the left, with her face halfway up. The strong horizontal created by the veil is two-thirds up and her hands are two-thirds down. You can look at this picture in all sorts of ways and it all comes back to thirds. There are strong diagonal lines in the stonework, while vertical lines in the bottom left and top right hold the shot together. The stonework was darkened in Photoshop to make the veil stand out.
Canon EOS-1Ds Mark II, 24–70mm lens, 1/640 sec at f/10, ISO 200

Wind can be the curse of the photographer but also the making of a shot. Here it ≫ was blowing the veil, which added dynamism and a sense of movement that is emphasized in other aspects of the picture. Unusually for me, the camera was tilted to play on the diagonals of the mountains and walls. There is also movement through the picture from the light areas to the dark, which I heightened by burning-in the sky and the area around the dress.
Canon EOS-1Ds Mark II, 24–70mm lens, 1/400 sec at f/10, ISO 400

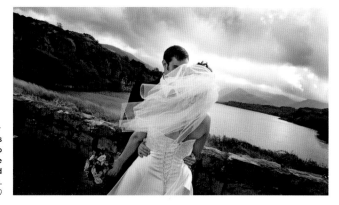

We had parked the car to go to St Paul's Cathedral in London to do some pictures of ≫ this couple but as we walked out of the car park I saw the word 'slow' in black and white and it matched the black and white clothing of the couple. I like the contrast of her finery in this urban situation and the humour of their calmly walking pose next to the prominent sign. I asked them to walk in slow motion to prevent movement blur. It was lit by the fluorescent light you can see in the background, and I shot in RAW mode so that I could adjust any colour cast in Photoshop later.
Canon EOS-1Ds Mark II, 24–70mm lens, 1/40 sec at f/3.2, ISO 800

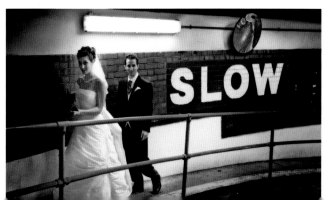

Steve Shipman

FAMILY GROUPS

Group shots of three or more people are undoubtedly harder to do than single portraits because of the difficulty in getting everyone to look good at the same time. In a way, I think you have to allow for imperfection in order to retain some looseness and spontaneity. I take a lot of pictures when doing groups, which does mean a lot of time spent editing later.

Although it is very often useful to check the composition on the back of the camera, I prefer not to for group shots as I don't want people to sense that I am seeing something they can't. In the old days I used to hand round Polaroids but it's harder with a camera. Sometimes I will show them, but it's rare. I will simply check the histogram once, unless the light changes, and make sure I shoot plenty and quickly.

Speed is very important and I try to maintain a sense of fun long enough to get 10 or 12 shots out of one set-up, then it's time to move on. If you feel a group isn't working, don't labour it. There's no point spending hours arranging people's feet and hands expecting things to come together that way. It has to be kept fresh and you need to stay confident and engage your subjects the whole time.

I don't spend too much time posing people. If you give them some encouragement and try to make them feel comfortable, they will often arrange themselves. I laugh a lot with them, make a fool of myself and tell them to get cuddly. I use silly words and can be a bit cheeky in the nicest possible way. It's important not to make them feel that you're imposing your will on them. Even though you are directing them, there are subtle ways of doing it. Getting people to change places every few frames keeps things lively, especially with children.

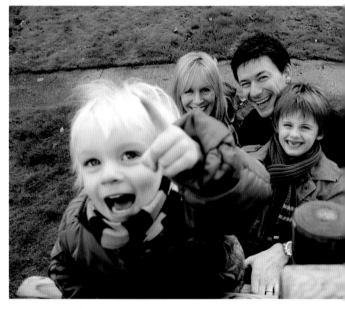

﹀ This was taken in the family garden on a winter's day. I climbed up the climbing frame to get a different viewpoint of the four of them and then looked back to see the little one chasing me up the steps. Even though the boy's face is out of focus, his family is sharp, showing the fun attitude and closeness of the family.
Canon EOS-1Ds Mark II, 24–70mm lens, 1/250 sec at f/6.4, ISO 400

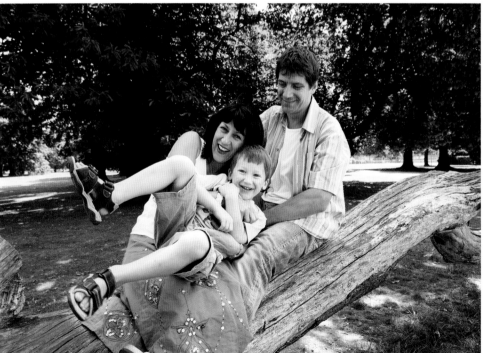

﹀ Walking around a park with this family, I spotted a fallen log and we used it as a starting point. The mum is a photographer herself and she knew that tickling her son would make a great picture. I took a lot of shots, some of them more static and arranged, but I think this a good fun shot of a family having a giggle on a Sunday afternoon.
Canon EOS-1Ds Mark II, 24–70mm lens, 1/160 sec at f/6.4 ISO 200

TIP

" Photographing groups of business people is a different scenario to families. They want to look dignified and powerful and you don't want to make a fool of yourself with them. It's a good idea to wear very smart clothing to photograph them so that you look like their equal, whereas with families it's better to wear something more casual. It's important to be accepted in whatever social group you are photographing and not be seen as different. That way you will get their cooperation and respect more easily. "

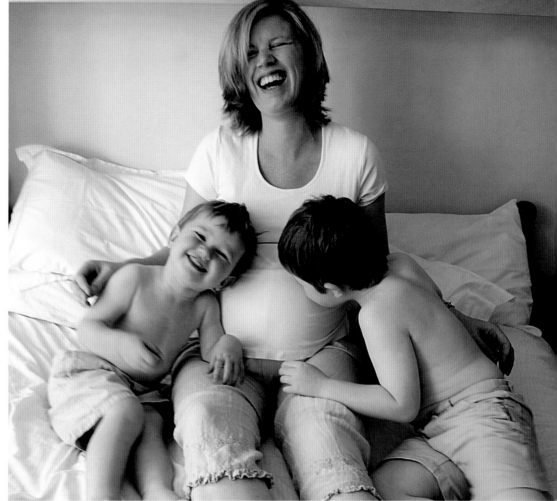

The mother suggested being ≫ photographed on the bed but we were not sure how it would work. Then, one of the boys kissed her tummy spontaneously, making her laugh and I was able to capture this loving moment, lit only with daylight. I took a lot of pictures in this situation, keeping the session very loose and just giving suggestions rather than directions. The boys were given the freedom to play, which I think is important with young children. I had already established a rapport with them and they felt comfortable and confident. With children, I make an exception to my usual rule and will show them pictures on the back of the camera. If they are still a little intimidated, I hand them the camera and tell them to take my picture, which is a good way of engaging them.
Canon EOS-1Ds Mark II, 24–70mm lens, 1/50 sec at f/5, ISO 320

When you have a session booked with a family for an hour and a half or two hours, you have to come up with ideas of what you are going to do with them. For me, this comes about by taking the family for a walk and seeing what we find. It could be a walk through a woodland, city streets or along a beach. In every case, I'm inspired by what's around me and I find it far preferable than taking the pictures in the client's back garden. Very often, when I'm commissioned for family portraits, the first thing they will say is that we can use their garden. I may start the session there and then say, 'Let's go out on to the street,' or 'What's your favourite place?'

The family shown on the right were uncomfortable at the beginning of their session, which had been the idea of one of the sisters. They didn't know what to expect and thought it was going to feel weird. We were walking through some very quiet back streets in London on a Sunday and I stopped them in the middle of the road and asked them to look at me, then took a picture. Then I asked them to change positions within the count of three, took another picture and then did the same thing again. By this time, they had started laughing and the ice was broken. They then knew I was not going to shout at them and make them feel awkward and they could be playful and have a laugh.

Making your intentions clear to your subjects also helps to control the flow of the session. You might set up a shot like the one with the blue background, and afterwards tell them that they are going to walk to the bridge for the next shot. This gives them all a chance to relax and have a chat. They then know that they are not going to be asked to do anything for the next 15 minutes until you get there, then they will be gathered for the next shot.

⌃ I was drawn to this space because I like the blue paintwork of the boards around the scaffolding but it's also good for a static shot if you can have people at different heights. One of the girls is sitting on a section of barrier that I dragged into the picture. I liked the red warning lights and arranged the group in the space between them. They are formally arranged so they are at different heights and angles, not confronting the camera, but they are all relaxed, laughing at something I said. The shot is cropped to a square because I saw it as a square shape with the two red lights fairly equally placed within the frame.
Canon EOS 5D, 24–70mm lens, 1/500 sec at f/4, ISO 400

Steve Shipman

61

POST-PRODUCTION: DODGING AND BURNING

Dodging and burning are techniques for print manipulation in the darkroom. Dodging is done using your hands or with pieces of card to prevent the light from the enlarger hitting the photographic paper and thereby keeping an area of the image lighter than it would have been with an uninterrupted beam. Burning, or burning-in, is the exact opposite where you allow a small area of light on to the print with your hands or shaped card in order to darken it.

In the digital darkroom the technique for lightening or darkening an area of an image has retained the same name. The basic tools for darkening and lightening in Photoshop are called the Burn tool and the Dodge tool.

The best images to work with are often fully toned with detail in the highlights and in the shadows. Dodging and burning techniques will bring an image to life by creating lighter and darker tones, which can lead your eye around the composition. Darkening areas of an image may reduce the impact of an area and so intensify another part of the image. Lightening an area may draw your eye to it more. I often think that an image with light edges leaks off the page and needs a little darkening at the edges to hold it in.

As with everything in Photoshop, there are always several ways of achieving the same result.

METHOD 1
Create a new layer, setting the Mode to Overlay, and checking the box for Fill with Overlay-neutral color 50% gray. Click OK. The new Layer 1 is your working layer. Ensure your Foreground Color is black. Use the Brush tool, with a soft edge set to 25% Opacity, to brush darker areas over the image. Using a low Opacity will allow you to build up dark areas gradually. If you want to lighten areas, set the Foreground Color to white, and use the brush in the same way.

METHOD 2
This method is fast but somewhat limited. Select the Burn tool from the tool palette and set the Range to Midtones and the Exposure to 10%. Move the tool over the image to darken areas. Build up gradually by repeating the movements. You can change the size of the tool by pressing the square brackets to increase or decrease the tool size to work on different-sized areas. Keep the brush soft so that you get gentle graduations of tone.

METHOD 3
This method involves using the Lasso tool to select an area, then feathering it to soften the edges (Select>Feather). The quick way to lighten or darken the area is to use the Curves tool (Command-M or Image>Adjustments>Curves). Pull the diagonal line of the curve up or down to lighten or darken the selected area. Another way is to make your selection into a new layer (Command-J) and change the Mode for the layer (Screen mode lightens, Multiply mode darkens – use the Opacity slider for more control over the effect) or simply use the Curves tool on that layer.

METHOD 4
Create a new Levels adjustment layer. Drag the left-hand slider to the right a little to darken the image. Click OK then change the Mode to Luminosity, which will prevent the colours from oversaturating. Now invert the Layer Mask (Command-I) and using a soft brush, paint over the image to reveal the dark areas.

BEFORE

⌃ I shot graffiti artists, the VOP Crew, in colour in RAW mode, knowing that this would become a black-and-white image.

GRAFFITI ARTISTS

- After converting the original image to monochrome, I used the Burn tool to darken the faces and areas of the black suits that were lighter grey.
- I then wanted to darken the sky. I clicked on the Quick Mask button, then the Gradient tool, and pulled a line from the horizon to halfway up the sky (picture 1).
- Clicking again on the Quick Mask tool button, the mask is converted into a selection (picture 2).
- I then pressed Command-M to bring up the Curves dialog box, and then dragged the diagonal line down to darken the sky area (picture 3).
- You could instead convert the selection into a layer (Command-J) and select Multiply mode to darken the sky (picture 4).
- I flattened the layers before the next step. From the Layers menu, I selected New Layer and set the mode to Overlay, with Fill with Overlay-neutral color 50% gray checked. Then with white as my Foreground Color and using a soft brush, I went over the dark areas of the suits to bring out detail in the shadows. This is good old-fashioned dodging.

TIP

" I often darken the edges of my images – an effect known as a vignette. Photoshop can create a vignette for you in several ways. Try Filter>Distort>Lens Correction then moving the vignette sliders. Another way is to use the Rectangular Marquee tool to select the area just inside your image and feather the selection by 250 pixels, the maximum. Then invert the selection (Command-I) and use the Curves tool (Command-M) to darken the edges. "

ONE

TWO

THREE

FOUR

AFTER

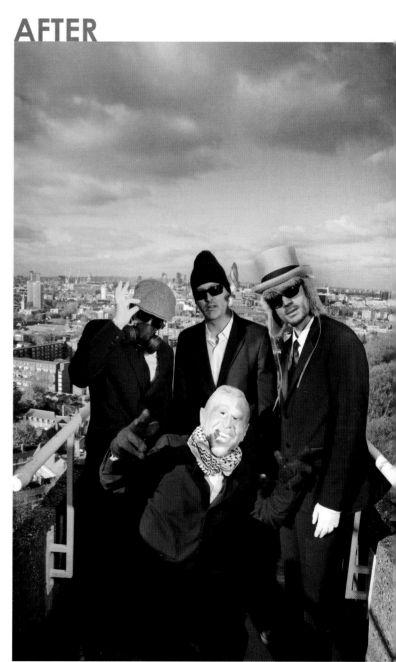

After burning-in areas that were too light, darkening the sky, and dodging to » bring out detail in the shadow areas of the suits, the image has more impact.

BUSINESSMAN

- The first thing I did with this image was to crop it to more of a letterbox shape and convert it to monochrome.
- The burning-in process was done with my fast and dirty method (Method 3 described on page 62). Use the Save As command to save the image, and keep your original untouched. First choose the Rectangular Marquee tool and draw out an area just inside the edge of your image (picture 1). In the Select menu, choose Modify>Feather and choose 150 pixels. This will soften the difference between the selected area and the unselected area.
- Press Command-Shift-I to invert the selection (picture 2), and Command-M to bring up the Curves dialog box.

- Grab the Curves line in the middle and move it down to darken the selected area until you are happy with the effect (picture 3). Press Enter to OK the new curve. While you have your selection live, you can use the Burn tool to darken your image, without it affecting the unselected area too much, allowing for the feathering. Press Command-D to deselect the area.
- I tend to go over an image with a combination of the Burn tool and selecting and feathering areas to darken them until I am happy with the image. You can take Snapshots or Save As at various stages to compare versions. Those of you with beady eyes will have noticed that I also cloned out the distracting telephone box.

BEFORE

⩔ In the original shot, the sky and river are rather bland and there are details that distract from the portrait.

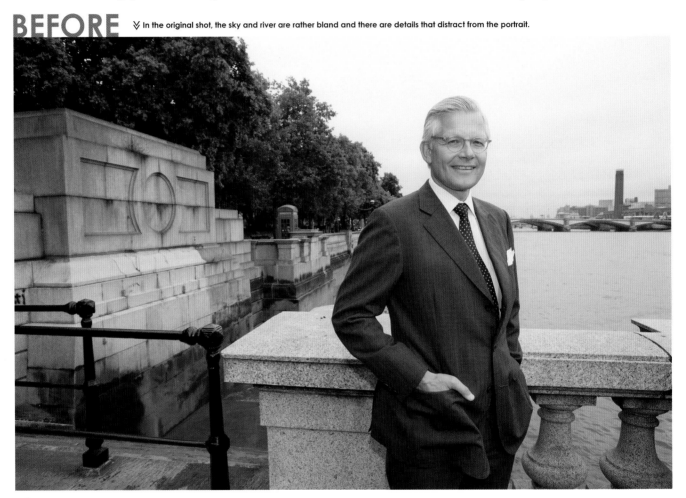

ONE

TWO

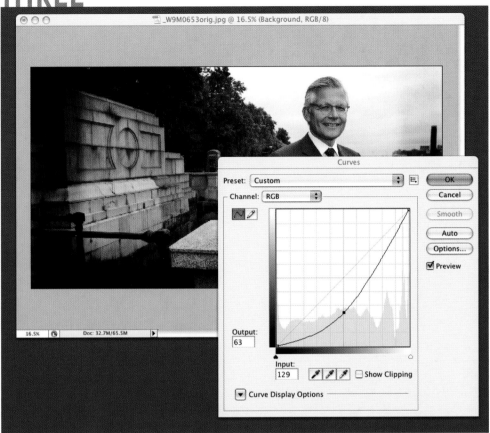

In the Curves dialog:

Preset: Custom

Channel: RGB

Output: 63

Input: 129

Show Clipping

Curve Display Options

Window title: _W9M0653orig.jpg @ 16.5% (Background, RGB/8)

16.5% Doc: 32.7M/65.5M

AFTER

Darkening the edges helps to contain the picture and makes the subject's face one of the brightest parts of the shot.

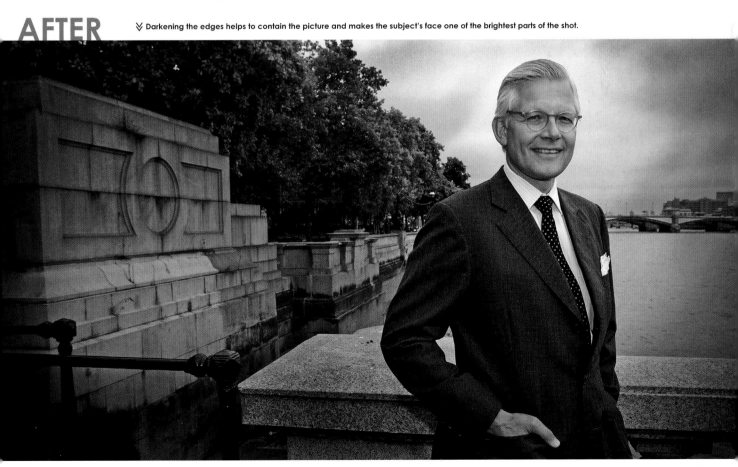

CHAPTER 3: STUDIO LIGHTING
Bjorn Thomassen

Studio lighting can be challenging and even those of us who have been working with it for years are still learning all the time. While there is a steep learning curve to using flash, you can embrace it quite easily to begin with, allowing you a great deal more creative control over your portraits than simply relying on daylight alone.

This chapter looks at combining window light with flash, using one or more lights in the studio, working with lights on location and the different qualities of reflectors.

Flash really comes into its own when ≫ you want to shoot active subjects like children and dogs. There were two lights on the background to keep it white and one large softbox on the subjects. A small aperture gave increased depth of field, allowing them to move around the studio area and still stay sharp.
Canon EOS 5D, 70–200mm lens, 1/125 sec at f/16, ISO 100

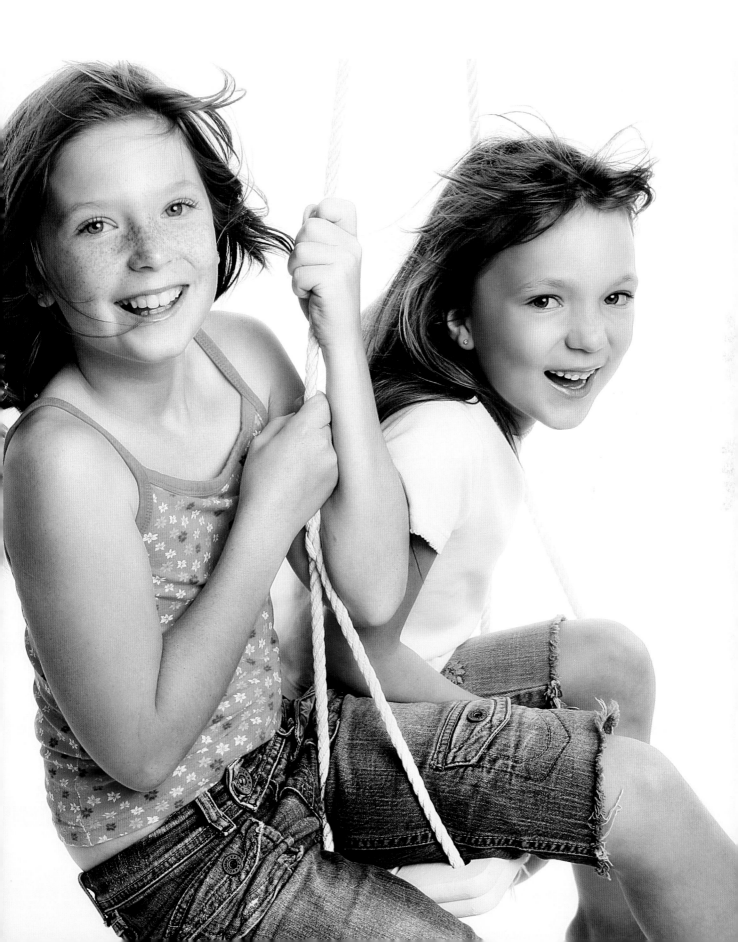

WINDOW LIGHT WITH FLASH

Most people find the light from a window beautiful, partly because it's something we are accustomed to seeing. When producing portraits, we are trying to stay within the parameters of what is psychologically comfortable to people. We're all used to seeing people by windows and we're constantly exposed to imagery where windows have been used, so it's an accepted, very pleasant style of portraiture.

So what is the point of using flash in addition to window light? Because a camera sees things differently to the way we do; it has an inability to record all the tonalities in a scene when the contrast in light is high. Light travels in straight lines and can't see round corners so, if it is coming in from a window behind a person, the camera will record them, at best, as a semi-silhouette and, if the window light is really harsh, more likely as a full silhouette. The dimensions closest to the camera will certainly be without tone. So you need to implement some control there to balance the light ratio, adding light to the near aspects that are under lit. This is where flash comes in. A reflector can do the same job and has advantages, as we'll see, but flash is more controllable.

By using flash, we're trying to make the aesthetic of the picture better but, paradoxically, without any evidence that flash has been used. You need to create a photograph that looks as though it was constructed purely with daylight by trying to get the flash to behave like daylight. This is one of the few examples where it is acceptable for a large part of the picture – the background of the portrait – to be overexposed. It is only tolerable because we're comfortable with it. That's because, if you look at a person standing by a window, you can see all the tonalities of that person but your peripheral vision sees the outside as overexposed. If you increase the power of the flash to bring more tonality to the outside, it starts to depart from the way we naturally see things.

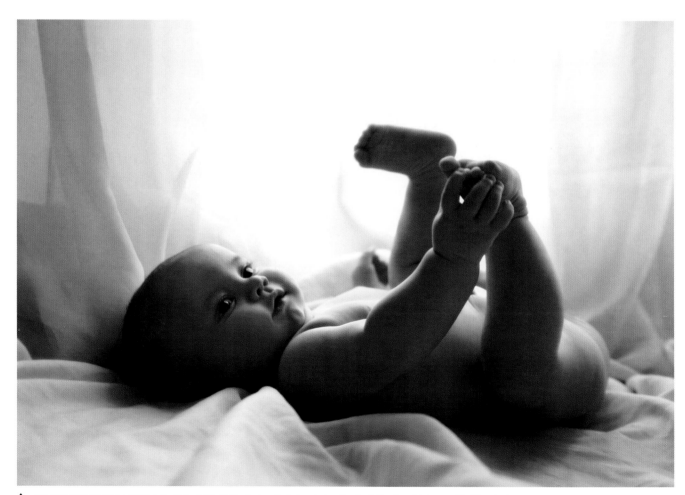

⌃ **The primary light source on this baby is daylight with the flash set to 3 stops below the daylight value. This has enabled the shadows to develop properly and give a nice contour feel to his cheeks. He was quite close to the window, against the netting that was used to diffuse the light. The powerful flash was bounced off the ceiling and the wall at the back of my small studio at an angle of about 45-degrees, so it was soft and even, like daylight. This is a beautiful light for photographing babies – mums love it!**
Canon EOS 5D, 70–200mm lens, 1/60 sec at f/8, flash at f/2.8, ISO 400

So what is the point of using flash in addition to window light? Because a camera sees things differently to the way we do; it has an inability to record all the tonalities in a scene when the contrast in light is high. Light travels in straight lines and can't see round corners so, if it is coming in from a window behind a person, the camera will record them, at best, as a semi-silhouette and, if the window light is really harsh, more likely as a full silhouette. The dimensions closest to the camera will certainly be without tone. So you need to implement some control there to balance the light ratio, adding light to the near aspects that are under lit. This is where flash comes in. A reflector can do the same job and has advantages, as we'll see, but flash is more controllable.

By using flash, we're trying to make the aesthetic of the picture better but, paradoxically, without any evidence that flash has been used. You need to create a photograph that looks as though it was constructed purely with daylight by trying to get the flash to behave like daylight. This is one of the few examples where it is acceptable for a large part of the picture – the background of the portrait – to be overexposed. It is only tolerable because we're comfortable with it. That's because, if you look at a person standing by a window, you can see all the tonalities of that person but your peripheral vision sees the outside as overexposed. If you increase the power of the flash to bring more tonality to the outside, it starts to depart from the way we naturally see things.

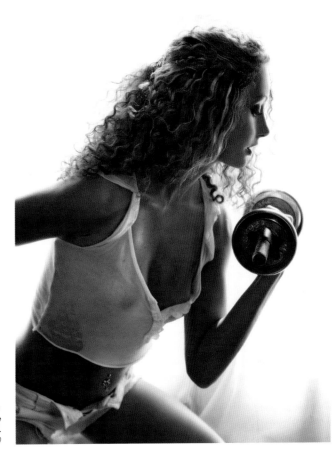

When you're working with profile positions in front of a window like this, you have ≫ to be sure that it is flattering to the subject. The flash for this shot was 2 stops below the value of the daylight to fill, and was bounced of the ceiling and the wall behind.
Canon EOS 5D, 70–200mm lens, 1/60 sec at f/8, flash at f/4, ISO 400

≫ The light on this child's face was coming from a window and was a little bit harsher than in the other examples here, as you can tell from the shadow of her arm. The flash was brought up to about 1½ stops less than the daylight. Children don't stay where you want them to so you need to bring the ratio up slightly to allow for any movement.
Canon EOS 5D, 24–70mm lens, 1/30 sec at f/5.6, flash at f/2.8.5, ISO 800

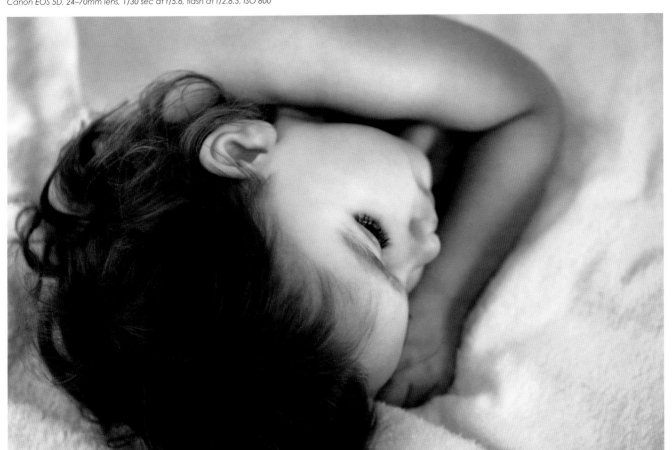

Bjorn Thomassen

SELECTING THE WINDOW

The quality of window light depends on many factors, so selection of the window in the first place is important. Firstly, consider the aspect. A north-facing window, where the sun never directly touches it can produce a highly flattering, very beautiful quality of light. On the other hand, a south-facing window with sun streaming through it can be problematic – you have to diffuse the light very heavily. It also affects the ratio of the flash required and you have to do a lot of work to control things. Window light with flash is not without its problems!

The size of the window is also a consideration. People have the general perception that window light is soft, but that is only true if it's coming through a large window because the size of the light source is instrumental in terms of its quality and contrast. A very small window with a harsh light coming through it gives an unflattering, brutal light, no good for portraiture at all. So, bigger windows are best, diffused with any type of netting and, ideally, on an overcast day.

The size of the room and the tonalities within it play a big part too. For example, a small room painted completely white acts as a natural reflector – the light doesn't have to travel very far before it bounces off a white surface and lightens the tonalities of the portrait. In a larger room, the light has to travel further to bounce off anything and starts to diminish in intensity by the time it reflects back on to the subject.

> **TIP**
>
> ❝ If you have a continuous level of light outside, whether a clear blue sky or an overcast day, flash is perfect. On a windy day, when clouds move quickly, it can be frustrating as the light levels go up and down quite dramatically. To avoid constant re-metering, set the flash-to-daylight ratio between the clouds and wait for them to pass. ❞

FLASH VS. REFLECTOR

What we are trying to do with flash, when used in conjunction with window light, is to understand how daylight behaves and then try to mimic that. The way to do this is to set up the flash to bounce off a large surface so that it falls back towards the subject. You could use a reflector instead to redirect any light coming past the subject back on to them. This lowers the contrast and starts to put tones into what would otherwise be a very dark area. One of the advantages of a reflector is that if the light levels drop outside, there is an identical lower amount of reflected light on the subject – the light ratio stays the same.

With flash, on the other hand, you have to work out the value of the light coming through the window and then take another meter reading for the flash. You then need to decide on the ratio that you want; perhaps the flash at 3 stops less than the window light. This ratio only works if the light levels outside remain constant. If they go up or down, even a little, your ratio has to move because the flash has a constant output. If a cloud comes over outside, the flash may equal the outdoor light and the result will look completely artificial. You then have to re-meter everything, lower the value of the flash and run the risk that, by the time that you return to the camera, the cloud has passed. It can be very frustrating and in these situations you may wish you were using a reflector!

Reflectors, however, are not as controllable as flash. To put a lot of light back on to a subject, a large reflector with a very efficient reflective surface, normally silver, is necessary. But silver has a different light property; you are applying a very shiny coating of light on to the subject, which may not be what you want. A matt white surface might be better for the skin, but this doesn't reflect as much light so it needs to be much closer to the subject to be effective. The reflector may have to be so big and so close that it affects your composition, whereas a flash light can be positioned behind the photographer.

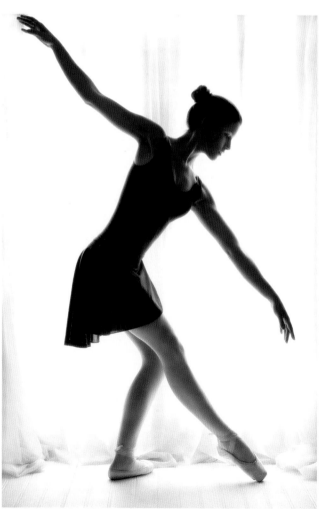

This was taken with two flash heads positioned at 45-degrees either side of ≫ the model. They were covered with gels, blue and purple, without softboxes. The model is leaning back into the window frame. A slow exposure was used here to enable the background to go white and I brought the power of the flash up to balance with the reading for the window light, so the ratio was 1:1.
Canon EOS 5D, 70–200mm lens, 1/30 sec at f/8, flash at f/8, ISO 100

≪ The bounced flash was 2½ stops less than the daylight here, just to lift the tonality of the camera side of the subject a little bit. The shutter speed was set low to enable the window to overexpose.
Canon EOS 5D, 70–200mm lens, 1/60 sec at f/8, flash at f/2.8.5, ISO 400

EQUIPMENT

You can do an awful lot of photography with just one flash light but buy the most powerful one that you can afford. You always have to modify the light source by bouncing it off a ceiling or wall, or with accessories such as a softbox, because the light coming straight from a flash is too brutal for any type of portraiture. A softbox modifies the light to make it soft, workable and very flattering. Modifying the light consumes a lot of its power though; typically about 2 stops gets lost, so you have to factor this in when buying a light. You can always turn the power down, but it's frustrating when you're at full power and you really wish you had more.

Anyone going into portrait photography seriously needs to purchase a softbox at some point. Softboxes come in various sizes, the larger ones generally producing a softer light than smaller ones (just like windows).

However, it's the size of the light relative to the subject that controls the softness and contrast, so even if you have the largest softbox available, if it is a long way away, the light source will be small relative to the subject.

You can very often bounce light with beautiful results but there are a couple of things to look out for. If you are doing colour photography you have to be very careful that whatever surface you're bouncing the light off isn't going to bring back a colour cast on to the subject. Very few rooms are actually neutral in colour. There's usually something – wallpaper, furniture, carpet or a large picture on the wall – that will contaminate the colour of the light. If it's black and white photography this is not a problem, but if you prefer colour then beware that you could be bringing in quite unpleasant colour casts that are difficult to fix in post-production.

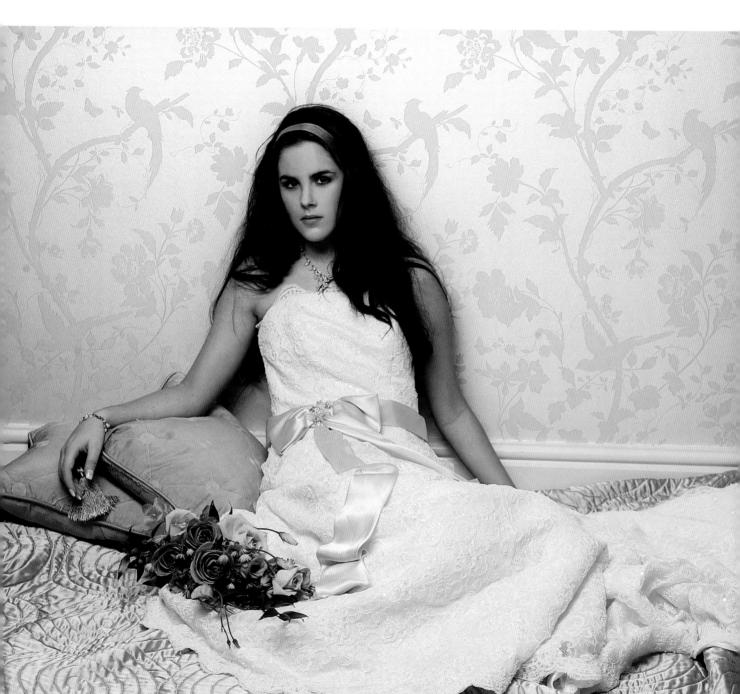

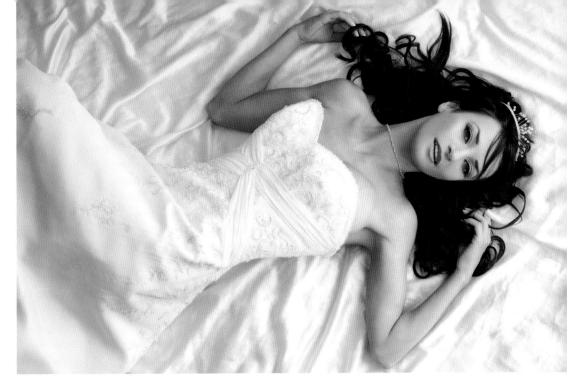

⌃ The subject here was lying in front of a window, which was about a foot above her head and the main source of light. I was on a stepladder above her. The flash was set at 1½ to 2 stops less than the daylight and was bounced off the high ceiling so that a very large, soft light dropped back down on her from above.
Canon EOS 5D, 24–70mm lens, 1/60 sec at f/8, flash at f/4, ISO 400

One answer is to use a softbox, but an alternative, which some people much prefer, is to use a large, portable screen to bounce the light off. There are various ones on the market in matt white, silver or gold, so if you haven't got a surface that's agreeable, you can just erect one. If you're in a small room, such a panel can be better than a softbox because it can go flat back against a wall. The extra distance from the subject can emulate daylight more effectively and reduces the amount of fall-off, which can be a great advantage.

While the window will often predetermine the placing of the subject, you do have a choice where to put the light source. The rule to work to is that the angle of incidence equals the angle of reflectance. It is the same principle as bouncing a ball: it bounces away at the same angle that it strikes the surface. Light does the same thing. If you shine a torch down on to the floor, the beam reflects up at the same angle as it goes down. So, when bouncing light on to a subject from a surface, whether a large panel, a wall or ceiling, you can vary the position or the angle of the light to reflect as much or as little light back as you want.

FLATTERING THE SUBJECT

When using a window, whether with reflector or flash, the predominant light source has to come around the contours of the figure and the face from behind. This means you will be working with the face in three-quarter positions or in profile. You have to ask yourself if your subject is going to be OK with that. Is the light going to render him or her in a flattering way? For example, if someone has a very strong feature, perhaps their nose or chin, it will be emphasized and you may be better off with a less directional type of lighting. Regardless of how good the picture is, if the subject doesn't like it, they won't buy it. Flattery is paramount in social photography.

≪ This shot was lit primarily by the large window behind the camera, so the light is falling quite flat on to the subject. There is just a hint of flash in a large softbox to lift things a little bit.
Canon EOS 5D, 24–70mm lens, 1/60 sec at f/8, flash at f/5.6, ISO 400

Bjorn Thomassen

STUDIO FLASH

One of the major challenges with studio flash is that what you see is not what you get. To be able to pre-visualize how your subject is going to look once the flash has fired is one of the harder disciplines to master. The big advantage of digital photography is that you can review the results immediately on the camera's rear LCD screen, but to move away from a basic level, it's essential to start learning about how flash behaves and to use a flash meter to take the guesswork out of exposure.

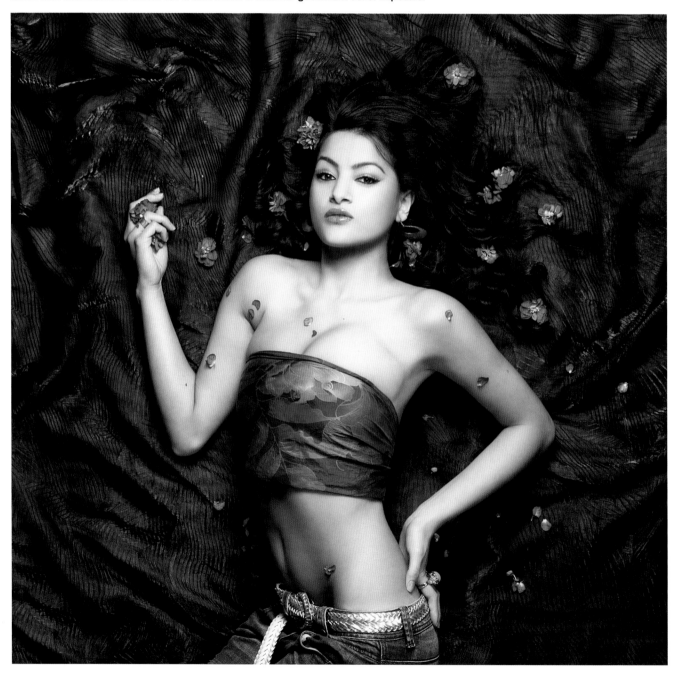

⊼ A strip light, which is more of a rectangular, elongated softbox, was used here. A strip light can be rotated to give many different effects. I used this light because it needed to come back away from the model to exclude it from the picture and because I didn't want it to fall off too rapidly. I wanted it to fall off a little so it darkened towards the jeans but without losing detail there. The aperture was quite small to ensure everything was sharp.
Canon EOS 5D, 70–200mm lens, 1/125 sec (flash synch speed) at f/11, ISO 100

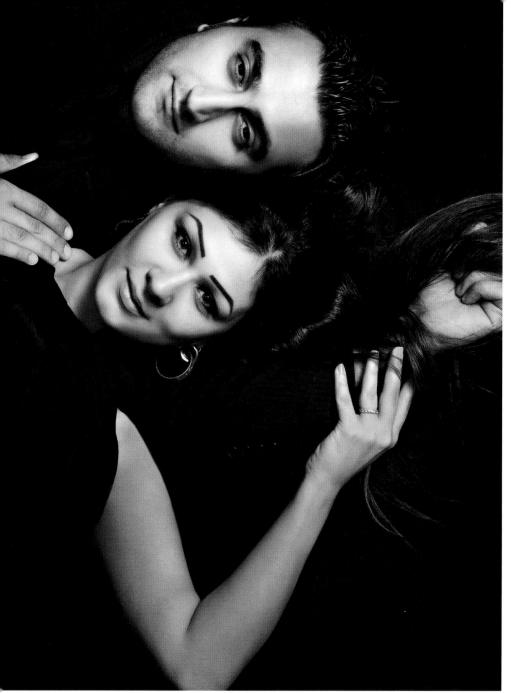

« This shot was lit with one light with a small (70cm square) softbox positioned close to the models at an angle adjusted to accentuate the contours of their faces – you can tell the direction from the shadows on the woman's face. This is a low-key image, which means the tones are predominantly dark – they are wearing black clothes and lying on a black background. The lighting needed to be small and quite directional because the depth of the picture is unusually shallow, from the tip of the nose to the back of the head. The objective was to create three-dimensionality so it was all the more important to emphasize the contours on the faces. The pose was constructed with an inverted triangle at the bottom. There are a number of lines that all point to the models' faces, framed in this architecture of hands and arms. *Canon EOS 5D, 28–70mm lens, 1/125 sec (flash synch speed) at f/8, ISO 100*

TIP

" When selecting a black background, be aware that some materials, like velvet, absorb light and other types are more reflective. You can test swatches of fabric with the camera's spot meter, which will tell you the surfaces that are reflecting more light. Care also needs to be taken with black clothing. It is important to retain some detail in it otherwise it will look too flat. It is easy to discard detail in Photoshop but you can't put back what wasn't there in the first place. If the shadows fall over an area that is already dark – hair or clothing – you can guarantee you've destroyed any potential of recording detail in that area. "

Lighting is about understanding angles, that incidence equals reflectance (see page 73) and the inverse square law. Briefly, this law states that if you move twice as far from a light source you will only receive a quarter of the light; move three times as far from the source and you receive one-ninth of the light. Once you have got to grips with these concepts and you know a little bit about metering, it's surprising how absolutely accurate your pre-visualization can be. I like to think that I know exactly what the light is going to look like when I've pressed the button because I've already worked out how everything is going to behave.

Some people believe you can keep fiddling around until you get it right in-camera, but if you don't understand the basic concepts you can push the power of lights up and down and move them around all day and struggle to get a pre-visualized result. You can waste so much time messing around in ignorance; it's much quicker and more convenient to learn some theory.

It is well worth making the effort because flash gives you a tremendous amount of control over the lighting. You can put modifiers on the flash heads and use accessories to shape and temper the light quality, which is enormously satisfying. The speed of the flash, measured in thousandths of a second, enables you to freeze faster movements that would be difficult with daylight or tungsten i.e. any continuous light source. The camera shutter may be set to whatever the synchronized speed is, as stated by the camera manual. This could be 1/125 sec or 1/250 sec but it is largely academic because the flash duration only takes up a tiny percentage of that and it is the flash that is taking the picture.

TUNGSTEN LIGHTING

You could buy tungsten studio lighting instead of flash. This is a continuous light source that can also be modified. The advantage is that you can see the effect the lighting is giving you and the quality can be supreme; tungsten was used in Hollywood portraiture, which has given us some of the most iconic images ever. However, whereas the colour temperature of flash is balanced with daylight, tungsten is warmer and so adjustments are needed to bring it back to neutral. Also, today's styles of photography rely heavily on energy and vitality and studio flash allows for that. To ignore it would be to turn your back on some of the more exciting and lucrative revenue streams of social photography.

Bjorn Thomassen

FLASH TRIGGERS

Flash units can be triggered in a number of ways. The cheapest is a synch cord from the back of the light to the synch socket of the camera. However, a lead lying around can be a problem. I've known photographers walk away, forgetting that the camera was tethered, bringing the light down.

Infrared and radio-controlled triggers have become less expensive. They are useful because you can put multiple receivers on the lights, enabling you to change the channel and control the outputs of the different lights from a single transmitter on the camera.

You can also trigger the studio head from another flash. This could be an inexpensive hot shoe-mounted flash on the camera. The less power it has the better because it contributes nothing to the exposure or to the effect of the main light but simply puts out enough flash into the room to trigger a slave on the monobloc, which then dominates. This method is popular because that little low light close to the lens puts a catchlight in the eye, which is sometimes lost when the light is at an acute angle to the subject.

WORKING WITH ONE LIGHT

You can do a tremendous amount with one light and a lot of my photography is done that way. It adheres to the principle that there is just one sun. All of the light that we enjoy outdoors is from one main light source and that then drives a number of ancillary light sources as the sun reflects off all sorts of things, even dust particles in the atmosphere, which make the light behave in a different way. If you think of the beautiful, infinite number of qualities that can come from daylight, it will show what a great deal you can do with one light and some knowledge.

Using a single light makes it easy to create shadow form, whereas with two or three lights you need to be more knowledgeable to work out ratios. You can control where shadows go with the position and angle of the light but be careful you don't drop areas into complete darkness where you will lose detail. Always look for extremes in tonality, black and white. If either is in the picture, you have to be very careful. You cannot overexpose white or underexpose black.

The model in the image on page 74 had dense black hair. If I had shifted the light to the left side, it would have put shadow on the right where there was a lot of hair. To get the right exposure, I needed exactly the right amount of light going into that hair. To diminish the light would have given a lovely drawing to her face and body, but her hair would have been devoid of detail. If she had brown or blonde hair, I could have accidentally underexposed up to 1 stop and still have rendered detail. So you need to consider the tonalities of the subject carefully when working with shadow form. If you want to move your light to a position that will under light part of the image, a second light may be needed to retain detail there.

While you may have only one light, this doesn't mean you are restricted to one light source. You can use a single light to drive other accessories like reflectors, diffusion panels or reflective surfaces. You may have one monobloc but surround the model with four reflectors, all angled to put light on different parts of the body, then you have five light sources. This is what the sun does – it is reflectance that controls the way light falls on us.

TIP

Some people feel they can't shoot low-key images because they can't black out their room enough, but this is a fallacy. You can have all the lights on in the room but compared to the flash going off they will be like a glow-worm, contributing nothing to the exposure at all. Press the shutter button and a bright room will be dark and black.

≪ This is a similar principle to the shot of the couple on page 75 but here there was an additional flash and reflector. The purpose was to create a little separation from the background by putting a hint of a highlight on top of his head. The main light was a small softbox, about 35-degrees above him. Another light behind him was fitted with a snoot to narrow its beam, providing a hairlight and a touch on his shoulders. A matt white reflector was positioned horizontally underneath, just out of camera view, to reflect some of the light that would have spilled past his waist. This has lowered the contrast on his face and created a softer feel that is flattering on the skin. The background is several feet away so the light had diminished sufficiently not to fall on it.
Canon EOS 5D, 28–70mm lens, 1/125 sec (flash synch speed) at f/8, ISO 100

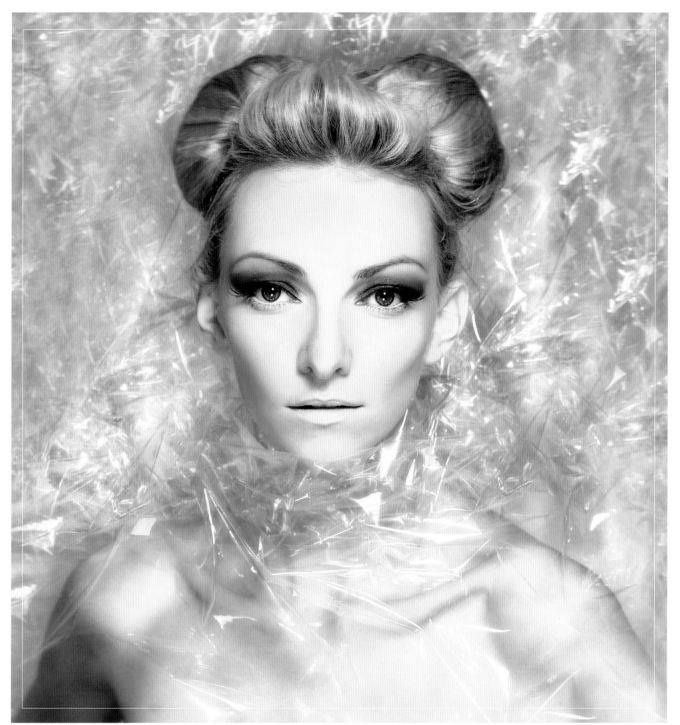

⌃ This image was a little more specialized and was taken with a ring flash – a 360-degree tube set into a housing that wraps around the lens. Ring flash can produce an unbelievably smooth light on the skin because it is difficult for shadows to develop. Light has to come from an angle to produce shadows – if it is even all the way around, it can't create shadows or highlights. Ring flash units are expensive and it takes time to learn how to get the best results from them. They can also have an adverse effect if used on subjects without the right bone structure and are not ideal for social photography. However, you could hire one to work out how it fits into your game and it could give an edge to the style of your work. In addition to the ring flash, I used a strip light immediately above the model, angled down at 45-degrees to keep the contouring to her face with shadows underneath her cheekbones. The ratio between them was 50 per cent ring flash and 50 per cent softbox. Cheap cellophane wrapped around the model added an interesting effect.

Canon EOS 5D, 70–200mm, 1/125 sec (flash synch speed) at f/8, ISO 100

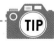
TIP

❝ A great thing about flash is that you can choose the aperture and then turn the power up or down. The aperture is determined by the depth of field you require. Lenses also have optimum apertures. If you want an extreme enlargement you need to find the aperture that will give you the best possible quality. The optimum is usually near 2 stops in from the widest aperture, but you need to check this with the manufacturer of your specific lens. ❞

Bjorn Thomassen

WHITE BACKGROUNDS

These are very popular for social photography. For the studio, there are white papers, vinyls and cloths you can buy but you could achieve a similar effect with a white wall and floor. For a high-key picture like the one of the little girl below and the children on pages 66–67, you need three or four lights: one or two on the subject and two on the background to prevent it from turning grey.

I take incident light meter readings that measure the amount of light actually falling on to the subject as opposed to that reflected off it. Holding a light meter with the dome out close to the forehead of the model, I adjust the light on her. If I decide on f/11 as the correct exposure for her face, I put that into the camera and adjust the power of the lights until I get f/11. The dome cannot see into the model's face so it can't be affected by the tonality of the subject, so she could have dark skin and dark clothing or light skin and light clothing. The meter just measures all the tones faithfully.

If I decide on f/11, call this our value of one, I can bring in as many lights as I want but everything has to be subordinate to that one value because that is what's going on to the camera. If I have two lights on the background, one either side, I place the meter flat against the paper with the dome facing towards the light source and adjust the power until I get f/11 on to that dome. I work on the principle that if I balance this one to one, with f/11 for the model, if the true tone of background is white it will record as white. Then I adjust and balance that light so it is even. I want the two lights to be far enough away and at such an angle that they give me an even f/11 all the way across.

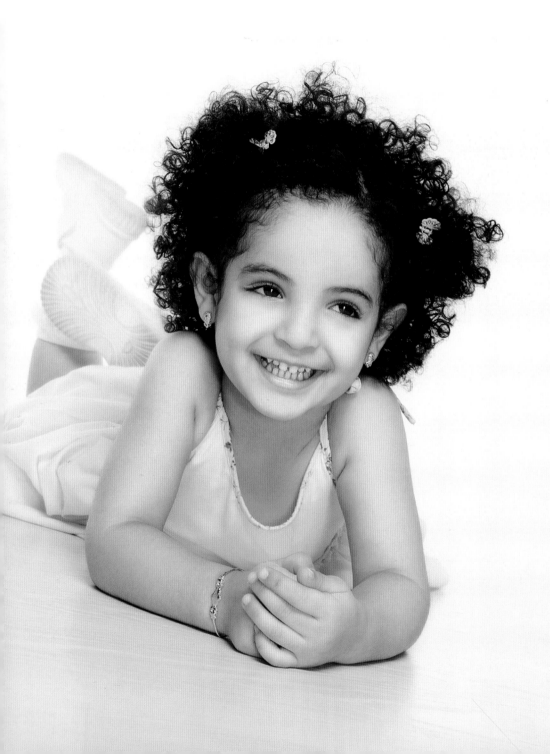

TIP

" While the camera's histogram is generally useful for checking exposures, it can be confusing when shooting high or low key. A low-key histogram can look quite horrific if you've got just a mass of black on the left, and with high key it will all shift over to the other side. Sometimes it confuses people because it looks so radical, but the scene will not have a full range of tones because it isn't supposed to. An alternative is to magnify the image on the back of the camera and look for detail in blacks and whites, where you need it to record, for example in hair or clothing. "

≪ For this shot, there were two lights on the subject on the same stand, each with a softbox, one over and one under so the light fell across her evenly. There were also two lights on the background, one on either side, to retain the white. A flash meter is essential to balance the exposures when using more than one light.
Canon EOS 5D, 70–200mm lens, 1/125 sec (flash synch speed) at f/11, ISO 100

Here, I used two small softboxes in ≫ a vertical line above and below the model, coming in at 45-degrees, down and up. The under lighting was to light the jeans and carries up his body to provide a fill on his face.

Canon EOS 5D, 28–70mm lens, 1/125 sec (flash synch speed) at f/11, ISO 100

∨ There were three lights here, each designed to bring a different element of the picture to life. Always start with the main light, which illuminates the main point of interest, usually the face. Here, it was positioned horizontally and away to the right and down on her face at approximately 45-degrees. This was the only light neutral in colour. Another light from the left had no softbox, just the edge of the reflector dish covered with a blue gel. You can see evidence of this in the light blue rim under her neck, on her cheeks and eyes, overlapping with the neutral main light. Another light with a blue gel was around and behind her pointing in, with barn doors (flaps that control the spill of light). The background was a black floor cloth with folds made to look like waves. There was enough light to spill on to it to add detail and texture.

Canon EOS 5D, 28–70mm, 1/125 sec (flash synch speed) at f/11, ISO 100

FLASH ON LOCATION

Using monoblocs in indoor locations other than a studio opens up many creative opportunities, as well as being necessary for commercial assignments. When planning a shoot, you first have to decide what the dominant light source should be. Is it going to be a window with the flash complementary to that, or are there going to be interior lights creating a nice effect that the flash will be subordinate to, just to lift detail? Is the flash going to be the dominant source, or do you want a balance between different light sources with none of them dominating? If you decide flash is going to be main light source, think about the right accessory and the position of the light to flatter the subject or reveal a particular point or message.

≪ Commissioned by a boutique, the lighting for this shot not only had to make the model look good and reveal the textures and quality of her clothing, but also had to emphasize the bag. There was a strip light on the left, set in a vertical position to send quite narrow shafts of light down her body. The outer diffusion panel was taken off to crisp the light up a little and make it sharper. Another strip light, also vertical, on the right side of her also had the outer diffusion panel taken off, revealing the silver interior. This is lighting the bag so there is enough detail and information there. The transfer edge, or shadow, always gives clues as to the lighting quality and you can see the strand of hair by her eye and the shadow cast on her cheek is defined. This tells us that the light is crisp and the contrast has been heightened. The light in the background came from the second exposure, which is the camera shutter. Without it, the flash would have overwhelmed the tiny lights on the wall, losing depth and atmosphere.
Canon EOS 5D, 28–70mm lens,
1/8 sec at f/5.6, ISO 100

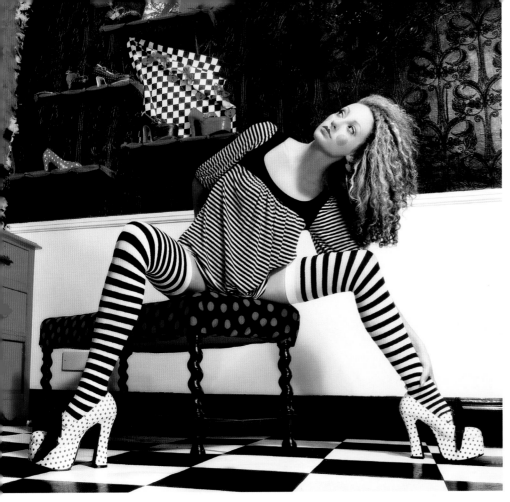

Shot in a little boutique, I was going for something quirky here because that was the nature of the products. The model was chosen for her big doll-like eyes and the make-up artist played on this idea. I built a simple theme of black and red, bringing in products to go with it. There were two lights on one stand, one at floor level and one high up, as you can see from the shadow that is coming up across her neck and down her collarbone. Both had beauty dishes, or minisofts, to give contrast and crispness. These are small dishes that come with a deflector kit, which interrupts the main path of light from the tube. You can change the properties of light by rotating the disc in and out. The discs come in translucent or opaque form offering different light properties. A 28mm lens gave a little distortion, making the feet look slightly larger to add to the quirky feeling.
Canon EOS 5D, 16–35mm lens, 1/125 sec (flash synch speed) at f/8, ISO 100

Very often, on location, you want to capture some of the atmosphere of the place, as that is the point of being there. This means lighting your subject with flash, controlled by the aperture, but setting the camera shutter much slower than the synch speed to allow a secondary exposure to record the ambient lighting and reveal detail in the background. To do this, you need to take additional light meter readings to work out how slow the shutter needs to be to record the ambient lighting, without burning out.

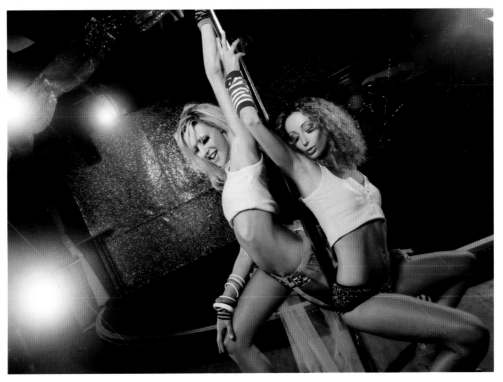

The idea behind this lighting was to reveal contours and give depth. Coloured gels added to the vibrancy. It needed to be an energetic shot that had a feeling of movement. One light with a 70cm softbox was back just slightly to the left of the camera and up about 45-degrees. This is the light on their faces. Another light outside camera view, on the left, was just a reflector with a blue gel. It's an accent light, adding dimension to the shin, up the abdomen and into the hair on the model on the left. A third light you can see in the right-hand corner had barn doors with a red gel attached. This is painting red accents on the offside of the model's legs, into her hair and spilling over on to the blonde model. The lights in the left of the frame were dropped in with Photoshop. It was shot on a tilt to produce strong diagonals and a feeling of movement.
Canon EOS 5D, 70–200mm lens, 1/125 sec (flash synch speed) at f/8, ISO 100

Bjorn Thomassen

If flash is going to be your main light source but you are going to work with a slower shutter speed to let in daylight or other lights, you need to be aware that the secondary exposure from the shutter could also affect your subject. If there was anything close to the subject, like a wall light, or even the modelling light from the flash head, there could be an over-layering of light on the subject, which would ruin the shot. It's worth having with you some lightweight black panels of around 1.8 x 1.2m (6 x 4ft). These can be easily clamped to stands to flag out the unwanted light above or adjacent to the subject, if that light can't physically be switched off (because other lights that you do need would switch off too). Some photographers unscrew bulbs, but it is more practical to bring panels as most lights will come from the ceiling. There are so many locations that can't take secondary exposures without flagging out some light so it really is worth being prepared.

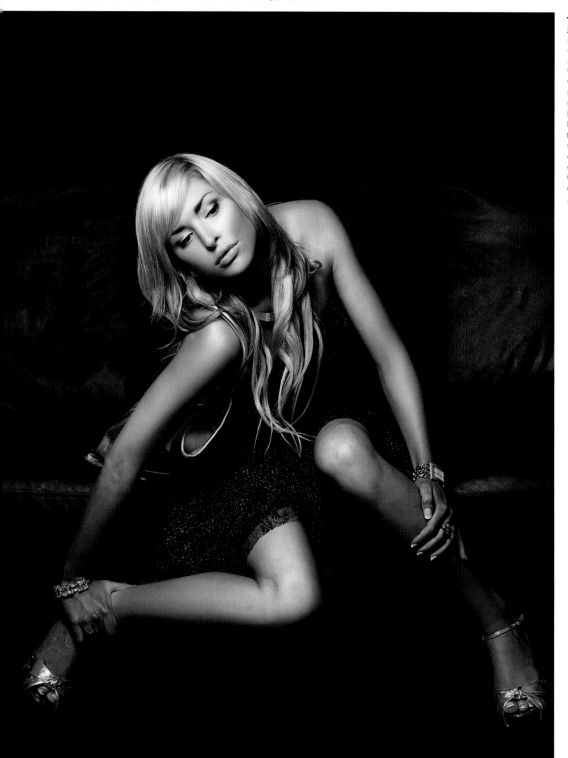

≪ The lighting was very simple here, just one light with a 70cm softbox positioned 45-degrees up and 30-degrees to the left of the camera. A triflector (three reflectors joined together that can pivot independently) was set in a vertical position to the right side. The black leather couch was shiny so it threw some light back – if it had been cloth it would have absorbed the light and the model would appear to be floating. Poses for fashion shots can be uncomfortable. You are looking for a lot of angulation and diagonal lines. Some of them conflict but it all adds interest to the pose.
Canon EOS 5D, 28–70mm lens, 1/125 sec (flash synch speed) at f/8, ISO 100

One strip light, set 45-degrees ≫ above and 60-degrees to the right of the camera was designed to drop down on the subject and reveal an angular, contoured look to her face and body. This flash was determined as the main light source and the shutter was slowed to enable a little light coming through a window to put an accent on the outer rims of the pillars. They form a series of parallel lines that recede away from her, which adds tremendously to the depth of the photograph. A wide aperture allowed daylight in without the shutter speed dropping too low and the shallow depth of field separates the subject from the background. The subject was parallel to the lens so there was no worry about any one part of her going soft.
Canon EOS 5D, 70–200mm lens, 1/15 sec at f/5.6, ISO 100

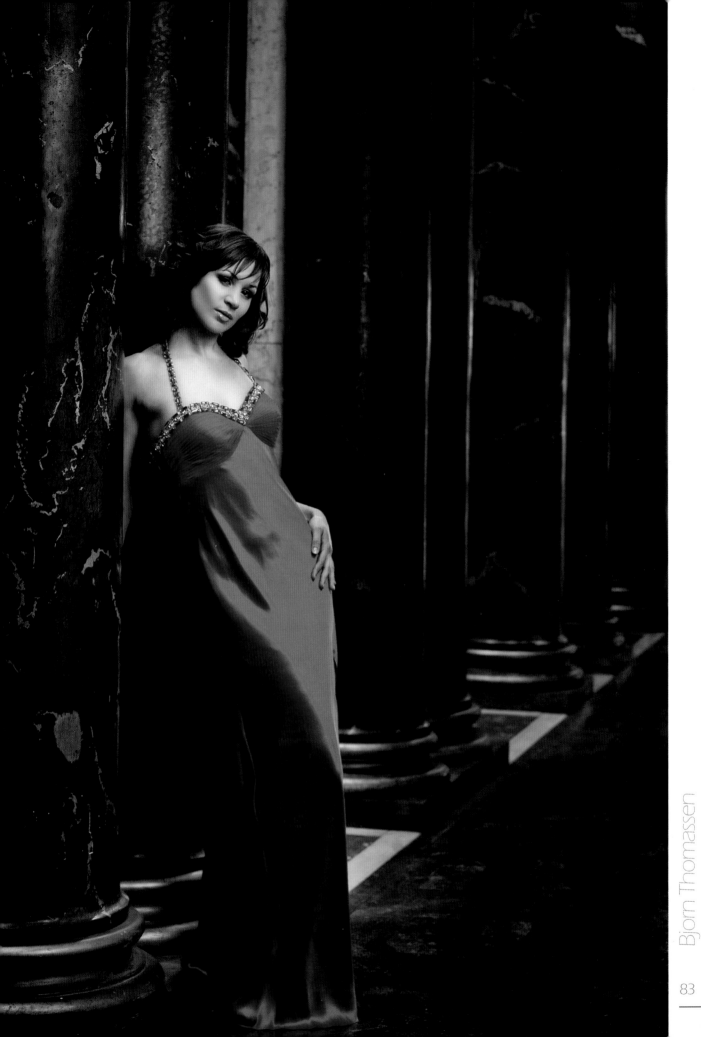

FLASH OUTDOORS

As lovely as natural outdoor light is, it's not always quite what you want it to be. You could be in a location at the wrong time for whatever reason and it is a great advantage to be able to continue creating portraits using studio lighting to achieve the exact look you are after.

Indoors you can work with studio-style monoblocs using a power supply. Outdoors you need portable power packs that operate with powerful batteries. It isn't generally advisable to take monoblocs out into the environment as there are risks with dust and moisture, but if the conditions are ideal, you can operate with monoblocs in a restricted way outdoors using a relatively inexpensive electrical generator.

≪ This was shot with the Elinchrom Ranger and an inverted umbrella with a matt white interior. The light was positioned just to left of the camera and quite high, about 35-degrees. The shop window provided a second light source and big sodium street lights the third. You can see evidence of that on her thigh. The three sources were each metered separately to ensure they were balanced.
Canon EOS 5D, 28–70mm lens, 1/8 sec at f/5.6, ISO 100

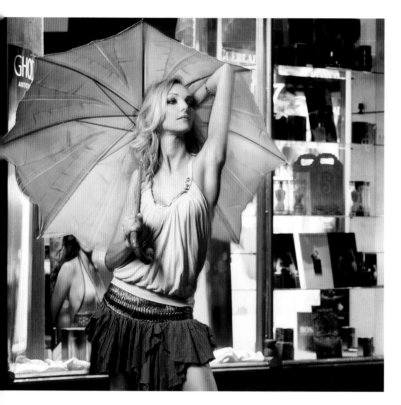

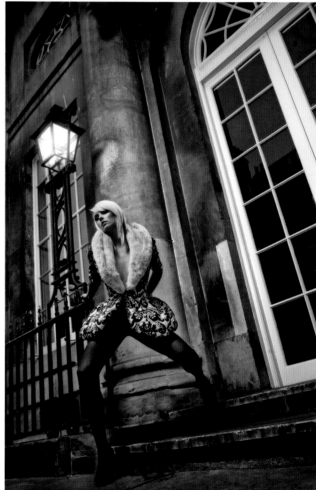

I was shooting down low to distort the perspective of things a little, ≫ creating convergence with the shorter, tilted lens. The light was an Elinchrom Ranger, a portable power pack, with a 70cm softbox, positioned high up, at around 60-degrees up, and 45-degrees to the left of the camera. With the light in as close to the model as I could possibly get, it gave very strong drawing to the face, accentuating her bone structure. The deep shadows underneath her neck and on the cheekbones added a lot to the shape of the face. If there had been a street light there, it would look quite similar to this with the same sort of angle and quality. At twilight, there was enough ambient light to get a full range of tones from the second exposure, made by the shutter. In Photoshop, all my photographs are tonally balanced with Levels, and dodging and burning is done to give optimum contrast.
Canon EOS 5D, 16–35mm lens, 1/8 sec at f/5.6, ISO 400

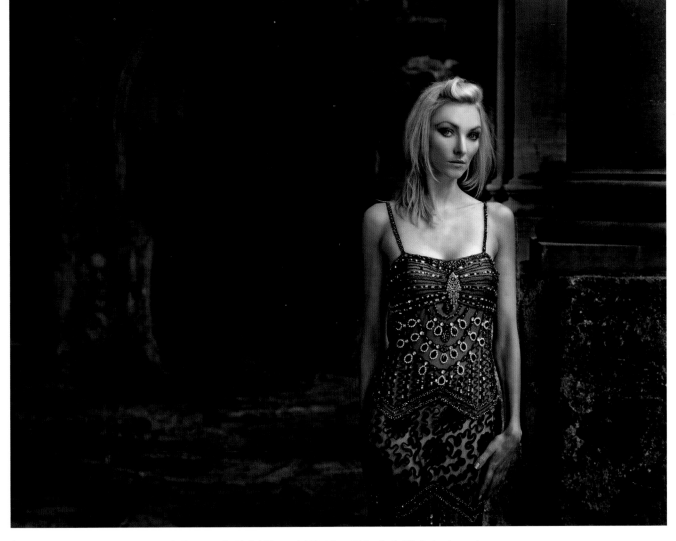

⋀ The available light here was very low so flash was required to light the model, blending with the daylight in the background. The small softbox was placed 45-degrees to the right of the camera and 45-degrees high. The model's face was angled away to give a shadow on the near cheek. Flash enables you to work with favourable ISOs, whereas, with daylight alone you may have to set the ISO higher and risk digital noise.
Canon EOS 5D, 70–200mm lens, 1/15 sec at f/4, ISO 100

 TIP

❝ Elinchrom has a quick release system that enables a large softbox to go up quickly. A large softbox will be very vulnerable to wind, however, so smaller softboxes or umbrellas, which are very light and portable, are often better accessories when shooting outdoors. ❞

This was a promotional shot for a singer/songwriter, who wanted a slightly sinister, ≫ gothic look. With the Elinchrom Ranger, I used a strip light so that the light continued down the figure. It was positioned high up to the right of camera, close to the subject to encourage fall-off. It was also angled away from her a little bit to work with the edge of the light rather than its direct path. This reduces the intensity and has a soft transfer as it goes into shadows. It was very dark, with a canopy of leaves in the trees above us, so I needed a slow enough shutter speed to get depth into the background.
Canon EOS 5D, 70–200mm lens, 1/8 sec at f/5.6, ISO 800

REFLECTORS

Reflectors are just about the simplest accessories you can use to modify the light but they are nevertheless invaluable. They come in many different forms: shiny, matt, silver, gold, white and a mixture of gold and silver. Which you choose is important because you can alter the colour temperature with a reflector. I prefer to use a matt white surface as it will keep everything neutral. I am not keen on a gold reflector because it will change the colour temperature in a localized area. So, it might give the skin and clothing an amber feel but if the background stays neutral then it doesn't stack up. At sunset, if that's what it is trying to replicate, the colour temperature of the whole scene changes. Personally, I find it disturbing if the model is amber and the background is green. If I want to warm up the picture a little, I do it in Photoshop – filtering in a little amber will affect the whole file and look much more natural.

⩔ As you can see from the overview shot, there was more going on behind the scenes in this picture than you would guess. There was a large 1.8 x 1.2m (6 x 4ft) reflector to one side of the subject, with an assistant holding a 1.8 x 1.2m (6 x 4ft) California Sunbounce Sun-Swatter over the top of him. It was a very overcast day so the light was soft anyway and the reflector just lifted a little darkness in the eye sockets and under the chin and pushed in softening tones on his face. The swatter, or diffusion panel, further softened the overhead light reaching him. I used a wide aperture to throw the boulders in the background out of focus.
Canon EOS 5D, 70–200mm lens, 1/250 sec at f/4, ISO 400

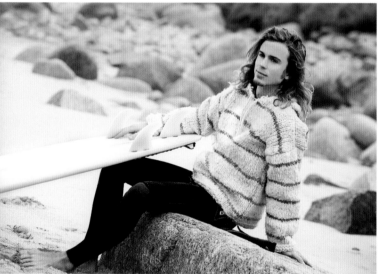

TIP

❝ There are certain pieces of kit that can help you take your pictures to the next level. A diffusion panel, like the Sun-Swatter made by California Sunbounce allows you to shoot in quite harsh light by diffusing it over the subject. The alternative would be to find some shade. ❞

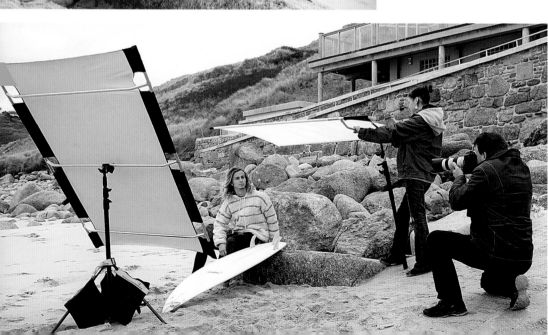

⩓ This is a promotional shot for a TV actress who has her own clothing range. A large diffusion panel over her head kept off the bright sun you can see hitting the car behind her and prevented the contrast going too high. A large reflector by the camera pushed soft light on to the subject, revealing delicate tones. There was a little wind that day so I used a higher ISO to give me a faster shutter speed to freeze any movement.
Canon EOS 5D, 70–200mm lens, 1/250 sec at f/5.6, ISO 400

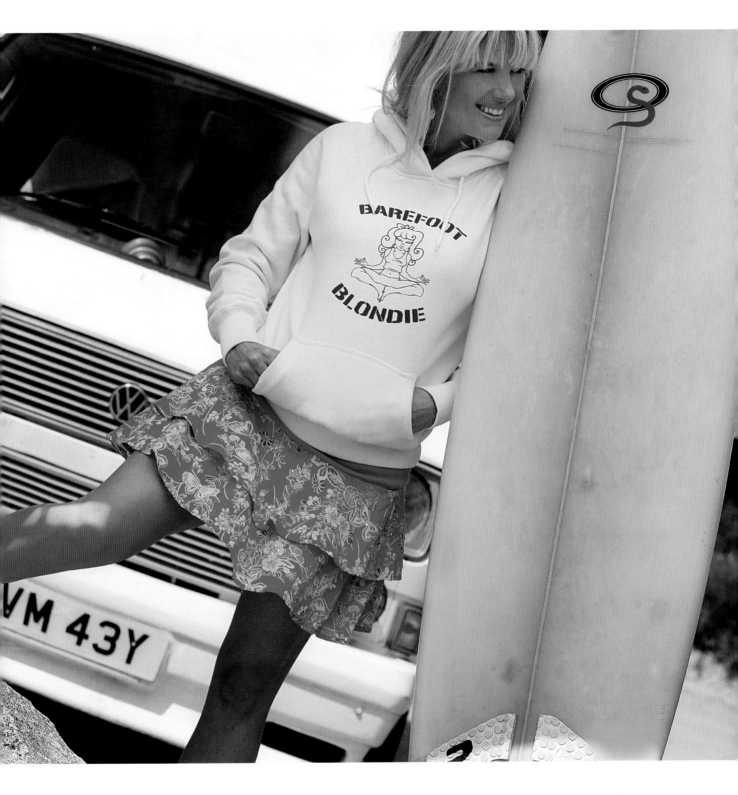

Most matt white reflectors are silver on the other side. Remember that silver is more efficient as it has a higher level of reflectance. People often think this is a good thing as it will produce more light, but it can be harmful. Very often people put reflectors too low, near the chest of their subject. Silver can be so effective that it unbalances the light ratio. Almost as much light is coming underneath the subject as there is from the sun on top – this rarely exists in nature. It might even reverse the ratio so there is more light underneath than on top. You only see that in horror films, with good reason – it's so odd that it's scary.

Silver also reflects a certain quality of light. On an overcast day, a lovely soft light comes down from the sky. If reflected off silver, it can accentuate shiny skin and so matt white would be more flattering. Rather than bouncing light up from below, it is better to hold the reflector (or support it on a stand) above the photographer or at his or her eye level. This will create a lovely soft fill light, retaining the contours on the face and rendering the person correctly, with a downward feel to the light. Nature does a great job. Study that and bring it to bear in your own lighting.

POST-PRODUCTION: SMOOTHING THE SKIN

Very often there's a conflict when using flash for portraits. Some lighting that is flattering to subjects' bone structures reveals textures on the skin that you would prefer to de-emphasize. Retouching in Photoshop enables you to shoot in the way you want to without having to worry about it.

It isn't just models that this applies to but children, grannies and guys. You can shoot to reveal a lot of three-dimensional form in the face and figure and then anything that has been accentuated along the way, like wrinkles, pitting of the skin or spots, can easily be removed and the skin smoothed. This gives you the best of all worlds. When I am selecting a person for a shoot, I am not at all bothered if they have the worst skin in the world. I am more troubled if they don't have a good bone structure or physique, as you can't easily change these things in Photoshop.

Smoothing the skin is always optional for a client. You can retouch a tiny amount, have a light enhancement or almost a full makeover. It is not being dishonest as it is still a true capture of the person, but if they would rather have had better-looking skin on the day, then you can step in.

LIGHTENING DARK CIRCLES UNDER THE EYES
If the skin pigment under the eyes is a little too dark, use this method to brighten it up a little:
- Use the Lasso tool with Feather at 20 pixels and careful select the areas that you want to change (picture 1). You can do both eyes at the same time by holding down the Shift key after making the first selection and moving your mouse to the second eye.
- Go to Image>Adjustments>Levels (or Command-L) and move the slider to the right to lighten the areas selected (picture 2). When you are happy with the result, press OK, then Command-D to deselect.

REMOVING BLEMISHES AND RETOUCHING THE SKIN
There are numerous different methods for removing blemishes and smoothing over the skin. I use three tools in quick succession to give a really smooth final appearance.

The Patch tool
- Draw around an uneven area of skin, drag it on to a clearer area of skin near the problem then click. The clear skin replaces the problem. This is a good tool to use if you are working close to the edges of other details.

The Healing Brush tool
- This is a quick way to sort out several different spots or freckles. The tool matches the tonalities from a similar area and blends them to make a smooth transition. You need to select the right kind of brush from the drop-down menu. A Hardness and Spacing of 10% is about right when working on very small areas but you can experiment with these settings.
- Zoom right in on the area you want to 'clean'. Place the brush over an area of skin that is similar to the piece you wish to change, making sure it is a fairly large area with no blemishes as these will be transferred across.
- With the brush in place, Alt-click (Windows) or Option-click (Mac). This selects that area as a sampling point, which will be used for all

your alterations until you begin the process again. Now place the brush over the blemish and start to 'paint' over it while keeping the mouse button pressed. As you are painting, a marker cross indicates your sampling point, which moves as you move the mouse. Make sure it stays within your selected patch. When you release the mouse button, the blemish will have disappeared.

The Clone Stamp tool
- This is the final part of the process. You can use it to go over the whole face, being mindful of contours. It has the effect of polishing the skin but takes a little time to master. If you overdo it, the skin can look 'plasticky'.
- Choose a soft brush and select the Size, depending on the size of the area you will be working on. Select the Opacity – I used 20% in the example image. Select a part of clear skin you want to clone by Alt-clicking (Windows) or Option-clicking (Mac), then drag this over the part of the image you want to correct (picture 3).
- When your image is blemish-free, you can apply sharpening. If you have overdone the Clone Stamp, sharpening the whole image can bring some texture back. Otherwise, only specific areas like the mouth and eyes. This gives the illusion that the whole image is sharp. First use the Lasso tool to make your selections. Go to Filter> Sharpen>Unsharp Mask and apply until the effect looks right (picture 4). Finally, deselect and save.

BEFORE

⌃ This bride-to-be already had beautiful skin but smoothing out the tones in her cheeks, nose and forehead, lightening under the eyes and sharpening the lips and eyes would make a difference.

ONE

TWO

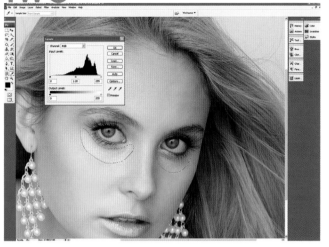

THREE

FOUR

TIP

" Consult your client before making any radical alterations and be tactful in the way you approach the subject if they haven't mentioned it first themselves. Don't remove any permanent features such as scars or moles unless specifically asked to do so. "

AFTER

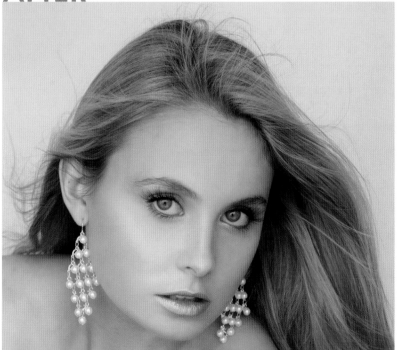

The final result – a much smoother skin tone all over. The client ≫ will be much happier with this far more flattering image.

Bjorn Thomassen

CHAPTER 4: OUTDOOR & LOCATION PORTRAITS
Matt Hoyle

Creating a photograph is a bit like sculpture. As you style it, light it, pose it and even as you post-produce it, you're chipping away things that don't make sense to you. What's left is something that is intrinsically you. How you come to select the subject in the first place has to be equally, if not more, personal.

This chapter looks at posed and candid portraits of people you may not have met before. How and where you find subjects that interest you, how to approach them or shoot unobserved, making the most of lighting and the environment, and Photoshop techniques for giving the image the look you had envisaged.

This is a waitress in a deli in Second >> Avenue in the Lower East side of New York and she has been there for years. You can get lucky and find characters that tell a story just by what they wear and how they look. Her hair, her makeup and the bubble-gum pink of her blouse fascinated me. I knew I wouldn't be doing her justice if I didn't get her actually taking an order and doing her everyday job.
Canon EOS-1Ds Mark II, 24–35mm lens, 1/30 sec at f/8, ISO 200

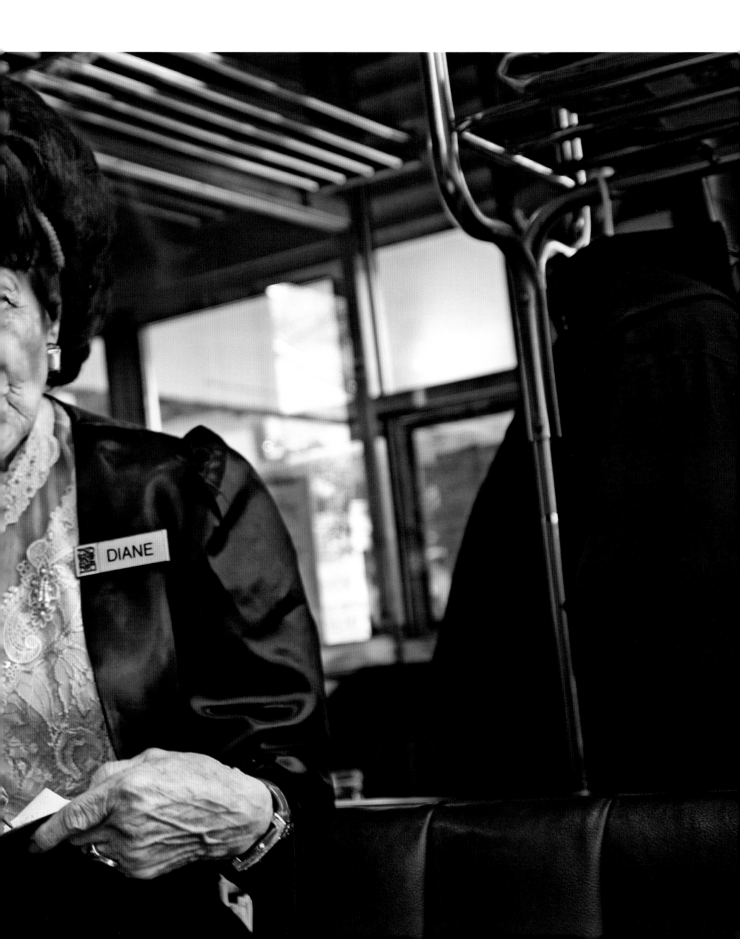

SHOOTING THEMED PROJECTS

For me, shooting themes is about trying to capture the people of my time in a creative way. As a former creative director in an advertising agency, I tend to see in themes rather than individual, one-off portraits. There's nothing wrong with those but to carry through a vision with multiple images makes more of a statement. There are always going to be one or two shots that resonate more strongly with any particular viewer – it's a subjective field we're in – but you go further to strike a chord if you have multiple characters.

IDEAS FOR THEMES

I come up with themes that not only interest me, but that I also feel will interest other people. I look at things sociologically, broken down into groups and sub-groups in our culture. They can be the oddest of groups, like winter swimmers or ageing boxers. In essence, you can think of anything and carry a theme through – and it's a lot of fun to do.

My advice is to begin with yourself. Any photographer who's going to succeed continually and not by accident has to do something that interests them and makes them feel something first. Otherwise they are just going through the motions and will create something quite hollow.

Draw on your own world, your past, your present and your surroundings. This could be something that has touched you, whether in reality or in your imagination, or something around you.

Start with something accessible. Discipline yourself to your own neighbourhood to get a taste of a series before jumping into anything too grand. A really good photographer is going to make the bland and mundane seem quite unique and wonderful – just look at the work of William Ecclestone. The most important thing is to set yourself some guidelines and a focus. This will help you to overcome that sense of a blank page, which you don't know how to begin to fill.

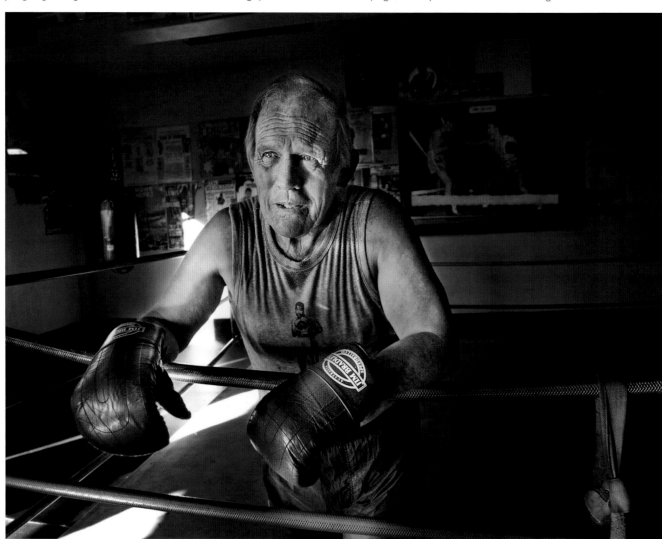

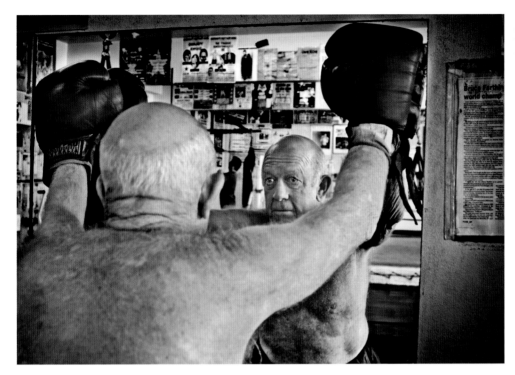

≪ Alfie gazes back at himself, remembering the times, long ago, that he used to train here.
Fujifilm FinePix S2 Pro, 18–35mm lens, 1/30 sec at f/8, ISO 100

 TIP

❝ Themes are great fun once you start to put things together. You could choose a day of the week for a theme, going around your city on a Tuesday, or perhaps the colour blue. One picture of someone with a blue shirt is fine, but continue that and you can really spark the imagination. A person could be blue because they're cold. Another might have blue lips from sucking a blue ice pop. The viewer will think, 'Isn't that a clever and interesting way of interpreting things?' ❞

PLANNING

If I find a subject that interests me, I start my research using books and the Internet. Google Images is a great tool. If I picked clowns, for example, I'd find out where they live and all about the various types of clown. Just reading and looking at things sparks the imagination.

Fairly early on, I work out how many images I need to take to tell the story, maybe 10, maybe 20 or maybe more. Then I start researching these images further. The most important thing is to find the various people, whether they are boxers, swimmers, clowns or cowboys. Again, the Internet plays an important part here. I start to make contact to see if they're interested in a personal project, referring them to the photos on my website to show them that I'm not a fly-by-night who will waste their time. Most of them have a day job and taking time out for no money relies on their generosity and interest in being part of something creative. More often than not, people agree because they're flattered that I find them interesting.

Once I have found the people, I start looking at the logistics of the shoots themselves – where will they take place and how will I light them? There is always room for spontaneity because you never know exactly what you're going to get, but you also have to go in with a vision, because that is what being a professional is about. Having a methodology to your work will make it unique.

≪ Reg on the ropes, contemplating fights of years gone by. I used a Speedlite flash for all of these pictures, mostly reflected off a wall or ceiling to soften the effect. In post-production, I usually mask out my main subject and then tint the background to complement the subject's skin. For the 'Fighters' series, I used a blue background tint. I also added a bit of contrast to the subjects' faces to bring out the lifelines and show their age.
Fujifilm FinePix S2 Pro, 18–35mm lens, 1/30 sec at f/8, ISO 100

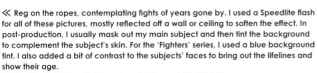

⌃ Mick at the bags, not in the same shape that he used to be but still with the same fighting spirit.
Fujifilm FinePix S2 Pro, 18–35mm lens, 1/30 sec at f/8, ISO 100

Matt Hoyle

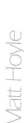

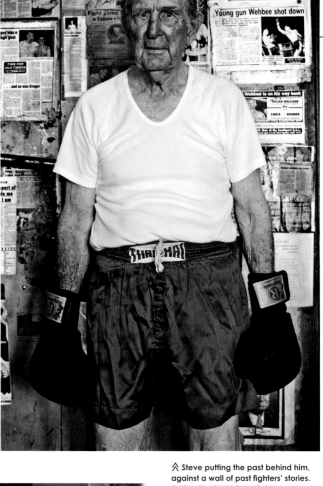

I look for interesting backdrops and props that will help to tell the story of the person in as minimal way as possible. It could be a punch bag, a background of water or a circus tent. I also look for a colour palette that will complement my subject. My work is very much about keeping the harmony of colours. Your game plan should be to follow certain rules that your series of photos always retains. That way, when someone sees your work, they don't see a generic, disparate group of photos throughout your series, or your career; they see something that's intrinsically you. Otherwise why would they want to purchase or view your photos rather than someone else's?

FIGHTERS

The characters in my 'Fighters' series are all former boxers, amateur and professional, who are long since retired and are grandfathers now. Something sparked my interest, and I think it could have been the Russell Crowe film *Cinderella Man*, which is about the spirit of a man who used to be strong and still has that strength in his eyes, but whose body has become weak over time.

This was a fairly quick series for me. It took about a month, shooting a couple of days a week, to get nine or ten images. They were taken in a few different old gyms that have been around for decades – the places these guys trained in when they were young. The location was important to give authenticity to this particular story. There had to be something there that gave a sense of age to reflect the character of the subjects.

EQUIPMENT

I travel with a very simple kit when I do my environmental portraiture. I have two Manfrotto portable, collapsible light stands and two Canon 580EX Speedlite flashguns. Two small adapters attach the Speedlites to

⌃ **Steve putting the past behind him, against a wall of past fighters' stories.**
Fujifilm FinePix S2 Pro, 18–35mm lens, 1/30 sec at f/8, ISO 100

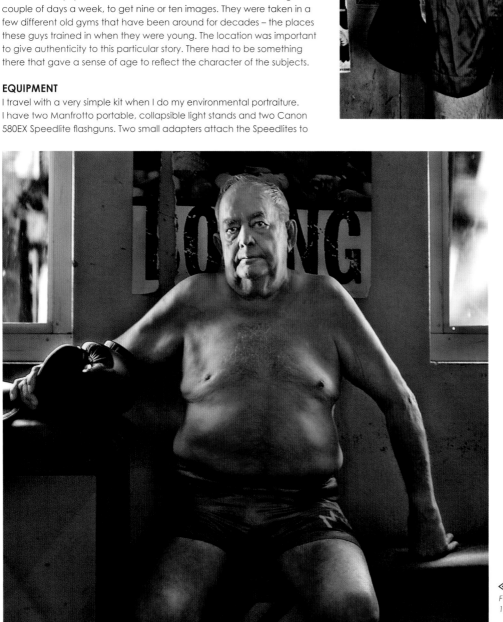

« **Mick with a boxing poster behind him.**
Fujifilm FinePix S2 Pro, 18–35mm lens, 1/30 sec at f/8, ISO 100

the light stands and in the middle of each adapter is a hole where an umbrella fits. I use either 14- or 20-inch speckled silver umbrellas, which give a little more contrast in the light than satin white.

I use one of these lights as my key light, placed above and to the left or right of the subject so it shines down and creates a three-quarter, Rembrandt-like light. The other light is my fill, placed in the opposite direction, shining upwards to fill the shadows under the cheeks. In more contrasty shots, I dispense with the second, fill light and allow the ambient light to fill in. When using two lights, my standard exposure is 1/125 sec, but with just one light, I drop the shutter speed to 1/60 sec or even 1/30 sec to allow more of the ambient light to come through. When I shot the 'Fighters' series, I used a coil that linked the key light to the camera and put a slave on the other flash. These days I use a Canon wireless trigger on the camera's hot shoe.

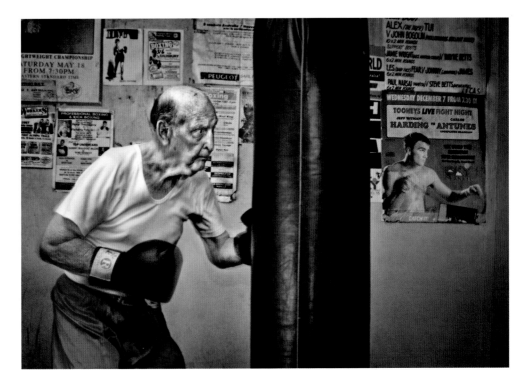

⋀ **History repeats itself with Steve inadvertently mirroring the famous Jeff Harding in the poster behind him.**
Fujifilm FinePix S2 Pro, 18–35mm lens, 1/30 sec at f/8, ISO 100

⋁ **Reg at the bags going through his paces.**
Fujifilm FinePix S2 Pro, 18–35mm lens, 1/30 sec at f/8, ISO 100

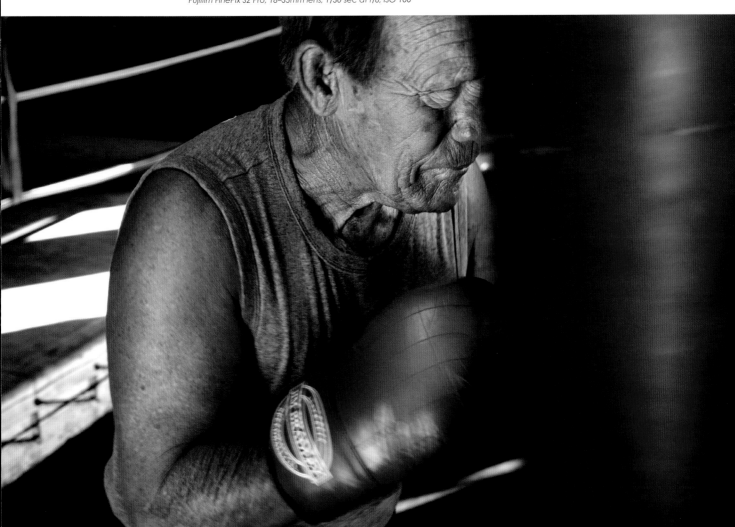

CANDID PORTRAITS

When I started taking street photographs, the first thing I had to teach myself was how to find the places where there is what I call 'a hive' of good subjects. In other words, where there is a lot of activity that is likely to yield the kind of photos I am looking for. I went to these places in happenstance mode, ready for anything, and this really taught me how to observe. Of course, these hives are a subjective thing for any photographer – mine could be very different from the next person's – but, for me, it was initially about finding interesting characters.

Then I started to learn to make better use of my time through research. It's ironic that to get a spontaneous image you have to prepare yourself but that really is a good piece of advice. So, let's say I wanted to photograph some of the older dignitaries from the American South, characters who are at the higher end of society. I would travel to New Orleans, or possibly Georgia, and go to the nicer parts of town where that group meets and socializes. Once there, I would wait. This would be a broad-brush way of me honing in on a particular subject, going to the area where I would find them and then posing myself in a nondescript way so that I didn't look obvious. This is as important as getting the shot. If you were a wildlife photographer, you wouldn't scare the birds away.

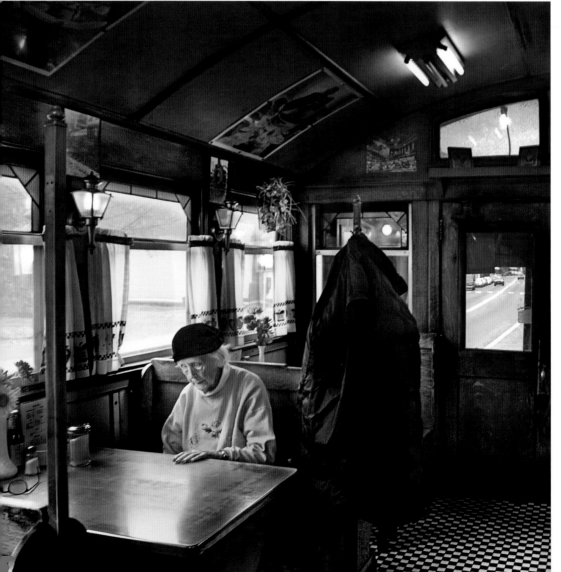

 TIP

❝ When you are photographing an ordinary member of the public, you don't want to be intrusive, so a long lens of around 80–200mm is useful. With semi-spontaneous moments, you never know how far or close you are going to be, so a zoom lens allows you to adapt. You can't light the subject, so choose the lens with the widest maximum aperture that you can afford – f/1.8 or f/3. For crisp images in indoor ambient light you will want to work at ISO 200 or 400. ❞

≪ This old lady was spotted in a café/diner in a quaint small town in The Berkshires, West Massachusetts. It was dark and very shadowy and she looked lonely. Most people say that it breaks their heart to look at this image. It's an example of touching the viewer and making them feel empathy for the subject and the moment. Her look into nothingness with her hand on the table showing vulnerability work in tandem with the environment to produce the feel that I wanted.
Canon EOS-1Ds Mark II, 80–200mm lens, 1/30 sec at f/8, ISO 200

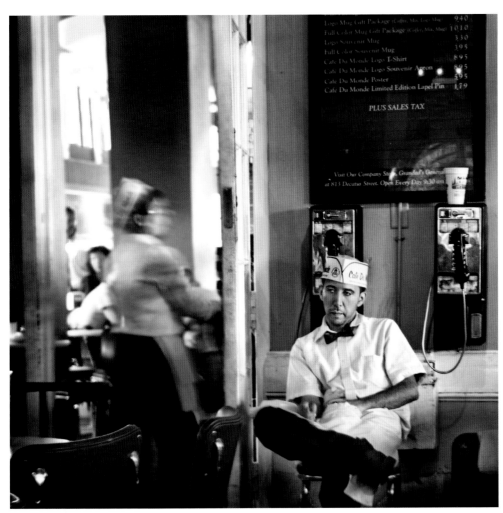

≪ Another café in the French Quarter of New Orleans and, no, it's not Nicholas Cage! This droopy-faced subject was photographed for my book, *Yesterday in America*, for which I wanted observational shots that hark back to the old days and don't date. There's nothing in this photograph to say 2007 – even the telephone could be 20 or 30 years old. I love the fact that I don't have to set up shots like this; it's just about framing out anything modern that dates the image and waiting for the moment.
Canon EOS-1Ds Mark II, 80–200mm lens, 1/30 sec at f/8, ISO 200

I shot from the hip to capture this ⋁ man who appealed to me with his hat and pipe. Shooting in tourist locations is easier than it was 20 years ago because everyone has a camera and, if you blend in as another tourist, no one will suspect you.
Canon EOS-1Ds Mark II, 24–35mm lens, 1/125 sec at f/8, ISO 100

Normally, you would try to avoid looking like a tourist because you'll get taken for a ride and ripped off. But if you look like a harmless tourist taking photos in London, New Orleans, New York or any other city or large town, people will just think you're taking photos of the architecture like all the others – you're a lot safer and more anonymous than you might think. So, disguise yourself as a tourist. That advice might sound very subtle but it always gives me comfort to know that I'm not going to scare people off by looking like a paparazzo or a professional photographer working on a book.

CREATING A CHARADE

I am lucky to have an ever-patient wife, who also produces my work. She will stand in the shot and we do that typical tourist thing of saying loudly, 'Let me get you in front of this beautiful café'. Little does the old lady with the silver hair and the lovely blue top, smoking a cigarette (page 98) know that my camera is pointing over my wife's shoulder at her. So, you signal your intentions to the subject that it's not going to be them you are photographing, avoid any eye contact and then at the last minute, using your peripheral vision, slightly change the angle and shoot. Even then, don't act like a paparazzo and run. I even nod my head and look at the picture I've taken as if to say, 'this is good'. It seems a basic trick when you think about it but it's very powerful and has allowed me to get shots of large men who might otherwise pummel me, as well as more timid and vulnerable subjects.

Having my wife stand in allows me the time and the confidence to set up the shot without having to snap it quickly, shooting from the hip.

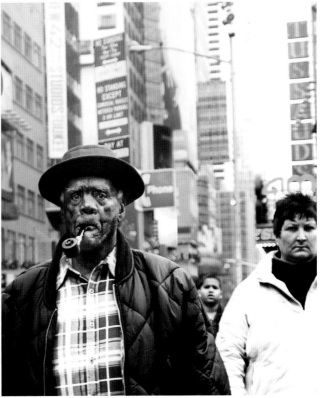

A lot of photographers do that and they will give you advice to practise setting infinity focus on your lens, opening it right up and shooting from the hip. That's great – it's good advice and by all means go for it, but my way allows more time to frame the shot and wait for the moment and, so far, I have not intimidated anyone, or been found out. We might draw attention to ourselves in a café or diner but not in such a way as to stop someone sipping his or her coffee or having a conversation. If I'm doing my job correctly, I will be interacting with my wife, telling her where to stand and so on and, by using a long lens, it looks as though I am photographing her rather than going slightly over her shoulder. After all, everyone has a camera these days and it's common practice to take a picture, especially if you look like a couple.

You can't depend on the husband/wife charade all the time but, even if you're on your own, you can look at something within range of your subject and almost French mime an interest in it, as though you really want to take a photo of it. Many photographers will try to be subtle, glancing around trying not to look obvious but actually looking sheepish and nervous. I stand there and confidently look at a window, making sure the lens isn't exactly on my subject so they are not alerted. The great thing is, you can take a photo of anything and nobody will suspect that they are your real subject, unless they're a celebrity. Why would you want to take a photograph of an old lady smoking a cigarette? Most people wouldn't consider it, which is what makes the subject unique.

GUILT-FREE PHOTOGRAPHY

My approach also avoids any feelings of guilt. You're not rushing in like a guilty paparazzo, snapping and crawling out. I think when you do street photography, or observational photography, you have to have a clear conscience. You can either feel like you're stealing a moment, or you can feel like you're complimenting a person in gathering and capturing the beauty of that moment. When you're straight out of photography school, it's usually the former. It's a kind of 'get it quickly before they see you' mentality. But that way you don't allow yourself into what I call 'the zone', which is when you feel completely part of the environment. You can blend in and wait for the person to give you what they do comfortably when they're not performing or intimidated by you.

When you get in the zone, you're not stealing anything, you're capturing the essence of a moment, as any good photographer will do. If you're feeling guilty then you're not being an artist. You're not sitting there sculpting and feeling. So if you can create a charade or something that allows you to position yourself, knowing you'll be there for a while and not signal your intentions, then you are using some artistry and skill.

≪ A refined, southern lady, photographed in an upmarket café in the French Quarter of New Orleans. I love the way she is smoking the cigarette in the most elegant way possible. I waited until a beautiful profile shot of her came about where everything told a story.
Canon EOS-1Ds Mark II, 80–200mm lens, 1/30 sec at f/8, ISO 200

⌃ I was not having a lot of luck on this particular day of shooting where I was trying to find interesting subjects in the American South, but then I happened upon a small town and immediately noticed this barber shop. It was a relic of the past that was art directed in a way that no Hollywood director could improve on.
Nikon D100, 24–35mm lens, 1/30 sec at f/2.8, ISO 100

TELLING A STORY

The technique and skill of shooting portraits unobserved is one thing, but there is more to producing quality work than that. The problem I see with street photography is that 80 or 90 per cent of it is someone shooting semi-blurred action moments, then converting them to black and white. They get caught up in the Cartier-Bresson idea that because it shows movement, is spontaneous and black and white, it is somehow 'artistic'. How often have you gone to an exhibition of photographs of homeless people? You look at the images altogether and go, 'Wow', because they are black and white and unposed and therefore reportage. I think, as a photographer, you have to steer away from that. Look at an image on its own merits and ask yourself if it's special. Is it just someone skipping over a puddle or does that puddle reflect something interesting? Is it telling you something about the subject? Is it aesthetically beautiful? Are all these things working in cohesion to make it different or is it just an urban moment that you are trying to make artistic?

For my portrait of the mature lady opposite, I went to a smart café in the French Quarter of New Orleans. She's a southern debutante from the old days of high society. She has big, perfectly moulded hair, long well-kept nails and obviously spends time on her make-up. She is pursing her lips to smoke very elegantly and you can see the rock on her finger. This is the essence of her. This wasn't just a grabbed shot; I waited for her to turn to give a profile that really tells the story. For me, this is as powerful a part of the content as the composition and lighting.

The performance and the storytelling is about waiting and having an expectation in mind of what you want, so you know when that trigger point occurs. You also need to keep an open mind and be ready for a spontaneous moment to erupt. Know when the time is right, don't just shoot sporadically.

TIP

❝ Digital cameras are very useful for street photography because you can change the ISO to suit the lighting. Always review your images instantly so that you know when you have got your shot and can move on without the risk of being found out. Although planning can help you use your time effectively, carry your camera wherever you go because you never know what you might find. ❞

Matt Hoyle

POSED PORTRAITS

If you find, by research or pure chance, a hive of wonderful people, or even just one, and you feel that the unguarded moment is not going to give you a good enough shot, or you think the person is so powerful that you must approach them, then you must make that decision. By doing so, you're running the risk of them saying no and it's a time when you have to have your wits about you and be skilled in dealing with people. This is something that I don't think they teach enough on any photography course: just like a being a teacher, you can be knowledgeable and academic but if you're not good with people, you're going to be terrible at your job.

With my posed portrait shots, I want to take the viewer somewhere that being a fly-on-the-wall, however observant, cannot take them. I want to tap my subject on the shoulder and say, 'Hey, talk to me, relate to me. Let our personalities meet for one moment and let me see the essence of you.' In doing this, eye contact is paramount and you're not going to get eye contact without getting their attention.

The first way to do this is to clear your conscience. As with the candid approach previously discussed, this is so important. You can make up a story to tell your subject, perhaps that you are working on an article on something, or flatter them in some way. I've done it myself but now I would advise against it because I've felt guilty afterwards. In fact, I can't bring myself to recall some of the stories I've told. Some photographers will think, 'Screw that, I'll do it if I'm going to get the shot'. If they can do that and still get an amazing shot, more power to them, it's not like they're killing anyone. But a photographer who claims to capture an essence of someone needs to take pride in the fact that they have evoked something from that person and have not misled them.

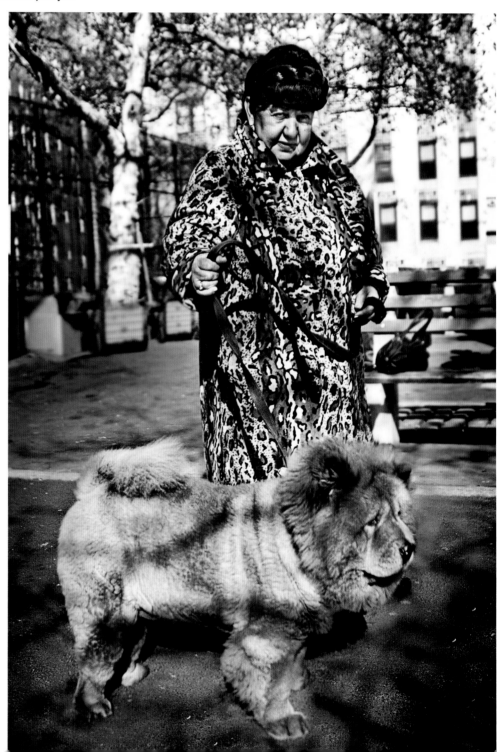

This shot was taken in Little Odessa in ≫ New York where this Russian lady was walking around with her dog. You know how some owners look like their pets? Dogs can make a great ice breaker because you can say, truthfully, how great they look.
Canon EOS-1Ds Mark II, 24–35mm lens, 1/30 sec at f/8, ISO 100

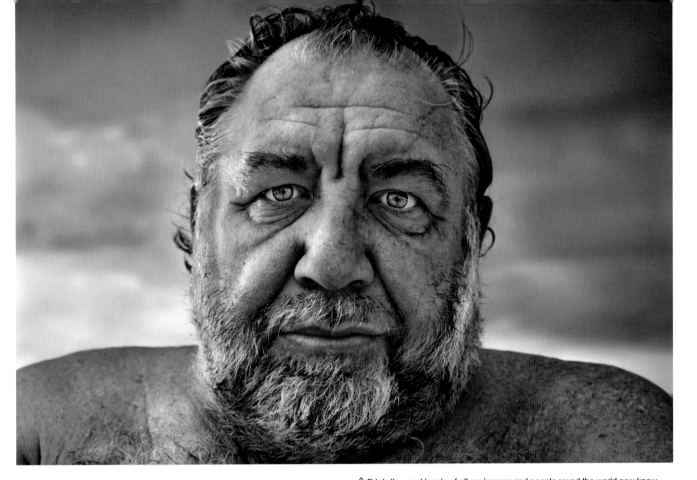

APPROACHING THE SUBJECT

Being honest about your motive and intentions is usually the best approach. Going up to someone and saying, 'You'll probably be surprised by this but I find you fascinating and I would like to take your picture,' has had more success for me than not. They are flattered and surprised but they don't think you're lying because what would be the point? Why would you take a photo of them?

If they say no, at least you tried and it's not the end of the world. It's a risk worth taking because more often than not they'll agree. It is better than nervously lying to them, asking for a quick photo, or giving them no explanation at all. So often people go on holiday, see an interesting character and shoot them just where they are, hoping that getting a nervous shot is good enough. You may go to India, see a snake charmer who doesn't speak English, signal to your camera and quickly snap him. 'Wow!' you think, 'I've got a snake charmer; that's very special for where I live.' Yes, it's a great subject but the market environment he was in was too cluttered and complicated. You went 80 per cent of the way there but how much better could it have been if you had asked properly? Don't take 30 seconds, take three minutes. If you're doing tourist shots, have money at the ready. How much is it worth to you to get an award-winning shot that's going to help you get a job?

⌃ This is the most iconic of all my images and people round the world now know John from the exhibition series I did of members of the Bondi Icebergs Club in Sydney, Australia. It was one of the first images that I shot as a professional and embodies everything that I try to do to this day – to get an interesting subject with a story in good light with a nice background.
Canon EOS-1Ds Mark II, 24–35mm lens, 1/30 sec at f/8, ISO 100

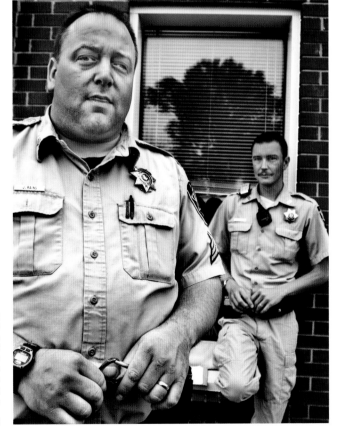

TIP

❝ When someone has given you their time for a few minutes, show your appreciation. Sometimes you can't offer money, but you can show them the photo you have taken and offer to send a nicely printed copy. Where would you be without them? ❞

There is a fine line between making ≫ fun of your subject and having fun with an image. These two police officers are typical deputies from cult cop shows like *The Dukes of Hazard*; a large one and a smaller one. They look almost like a comedy team and I was lucky to get this shot. Part of the humour is that they are so serious – they have a 'don't mess with me' kind of look.
Canon EOS-1Ds Mark II, 24–35mm lens, 1/30 sec at f/8, ISO 100

Matt Hoyle

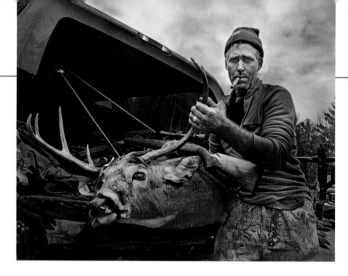

If your subject agrees to be photographed, you can set things up properly. Quickly scan the area, looking for a place you can take them. It's just like any great editorial photographer will do if they've got a celebrity for only 15 minutes. Find a simple, graphic background – a brick wall, a concrete stucco wall, a blue sky. It could be a nondescript textured pattern to complement their eye colour, their shirt or the texture of their skin – something that simple. Otherwise, find a scene that tells a story that, again, is very simple. Find it, take the person there and you're going to get a much better shot. I'm not suggesting a two-hour trip in your car, but look around and there will be something there you can use.

With street photography, posed or not, you can easily cross the fine line and make fun of your subjects. I run that risk myself but hopefully stay on the right side. I want to give my subjects dignity and show that they're proud of themselves. In my 'Iceberg' series, some of the characters have missing teeth, freckles or wrinkles, but I am celebrating them in the most beautiful light. I would say don't take photos of homeless people, ugly people or the elderly to try to poke fun at them. There are some easy cheap shots that you should stay away from if you want to be a good photographer. If you want to stand out, try to get something that shows a higher degree of difficulty and is more thoughtful.

If you want your photographs to be liked, editorially or artistically in a gallery, they have to capture the essence of something about your personality to say, 'Hey, look what I've observed in society.' There also has to be commonality and human sensitivity about what you are seeing that touches other people besides yourself. In that respect, you have to be a barometer for society.

⌄ Some people are a little 'heavy duty' and you need to use your skill to get their permission, otherwise they're going to kill you. This is a member of the Banditos, the toughest biker gang in the world, in front of a biker bar. The pose and the camera angle make him look commanding and the red bandana links with the sign on the door and badges on his jacket.
Canon EOS-1Ds Mark II, 24–35mm lens, 1/30 sec at f/8, ISO 100

⌃ This character is so serious as he's holding a dead animal in his hands with a phallic cigar in his mouth, as if to say, 'Look at me – I'm a mighty hunter.' The dead animal, large enough to be human, is hideous and the proud look of the hunter is very American. It captured a statement I wanted to make – on the one hand a proud shot for the hunter to hang on his wall but on the other hand revealing the pathetic act of killing such a large beast and holding it in front of you as a trophy.
Canon EOS-1Ds Mark II, 24–35mm lens, 1/30 sec at f/8, ISO 100

TIP

❝ Photographing people is not only about waiting for a moment but also how to frame to tell the story. Frame wide to make someone seem lonely; go in tight or shoot upwards to make them look powerful. ❞

I had to pay this pimp a little ≫ money, naturally, and he was fine. The colours here harmonize with the background. You don't need to use such a long lens when your subjects are aware of the camera; a 35–50mm is fine.
Canon EOS-1Ds Mark II, 24–35mm lens, 1/30 sec at f/8, ISO 100

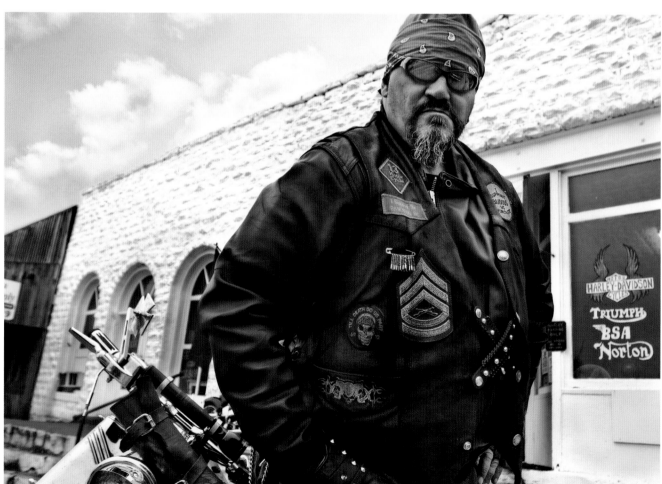

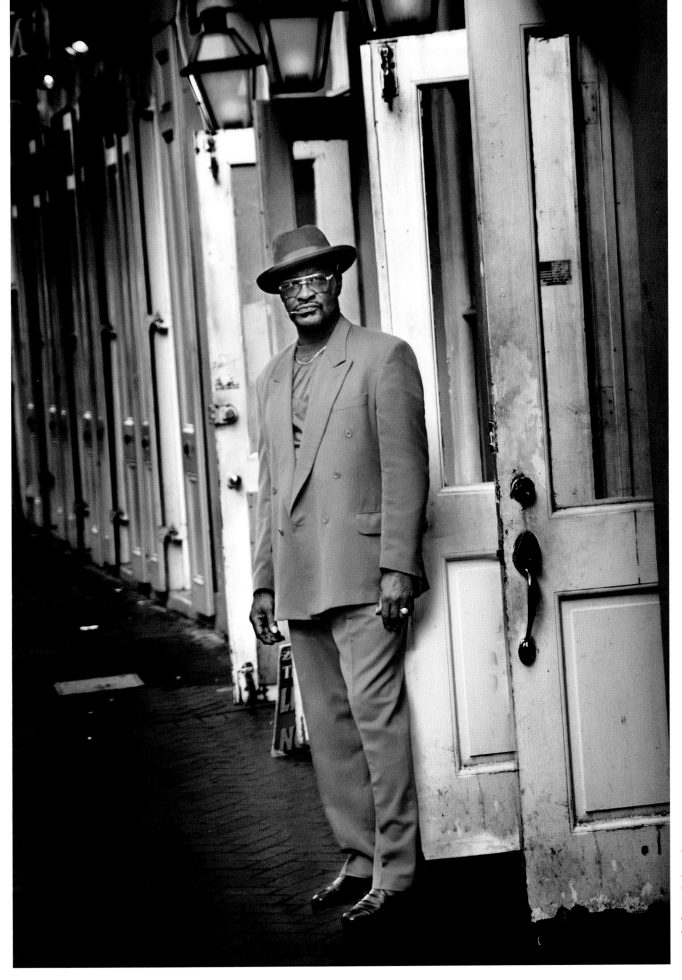

OUTDOOR LIGHTING

For outdoor photography, unless you particularly want the harsh shadows of midday sun, go for what photographers call 'the magic hour', which is either at sunrise or sunset, when the sun is at its lowest, creating deep colours and long shadows of buildings and trees. Both times of day have a different quality of light so find out which you prefer. If you do decide to shoot at midday, or if that is the only time you will find your subjects, avoid a totally open area like the middle of a field or beach. Shoot somewhere where there is some sort of shade or cover so that the light on the subject is reflected and therefore much softer than harsh, direct sunlight.

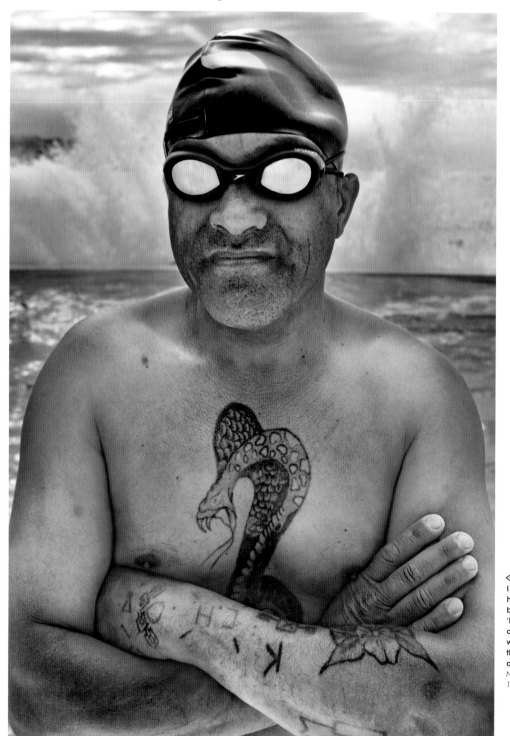

TIP

" If you have a boring sky, the alternative to using flash on the subject and underexposing the sky is to change the sky for a more interesting one in Photoshop, which is a fairly simple copy-and-paste technique. Build up a library of interesting skies to use for this purpose. "

« This is Charlie, a former gang member. I wanted to capture his tattoos and his tough façade against a harsher background than for most of my other 'Iceberg' shots, so I timed it to include the crashing waves. The early morning sun was my key light with the white walls of the swimming pool in front of him acting as giant reflectors.
Nikon D100, 24–35mm lens, 1/125 sec at f/11, ISO 100

For my 'Iceberg' series, the swimmers gathered at the Bondi Iceberg Club very early on Sunday mornings during the Australian winter. This suited my photography perfectly, as it gave me a lovely soft light and dramatic shadows in the background. I didn't need to use any artificial light at all for these portraits because the white walls of the sides of the swimming pool provided ideal, ready-made reflectors to bounce light on to the subjects' faces and torsos.

ADDING FLASH

Sometimes you may want to add artificial lights to achieve a certain type of look. For some of my outdoor environmental portraits, for example, I use the same lighting set-up as for the indoor shots of the fighters on pages 92–95, that is Speedlite flashguns with umbrellas, on portable stands. One is the key light on the subject, with the other one, 2 or 3 stops down, as a fill. Or I will just have the one key light with ambient light filling in the shadows. To darken the sky, I underexpose the background 1 or 2 stops below the subject. It is not an original technique but can be effective in giving a deeper contrast in a pale sky or the clouds, which creates a better dynamic in the picture and frames the subject effectively.

It is important, however, not to become caught up in using so much equipment that you lose the spontaneity and passion of the moment. Digital photography is gadgetry at its finest and you can spend a lot of money – as I have done – buying gadgets that you'll never use, or you try to justify and end up over-complicating a shot.

Only use the equipment that is absolutely necessary to achieve the effect you want. This may be just a silver reflector to reflect a soft light on to the face rather than a battery pack, umbrella, flash and wireless trigger. Or you could use a single flash on-camera, turning it on its side to bounce off a wall. Generally, artificial lighting should only be used to emulate natural light so carefully consider what is already there before trying to improve on it.

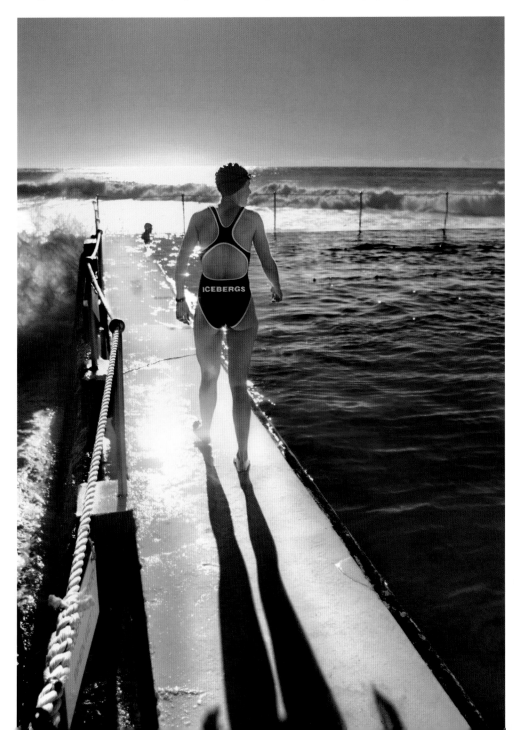

≪ The early morning winter's sun on the horizon brought a beautiful warm hue to the sky. The long, soft shadows are a wonderful feature of this time of day and I pulled back here to include the woman's shadow as an important part of the composition.
Nikon D100, 24–35mm lens, 1/125 sec at f/11, ISO 100

Matt Hoyle

⌃ This was part of the 'Encounter' series of photographs that I produced as a book. It was about people who had seen monsters, UFOs and ghosts. This lady had seen a UFO in the field and I wanted a dramatic but simple environment. I shot at sunset with one key light, my Canon 580EX Speedlite flash, on the subject. The background was underexposed to darken the sky and emphasize the clouds, which helps create the mood.
Canon EOS-1Ds Mark II, 24–35mm lens, 1/30 sec at f/8, ISO 100

EXPOSURE

The beauty of digital photography is that you can learn how to achieve the correct exposure without using a meter. I never use a light meter on professional shoots, often to the surprise of assistants. I tell them that there is no point wasting time when shooting digitally. If I am shooting a portrait with two lights, I will start at 1/125 sec at f/8 or f/11, to get enough of the subject in focus. The fill light will be 2 or 3 stops down on the main light. Generally the ratio will be the same, unless you want to change it for creative reasons.

You need to know where you are going to shoot and what you are going to be shooting and start off with an exposure that technically works for that. In natural light outdoors, for example, you could begin with a shutter speed of 1/30 sec with the aperture as open as possible while keeping the face sharply focused – f/4 to f/5.6. Take the picture, look at the histogram and understand that all those squiggly lines need to go inside the box. If they are touching the sides, you need to make the image lighter or darker and for that you have the aperture and shutter speed controls. If it's too dark, either open up the aperture or make the shutter speed slower. If you don't want to go down to 1/15 sec, perhaps you can compensate by using a reflector or positioning your subject near a reflective surface. It really is as simple as that.

Make the most of the immediate feedback from your digital camera – this is what it does best. Walk around, taking shots in various lighting conditions and learn what the ideal exposure is in a café, or on a street at the middle or end of the day. What do you need for a night scene? You can take a million experimental shots without them costing you anything and, as the digital camera records the exposure information, they can teach you valuable lessons. Don't get caught up with sepia tones or anything like that until you have mastered the basic art of getting the correct exposure.

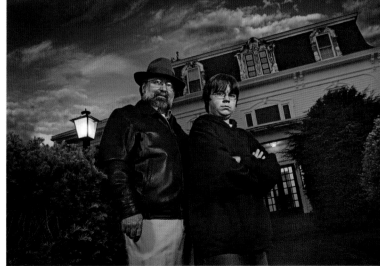

Another image from the 'Encounter' series, this father and son are standing ≫ outside their haunted house. I tilted the camera, lining up the background so the light on the left was just below the shoulder of the man and his hat and shoulder were outlined by the sky. The lighting on the subjects came from two Canon 580EX Speedlites with umbrellas. The key light was above and to the left of them with the fill light shining up from below.
Canon EOS-1Ds Mark II, 24–35mm lens, 1/30 sec at f/8, ISO 100

THE WIDER ENVIRONMENT

There are two types of environmental portraiture that I do, the close-up, where only part of the person's body is seen, and the wider shot where the person becomes almost part of the landscape, be it urban or natural. For the latter, I like to have the subject interacting with the background, perhaps walking into it or across it.

⩗ This shot was taken very early in the morning during winter in Australia. It was a very low-contrast day with morning mist in the air. The man was going out for a swim and I shot a whole sequence of him as he was walking. In post-production, I enhanced what was there, making it even less contrasty to play on the mist. There was a very soft light and I took away any other light and colour, to leave just this pastel blue light.
Nikon D100, 24–35mm lens, 1/125 sec at f/11, ISO 100

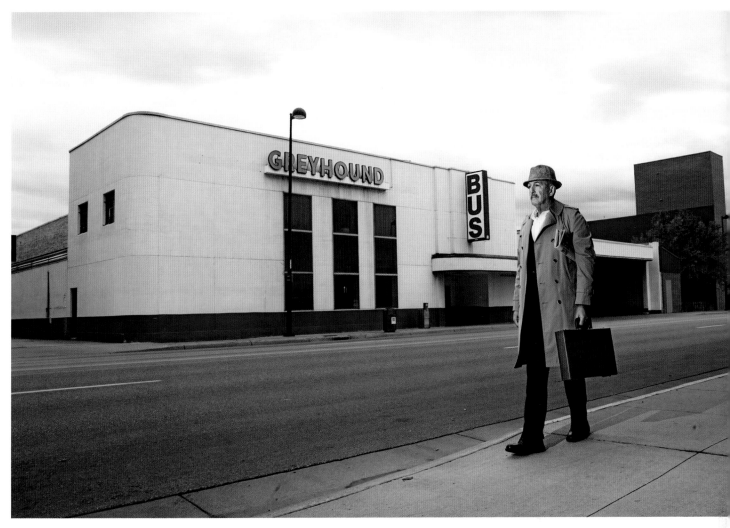

⌃ Shooting at a slight angle upwards, the man's hat and right shoulder are silhouetted against the sky with the horizon line on the right just below his shoulder. He is placed in the right third with the lines of the road and building leading the viewer's eye towards him.
Canon EOS-1Ds Mark II, 24–35mm lens, 1/30 sec at f/8, ISO 100

If you are going to pull back a little bit, there has to be a reason for doing so. The background is not just there to be pretty, it has to do a job. For me, that is to give the subject a context, or to tell a story, no matter how subtle or symbolic. There is a temptation when shooting street photography to think that just because the environment has a foreign or romantic nature the picture will be good enough. A Parisian market or a Spanish bullfight arena may be exciting to you but will not make a successful photograph by itself. With portraiture, you are always trying to capture the essence of someone or their life that nobody else could.

I often place the subject on a 'third' in the image, whether from left to right or top to bottom, especially if there is nothing in the background to compete with the person. The horizon line usually falls somewhere around their shoulders, or sometimes the neck or head, to give a silhouette line around that part of them. The key focus is always on the face and eyes. I shoot at a slight angle upwards because it helps to give the person dignity and as I lower the camera, the environment goes a little higher relative to them.

Sometimes the utmost simplicity is required from the composition, as with the swimmer in the mist (opposite). When there is more going on in the scene, or if architecture is included, lines and angles can be used to add dynamism or perhaps to lead the eye of the viewer into the image and towards the subject. I'm not a fan of pure symmetry in a shot unless it is used for effect in a close-up portrait where the background is either totally plain or obviously lends itself to symmetry. I think a little 'fight' in an image creates interest, as long as harmony is achieved elsewhere, through light or colour.

TIP

❝ When shooting a portrait in a wider environment, it's easy to get carried away with the view and lose your subject within it. The key is to make sure that your subject is the central point of focus to ensure that the personality or essence of the person doesn't get lost in the landscape, which would defeat the purpose of the portrait. ❞

Matt Hoyle

POST-PRODUCTION: CONTRAST, COLOUR AND FOCUS

Post-production is as important to me as lighting and location. With the technology available today it seems logical that I use it to the best of my talents to create my vision. Photoshop is second nature to me now, as much as pressing a shutter. I try to bring out the character of my subject as much as I can, through contrast, colour and focus using the following method in Photoshop.

BEFORE

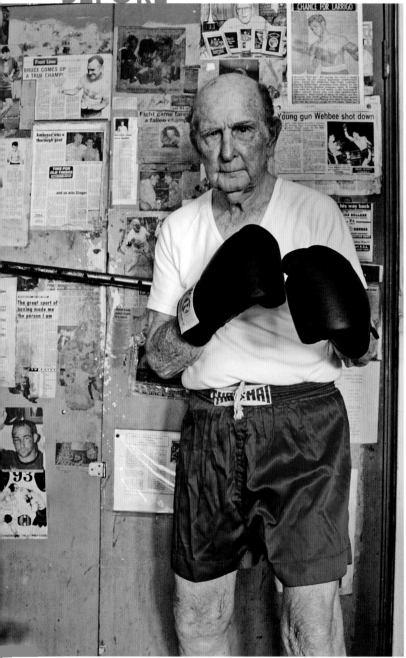

ONE

TWO

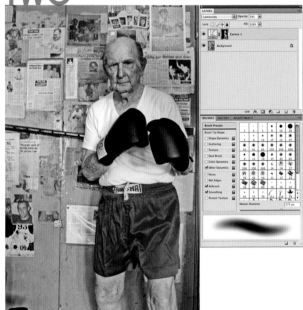

⚐ This shot is from my 'Fighters' series, taken in an old gym, and shows former boxer Steve against yellowing newspaper cuttings of boxers' glories.

THREE

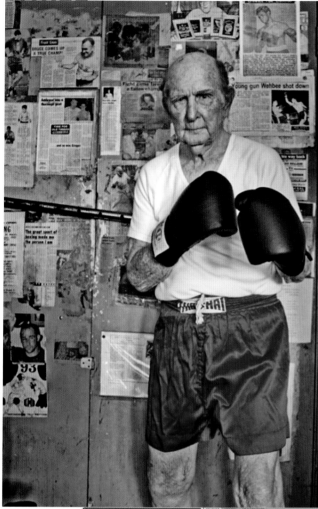

FOUR

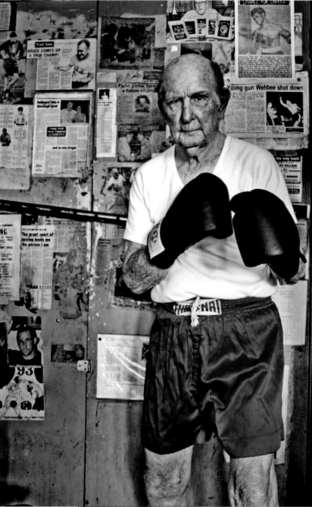

EXPOSURE AND CONTRAST

- Import the image into Photoshop, making sure it is the largest file possible, and save it as a .psd file.
- Look at the image and see what areas need to be fixed. You should make a habit of not manipulating things just for the sake of stylizing them – always have a reason for everything you do. Firstly, the exposure needs fixing as the image is looking a little flat (picture 1).
- Begin with a Curves Layer Mask, simply using the Layer Mask drop-down menu at the bottom of the Layers palette. Select Curves then in the dialog box adjust the curve to suit how light or dark you want to make the picture. Next, fill the Layer Mask with black using Fill. Select white as the Foreground Color and begin to paint the areas you want to be revealed through the mask. In this case I made the overexposed areas on the subject a little darker (picture 2).

- Then correct the exposure for the background. In this example, it needs to be darker so again use the Curves Layer Mask and paint in the areas that you want darker. This gives the subject more 'pop' through the background (picture 3).
- Next, use a Brightness/Contrast Layer Mask to give the image even more punch. If, as here, you do this to the overall image, there is no need to add black to the mask and paint certain aspects of it back in. I sometimes use a Black and White Layer Mask and utilize its individual channels to make each colour more contrasty. When you have finished with the Black and White Layer Mask, click OK. This, of course, leaves you with a black-and-white image, so use the drop-down menu at the top of the Layers palette and select Soft Light. This will change it back to colour and give you a more contrasty image (picture 4).

Matt Hoyle

FIVE

SIX

SATURATION AND SHARPENING

- After adjusting the exposure and tweaking the contrast, finally reduce the saturation (Image> Adjustments> Hue/Saturation) to give the image an older feel (picture 5). I don't always do this of course but I do tend to favour more desaturated palettes.
- Lastly, sharpen certain areas of the image to give it added impact. Rather than use Unsharp Mask, merge all the layers together on to a new layer by pressing Shift-Alt-Command and, while these keys are held down, press N followed by E. You will then have merged all your previous layers into one layer. Then go to Filters> Other> High Pass. Select about 6 to 10. You will now see a grey image. Go to the drop-down menu at the top of the Layers palette and select Soft Light. Now go to the bottom of the Layers palette to the Mask icon (a square with a circle in it). Click it and it will give your High Pass layer a mask. Repeat what you did in the previous Layer Masks and fill it with black. Now paint with white all the areas you want sharper (picture 6).
- I sometimes create a mask that separates my subject from the background. I then go to the Color Balance Layer Mask, which is in the same drop-down menu at the bottom of the Layers palette. I manipulate the colours to tone the background to a colour that is complementary to my subject's skin, eyes or even something they are wearing. As this shot already had a nice sepia-washed texture with the newsprint, I didn't have to do this final step.

TIPS TO REMEMBER

Masking
This is a simple and effective technique that gives you full control.
- First, create a Layer Mask and make a change to that layer. Perhaps brighten it with Curves.
- On that Curves Layer Mask, which should look white now, fill it with black.
- Go to the paintbrush, make it soft and select white.
- Begin painting right on to your image (while the Curves Layer Mask is selected) and the white will reveal the changes you made earlier. You're essentially painting in the changes.

Filters
People are fairly fed up with plastic images. Photoshop can get a bad name from the over manipulation of people's faces. There are so many bad filters out there that make overall changes to your image where you lack control. Stick to the basics.

Focus
I try to get everything crisp in camera, then double the layer in Photoshop and blur that layer with a camera blur. Then again using masks, I hand paint in the areas I want to be out of focus. I also use the masks I've already made of my subject. This may not be for everyone, some may want to get this on the day but by getting a crisp RAW image, I can easily have full control over depth of field after the shoot.

Tablets
A Wacom, or similar, is great for getting a natural flow to your manipulations in Photoshop. I used to be awkward with it but now it is second nature and my post-production is much faster.

After a simple process to improve »
the exposure and boost the contrast,
the finished image packs much more
of a punch.

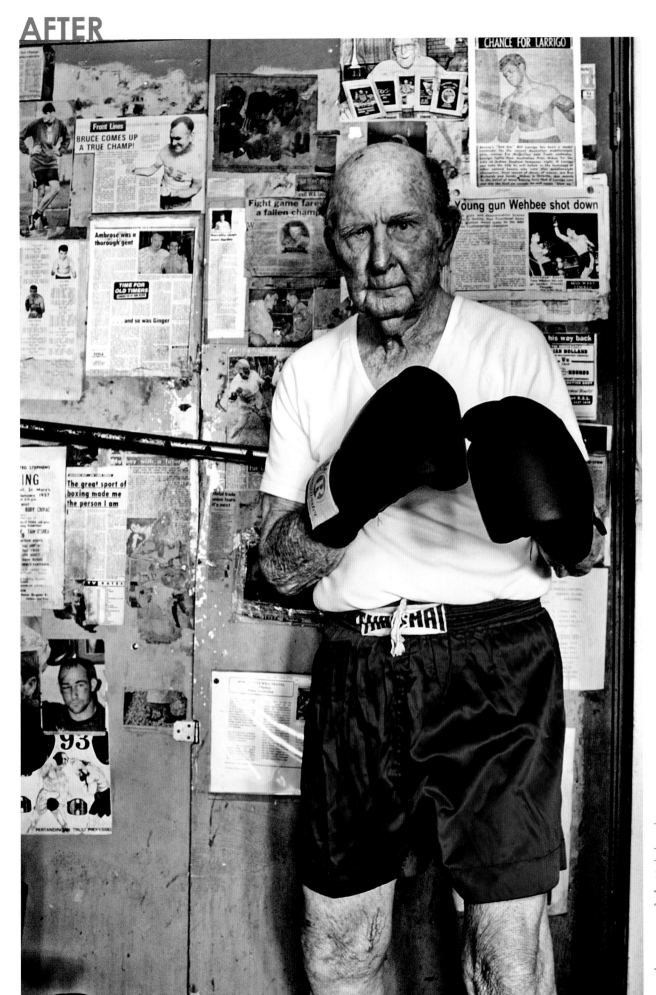

CHAPTER 5: WEDDING PORTRAITS
Mark Cleghorn

For many people, a wedding is the only time in their lives that they commission portraiture. Wedding photography is portrait photography at the gallop. Instead of photographing just a handful of people in a day, you can be faced with 120 and combining close-ups with wide-angles, group shots and individuals, candids and posed portraits, inside and out. As well as great people skills, sound camera skills are a crucial foundation.

Digital technology has driven creative advancements in wedding photography. Without the cost of processing, there is the incentive to experiment with lenses, lighting and angles to introduce great variety into your work.

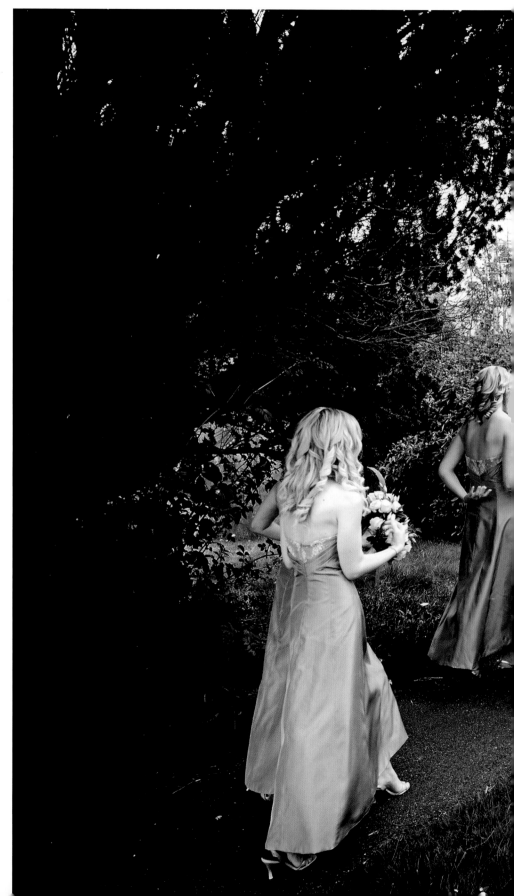

This was a candid shot of the wedding ≫ procession, captured with a wide-angle lens. Stepping back allows you to show the 'stage' and black and white is a perfect medium for this. After this shot, I ran ahead and caught them coming towards me.
Canon EOS 5D, 24–105mm lens, 1/250 sec at f/5, ISO 100

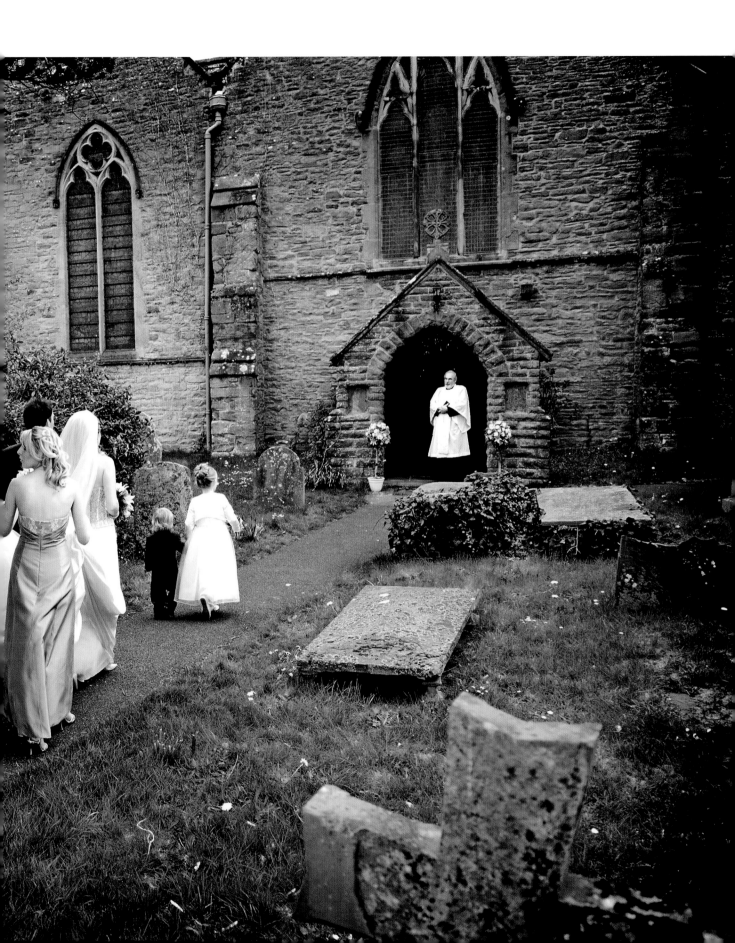

PREPARATION

Just like when you're painting and decorating, careful preparation leads to a better end result. It begins for me six weeks before the wedding when I have a meeting with the couple to chat about what they want from me on the day. It's really important that I get to know them and establish their likes and dislikes so I ask them to bring along cuttings from bridal magazines that reflect these and I show them albums that include different styles of photography. A little bit of psychology is required because they will often pick out a photo they don't like and yet another, very similar shot appeals to them. There is a certain amount of reading between the lines. I also need to know if they are a 'lovey-dovey' kind of couple or not. Some people are very demonstrative in their feelings for each other but others are more reserved and I need to keep the poses within the boundaries of what they feel comfortable with.

It's vital that the couple will feel really happy that they look their best in the images, so I get straight to the point and ask them if there is anything they don't like about their appearance. If they have an issue with their weight or certain facial features – and it's often the prettier ones who do – it's a help to know that so I can minimize or enhance certain aspects with the poses and the lighting.

During the meeting we discuss locations and timings so I can be sure to allocate enough time to different aspects of the day, such as going to the bride's house, time alone with the couple and the group shots. They also tell me any special people that they want to be photographed, which takes a lot of pressure off the day. All this enables me to plan the equipment I will need. If it's a winter wedding in the afternoon, I know

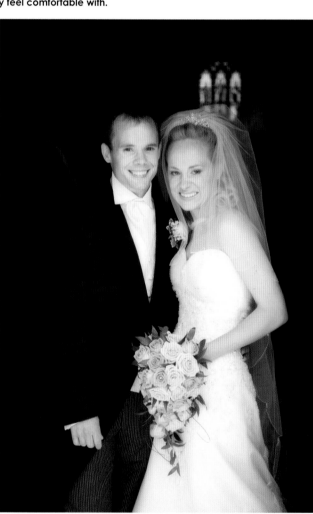

≪ The couple at the main door of the church just after the wedding is a best-selling shot with members of both families. An archway to the entrance subtracted light from above, allowing some detail in the background to come through. In full sunlight, more exposure would have burnt-out the top of the bride's head and lost detail.
Canon EOS 5D, 24–105mm lens, 1/60 sec at f/4, ISO 100

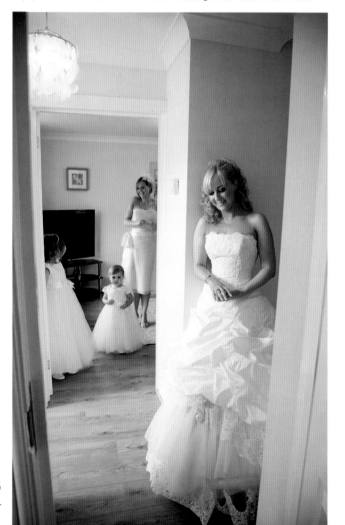

≪ If you have an agreement to photograph the bride getting ready it helps to set the scene and tell the story. Maintain a discreet presence, use a wide-angle lens if space is tight and make the most of window light as it will be much more atmospheric than flash. Use a higher ISO on the camera if necessary.
Canon EOS 5D, 24–105mm lens, 1/60 sec at f/4, ISO 400

that I will need flash gear and a tripod for slow exposures; if the location will be restricted in space I will need a wide-angle lens; and if they want some creative images, I might want to take an extreme wide-angle or an extreme close-up lens. Sometimes they want me to stay for the speeches, in which case I will take a laptop so that I can download and edit my images during their meal.

EQUIPMENT CHECKS

The day before the wedding, I make sure that everything is in order:

- the camera batteries are charged – one charge will last a couple of weddings but I always have a spare
- the Quantum rechargeable battery packs are charged
- the cameras' CCD sensors are clean – if not, vacuum with Green Clean, a pressurized air canister that sucks rather than blows
- the memory cards are formatted – I will shoot around 10–12 gigabytes of RAW files in a day, so take 16–18 gigabytes of two and four gigabyte cards with me
- the correct lenses are on the camera bodies – leaving them attached helps keep the CCD clean. I have a 24–105mm lens on one camera and a 70–200mm lens on another. A spare bag in the car contains another camera body and 28–70mm lens, memory cards and flash. This is insurance in case my main bag is stolen on the day.
- all the required accessories, such as diffusion screens and radio triggers for the Speedlite flash, are packed.

MUST-HAVE WEDDING SHOTS

Whatever the style of wedding you shoot, reportage or more formal, small or large, there are certain shots that you should always aim to have included by the end of the day:

- details such as shoes, flowers, table decorations and rings
- scene-setting shots of the church, locations, the bride getting ready etc.
- the bride and groom full-length, three-quarter length and close-up, taken at various times during the day
- the back of the bride's dress
- special people – as requested by the bride and groom
- candids of all the major players

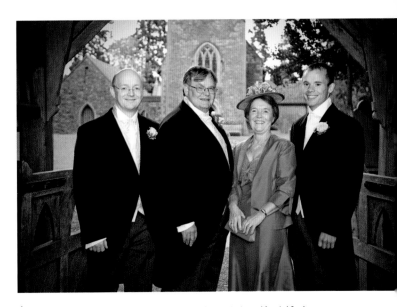

⌃ The groom with special people – his brother and parents. I used frontal flash on-camera using the catchlight card to bounce light on to their faces. The canopy of the lynch gate removed overhead lighting and also kept them out of the rain!
Canon EOS 5D, 24–105mm lens, 1/60 sec at f/4.5, ISO 400

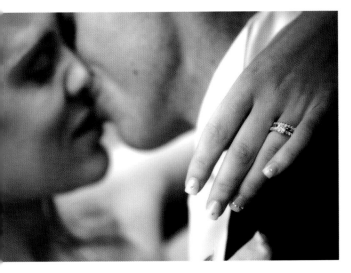

⌃ This was a simple way to show the detail of the bride's rings and fingernails. I asked the bride to put her hand round the groom's neck and the kiss is a nice interaction between them. With a long lens and an aperture of f/4, the focus drops instantly.
Canon EOS 5D, 70–200mm lens, 1/125 sec at f/4, ISO 100

This captures a candid moment and shows details of the hair, the flowers and the ≫ backs of the dresses. Because of the black interior and the bright dress, accurate exposure was essential to avoid overexposure with burn-out on the shoulders.
Canon EOS 5D, 24–105mm lens, 1/125 sec at f/4, ISO 100

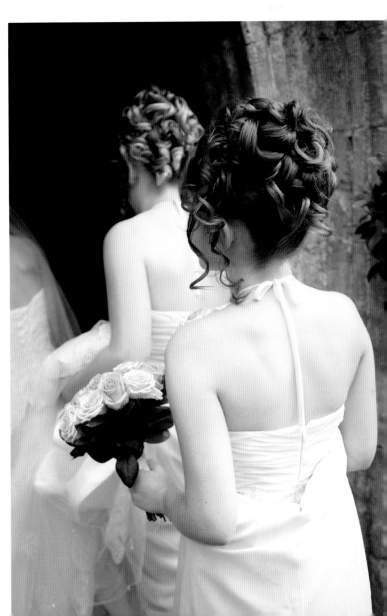

REPORTAGE

With reportage, the principle skills are being in the right place at the right time, which means being able to anticipate events, movements and even small gestures. Where is the bride? Is she near a window that will provide nice light? Is she chatting with friends and likely to show them her ring? Aim to capture the natural animation of people, their expressions and the general ambience. Sometimes, this happens easily when the couple and their guests are relaxed and outgoing. Others are quieter and more nervous, which certainly makes it harder to take great pictures.

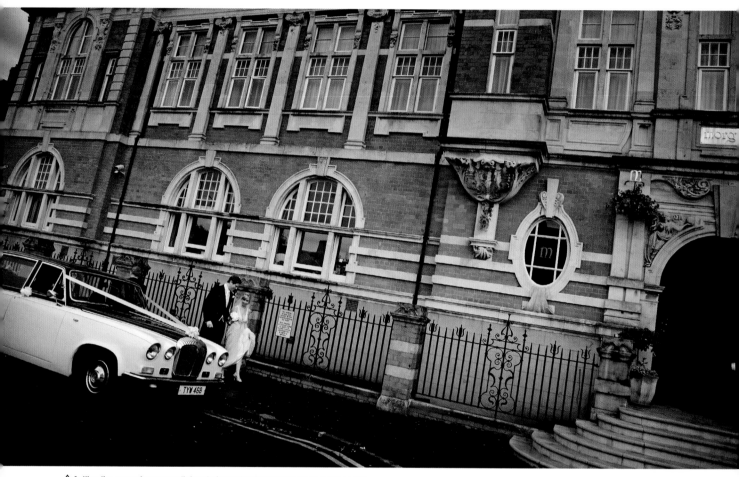

⚐ Setting the scene is an essential part of reportage photography as it gives scale as well as mood, just like a writer does in a story.
Canon EOS 5D, 24–105mm lens, 1/500 sec at f/4, ISO 100

The bigger the part that reportage will play in the album, the bigger the worry that you will miss something important, as you will not have the set-up shots of the main family members to fall back on. Digital photography allows you to shoot virtually continuously without worrying about film costs or changing the roll, but there is a danger that a machine-gun approach will produce a lot of rubbish. Use your eyes and watch how people gravitate together forming groups for you to shoot. Straight after the wedding, for example, the most important people will often congregate to offer congratulations – seize the moment!

Ensuring that you have three or four shots each of the best man, bridesmaids and ushers is important but getting variety in your images is also essential. Think of it like making a movie, where you have close-up details, wide-angles and medium-range shots that build up and work together to tell a story. Using two cameras – one with, say, a 24–105mm lens and one with a 70–200mm lens – and swapping between them will allow you to get up close or move further away as necessary. A 12–24mm wide-angle lens will allow a whole new perspective and show a much bigger picture.

⌃ A long lens is an easy way to throw people out of focus, which can dramatically help the framing of an image.
Canon EOS 5D, 70–200mm lens, 1/60 sec at f/2.8, ISO 400

There are always two or three characters at a wedding that are larger than life and natural to photograph but be careful they don't dominate the images. Also, I love the chocolate-box factor of a cute kid and it may provide you with lots of reprint orders. Remember, if you are in this as a business, there is no point taking masses of pictures of someone that nobody is going to buy.

LIGHTING

Reportage shots are much easier to take outside in natural light but to limit yourself only to outdoor shots would be to miss many opportunities before the wedding and at the reception afterwards. As the whole point of reportage is to go unnoticed, flash is best avoided as it's like having a big sign on your head saying 'photographer'. The alternative is to use the ambient light wherever possible, choosing wide apertures and higher ISO speeds. One of the great advantages of shooting digitally is the ability to change the ISO from frame to frame.

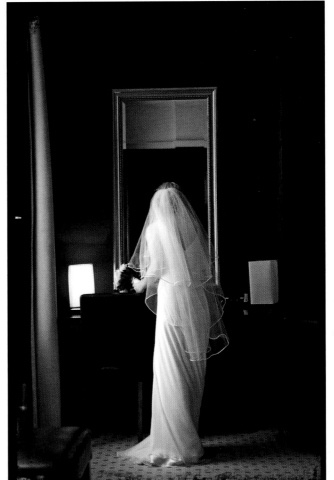

 TIP

❝ Choosing a theme for the day is a great way of developing an individual style, as well as giving you a focus and a goal. Hats, shoes and bags are ideas that work well and will make quirky additional shots running through the album. ❞

A large window near to the subject ≫ allows light to flood into a room, as well as illuminating the scene. If there is a mirror in front of you, watch out for your own reflection.
Canon EOS 5D, 24–105mm lens, 1/60 sec at f/2.8, ISO 400

Mark Cleghorn

119

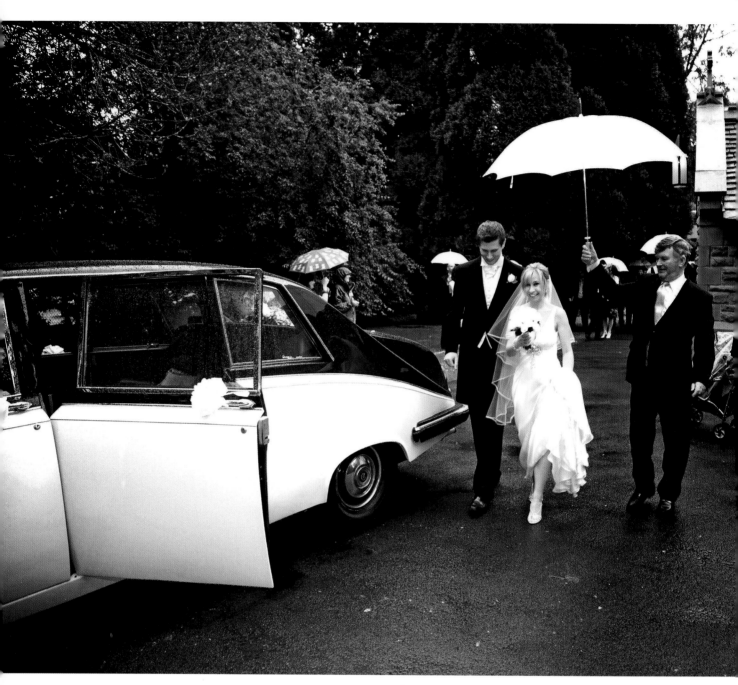

Whether you're shooting indoors or out, the exposure must be right. Do not assume that the photo will be exposed correctly just because it looks good on the LCD screen – it is not an accurate indicator. I always use a hand-held meter and would recommend this practice. You don't have to take a reading for every shot but, unless the sun is going in and out of cloud, only around six readings for the whole day – in the sun, the shade, inside the church and the reception venue.

If you don't have a hand-held meter, or you want to check that yours is working properly, you can check exposures with the histogram on the back of the camera. This reveals the distribution of tones, shown on a graph by the number of pixels falling into each level of brightness. These tones should be centered or slightly biased towards the right side of the histogram, the highlights. If they are spilling over on the left side, this indicates underexposure wend on the right side, overexposure.

∧ **Try to get a groomsman or the best man to carry the umbrella, especially if the driver is, how do I say, unphotogenic! Be prepared to get wet if you are shooting weddings as nothing stops for rain. The timings of the day will need to be adhered to no matter what.**
Canon EOS 5D, 12–24mm lens, 1/125 sec at f/4, ISO 100

Storytelling is the secret to reportage so try to predict the moment but avoid ≫ any embarrassing images, especially of the bride.
Canon EOS 5D, 24–105mm lens, 1/60 sec at f/4, ISO 400

DIRECTING POSES

While the current trend for wedding photography is for a much greater degree of informality than in the past, many photographers and their clients will still opt for a number of more classical images that need to be set up and posed properly. Every bride wants to look like a princess on her wedding day, whether she's 17 or 70, and the aim with these shots is to make her look perfect. She will have spent a lot of time getting her outfit together so you need to make sure that you arrange the pose to make her look slim and elegant and to show the dress at its best. Naturally, the groom doesn't want to let the side down so his importance should not be underestimated either.

The bridal images are taken several times during the course of the day, perhaps beginning at her home, then as soon as she arrives at the church and again as she comes out of the church. The bride and groom together are usually photographed at a location between the church and the reception, or it will be the first thing you do when they arrive at the reception.

THE BRIDE

All the posing starts with the feet. Most of the weight is put on to the back foot with the front foot to the side to provide balance and to give shape. As with general portraiture, the idea is to turn the body at a slight angle, which narrows down the profile and has a slimming effect.

Aim to take full-length, three-quarter length, close-ups and some scenic shots where you shoot from more of a distance in a location that you've chosen. This will more or less cover you, then you can expand on that with her looking towards the camera, looking towards the light source and down towards the ground. The light will also play a part. If it's dappled, for example, and not as good on her face as you would like, the trick is to ask her to look off-camera, perhaps towards her husband.

For seated poses, you don't want the client to sit flat on their bottom. Easing the weight slightly on to one cheek or the other will add a little more elegance and animation to the pose. It's usually down to the bride if she crosses her legs, some do and some don't. If she does, then you can ask her to lean towards her knees.

Props are very useful to help elaborate the pose. It could be a bench, a wall or an old stone bridge; these are all the kind of locations you're going to find yourself in as a photographer. I would try to avoid a park unless it has a prop in it, otherwise it's just another tree. Realistically, there's only so much you can physically do in the middle of a park with a tree (or no tree) and a full-length position, so that's when you need the groom to animate the bride. In this situation, he becomes a prop or a mannequin to allow you to exaggerate the bride's curves and help her to look even better.

The poses of the bride, alone and with the groom, will change a little depending on the design of the bouquet. If it's a traditional posy, she can lean towards the groom with her left arm and the right arm can

sway away, so the flowers add to the line of the image. If she has the type of bouquet that lies across the arm, you are a little more limited. You can sometimes let it drop it towards the floor but you have to keep an eye on it to make sure it is still presented attractively.

It doesn't matter if you get the pose a little bit wrong but the expression is vital as this is what will actually sell the photograph. You have to make sure you have the right kind of expression for the pose. If you are exaggerating the pose, then it's either got to be a dramatic, pensive look or a full-on laughter position, it depends on the picture you're trying to get. If she's looking towards the camera, you must avoid the toothy grin. You might be playing the clown a little bit to get a reaction and go too far, so the mouth is a little bit too wide and the expression is over-the-top rather than pleasant.

> **TIP**
>
> " As with all portraiture, backgrounds are important. If there is not a suitable, attractive background, throw it out of focus by getting in close or using a long lens. "

⌃ This image, from a winter wedding in a country house, was taken just after the shot of the couple together on page 12. I dragged the chair into the pool of light and used a large diffusion screen to block out the strong, dappled light coming in from the window. A touch of flash, bounced off the high ceiling, added light to the bride, while the darkened edges of the image draw the eye towards her. Using the Hue/Saturation tool in Photoshop, I added some warmth to add to the Christmas feeling.
Canon EOS 5D, 24–105mm lens, 1/60 sec at f/4, ISO 800

≪ This gate made the perfect prop, allowing the bride to lean against it, forming a lovely diagonal line. I used a 200mm focal length and shallow depth of field to make the background a pleasing blur of colour and light.
Canon EOS 5D, 70–200mm lens, 1/200 sec at f/4, ISO 100

THE GROOM

It's not all about the bride! A mixture is needed and the commercial side of me says that the groom has a mother and the bride will also want a shot of her husband. Things have moved a long way in the past 25 years when there would only be a few shots of the groom as he arrived at the church with his groomsmen. Today, there is more demand for the groom by himself, or perhaps with the bride in the background, because he wants images as much as the bride does.

To photograph the groom alone, let him pretend he's at the bar. He's going to want to lean against a tree, a doorway or the edge of a gate to make him feel relaxed. If you absolutely hate hands or struggle to pose them, ask him to put them in his pockets, perhaps leaving out a thumb so it doesn't look like he's physically had his hands removed. But the main thing is to try to make him look relaxed, unless, with his compliance, you are deliberately going over the top to make him look ultra cool or sophisticated. It's not uncommon today for grooms to have a cane or a top hat. Like a location, this will give you more to base a variety of pictures on than just to have him propped up against a tree.

Whereas the bride will need soft light to flatter the complexion, it can be much stronger for the groom because shadows can highlight the contours of the face and enhance his masculinity. If it's a very sunny day, don't be afraid to put the groom into split light or full-on sunshine. In this situation, I'll often use him to shade the bride as well.

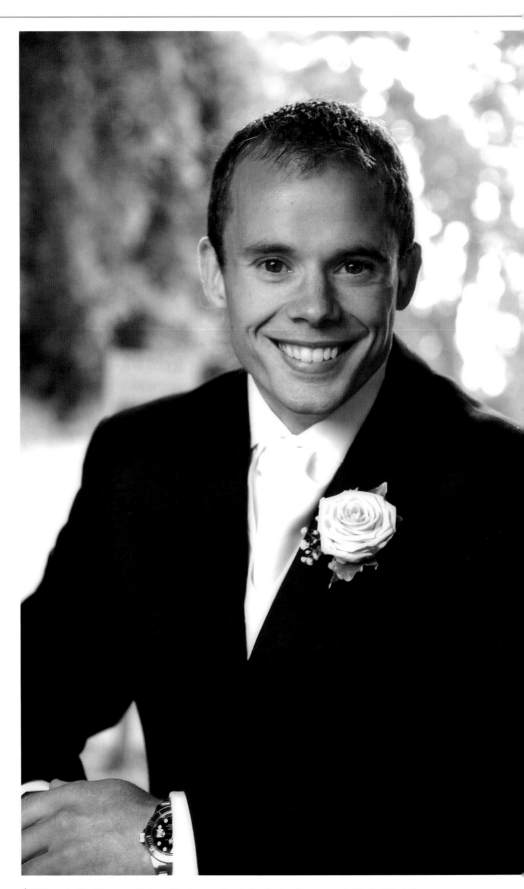

⌃ It's important that the groom looks and feels relaxed and often that's a 'leaning against the bar' kind of pose. You can get away with stronger lighting on him than the bride because modelling on the face is an advantage.
Canon EOS 5D, 70–200mm lens, 1/250 sec at f/4, ISO 100

⌃ When you are taking the couple away from their guests, you can allow them a little space. This shot has just as much a feeling of intimacy as a close-up of them embracing and it's also a good way to show the back of the bride's dress.
Canon EOS 5D, 70–200mm lens, 1/125 sec at f/2.8, ISO 100

THE COUPLE TOGETHER

Again, the feet should be your starting point. Both should have their weight on their back foot and their front foot to the side. They can then turn their bodies in towards each other to slim down the lines. If the feet are not positioned like that and you ask the couple to turn together, they'll turn from the hip. Within a couple of minutes, they'll get tired of that and will turn back. As a result, they'll look as if they're in the 'thin' pose to begin with but will slip into being straight on to camera. If the bride is big, the groom can stand straighter on to camera so she can hide a little behind him, still with her body turned. Similarly, with a big groom and smaller bride, he can hide behind her a little bit.

Usually the bride has a bouquet so one of her hands, at least, will be busy with that. The groom's inside arm will tend to go around her waist but avoid the fingers just peering around the waist because it looks like a hand has appeared from nowhere at the side of her. If they get close to each other and the bouquet is right, then the bride's inside hand can rest on his chest. This will produce a small gap between them so they're not actually on top of one another.

Interior shots can be just as ≫ atmospheric, if not more so, than outdoor ones, providing you have good light. Here I needed more light to add to that coming through a window above them to the right. Using the Quantum radio trigger and flash system, my assistant held the portable flash unit on a pole up the stairs. It didn't affect the overall quality of the light, just added an extra stop to give more life to the image.
Canon EOS 5D, 24–105mm, 1/50 sec at f/4, ISO 800

 TIP

" Always have your camera's white balance set to 'Flash'. You don't want the camera trying to correct the colour balance for you with Auto White Balance. If every frame is shot with the Flash setting, the images will be consistent all the way through and you can then tweak the colour balance collectively on the RAW files in post-production. "

Mark Cleghorn

125

When most wedding photographers are starting out, they'll either squeeze the couple very close together, or turn them full on to camera looking at their widest and with an obvious space between them. The psychology of it is telling you they're not as close as they should be. If they're too belly-to-belly, necks will be strained as they turn back towards the camera and if either is overweight, this will be exaggerated, too. Remember, anyone who is fat wants to look thinner. The job of a photographer, especially a paid one, is to make them look better. You don't want to exaggerate a big nose with harsh lighting or a big tummy with the wrong pose.

Some couples will find it easy to look romantically and lovingly into each other's eyes and some won't and that's the point of discussing with them before the wedding what kind of couple they are and what style of photography they like. It seems quite strange that on the happiest day of their lives, a couple don't really want to kiss much but that is so often the case. It's very hard to get natural, reportage pictures of the couple looking loving because they don't do it. Even a strictly reportage photographer needs to bend the rules a little bit to get them together. Otherwise that element of the day will be absent, or it will happen so quickly that you miss it.

Once you have the basic poses established, start to think about how you can animate the couple. You only have to look at *Strictly Come Dancing* on TV to get ideas for poses. You can see how the elegance of an arm, a leg, the bend of a hip gives you line and so much more to build photographs on. Obviously, you have to adapt the poses to the kind of people they are and the way they dress. If they are a funky, young couple or really up for a laugh, it's easier to have over-animated poses than if they are very classically dressed or older and more reserved.

I try to photograph the bride and groom in the 20 minutes I am alone with them at a pre-determined location, reserving some shots to take later at the reception to add variety. The more fun the couple have during this period, the more it will show in the pictures. Speed is the key and experience helps you to make the best use of the time. When the formal poses are done, they can relax a little bit and a natural style and look will follow.

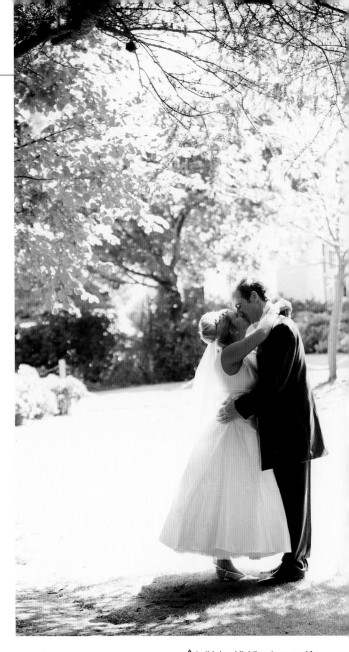

⌃ In this backlighting, I exposed for the shadow side of the faces, otherwise they would have become silhouettes. It had to be accurate because overexposure would mean losing detail in the dress and underexposure would have lost sharpness in the dress and introduced digital noise. Shooting through a tunnel of trees, I asked the bride to stretch up towards her tall groom, which adds to the composition.
Canon EOS 5D, 70–200mm lens, 1/200 sec at f/2.8, ISO 400

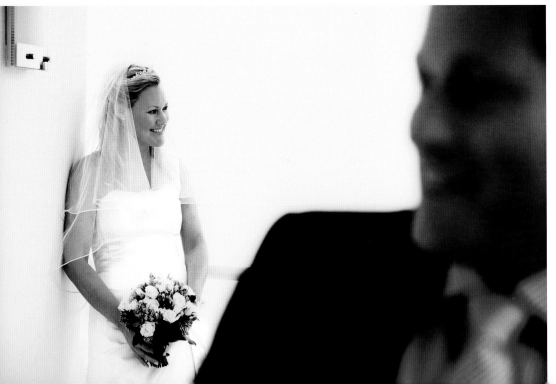

« On a wet day we used the corridor of the hotel, which had opaque glass behind and in front of the bride, creating a lightbox effect. I pulled the groom, in his dark suit, away from the light so there is a dual tonality to the image, as well as the differential focus to add interest. A high-contrast action in Photoshop boosted the colour and made the whites lighter and blacks darker.
Canon EOS 5D, 28–70mm lens, 1/125 sec at f/2.8, ISO 400

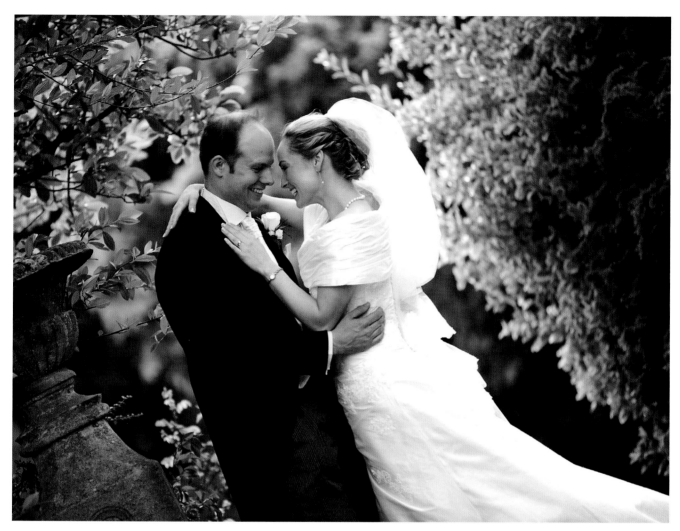

⋏ This was a classical location with trees providing a tunnel effect, leading the eye to the couple and also subtracting light overhead and to the side. This gives beautiful detail on a sunny day. I posed them with their hips towards each other, touching and then leaning away with their torsos. It's a ballroom dancing idea – with no gapping in the hips, the couple appears closer.
Canon EOS 5D, 70–200mm lens, 1/250 sec at f/2.8, ISO 10

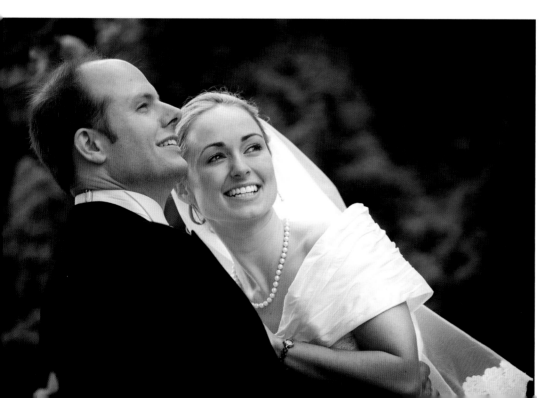

≪ Using the same location, you can change the pose quite subtly to give a different effect. Here, the newlyweds are turning their heads towards the light on the right and the bride has removed her hand from his neck, as this would have been a distraction. The tilt of the camera allowed me to include her elbow in the composition without moving backwards. I always take a horizontal and vertical shot of the same pose.
Canon EOS 5D, 70–200mm lens, 1/250 sec at f/2.8, ISO 100

Mark Cleghorn

USING LOCATIONS

Very often my 20 minutes alone with the bride and groom will be spent at a location on the way to the reception, after the wedding ceremony, but some couples prefer to head straight to the reception and do the photographs there. Either way, make sure you choose a place that will offer variety. Look for two or three different backgrounds, which might be as simple as moving the camera position rather than the bride and groom.

Always visit a location beforehand, unless you are already familiar with it. Even then you can arrive to find a bridge or walkway closed off, some trees felled or a fete taking place that day. If you haven't been somewhere for a while, don't take a chance because you want to take the couple to a location knowing exactly what you are going to do. That way, you will look efficient to them.

For me, locations fall into two categories, classical and funky. For a classical style, look for a subtle use of light, so a tree or an archway that will subtract some of the light coming from above to give pleasing directional light. Steps and walls will provide a natural element to pose the couple around. I love pillars and architecture in an image. It adds to the scene and helps add a three-dimensional quality to an image.

For funky locations, think about colour and graphic elements that you can include in the composition. Generally, the light is less important than for a classical shot, unless it is so bad on the faces that it becomes unacceptable. In this case, you need a safer alternative, finding some shade no matter what. Sometimes the couple will request a specific location that means a lot to them – perhaps where they got engaged. If the time constraints will not allow for this on the wedding day, they can dress up again at a later date to get exactly the pictures they want.

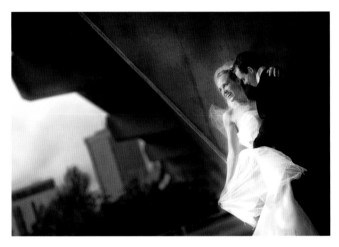

⌃ The underpass of a motorway might not seem the most romantic of locations but the strong lines add dynamism to the picture and there is a great contrast between the texture of the bride's skin and dress and the hard, concrete structures.
Canon EOS 5D, 70–200mm lens, 1/640 sec at f/2.8, ISO 200

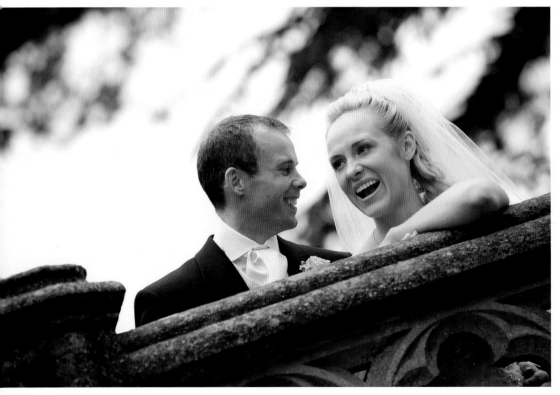

 TIP

❝ A mistake a lot of photographers make is trying to do a session with the bride and groom on location and then another session with them at the reception venue. Instead of 20 minutes, you've eaten up close to an hour. Decide which is the better option in the circumstances and concentrate on that. ❞

≪ A more classical location in parkland with the stone balustrade by some steps providing a perfect prop. The greenish colour of the stone is echoed in the blurred shapes of the tree above their heads, which also served to diffuse the light on them.
Canon EOS 5D, 70–200mm lens, 1/250 sec at f/4, ISO 200

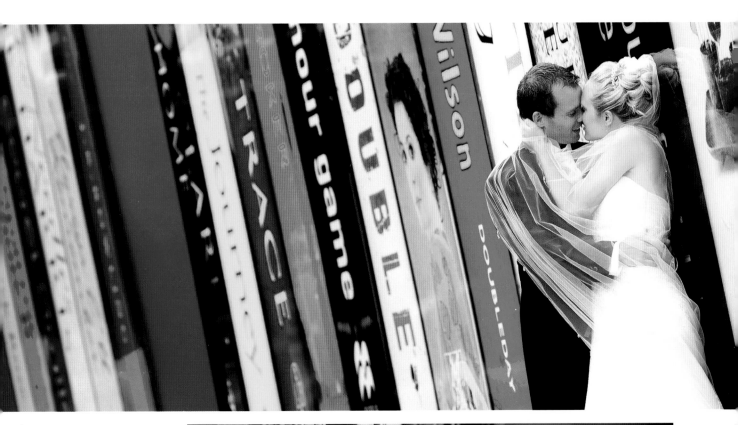

⌃ The bright, graphic posters outside a bookshop created an unexpected backdrop to the couple. I made sure they were positioned to give a dark background behind the bride and a light one behind the groom.
Canon EOS 5D, 70–200mm lens, 1/400 sec at f/4, ISO 100

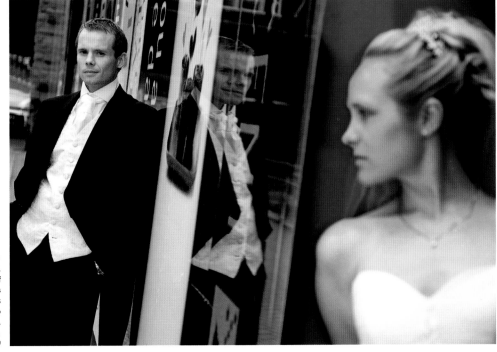

An urban setting with the reflection of ≫ the groom providing an interesting twist. The bride was deliberately put out of focus and the division in the image was heightened by converting the two thirds of the frame containing the groom into monochrome in Photoshop.
Canon EOS 5D, 24–105mm lens, 1/250 sec at f/4, ISO 200

If the reception venue doesn't lend itself well to photographs, the couple can usually be persuaded to stop off en route. If not, it's your job to remain positive. Try to find two or three places that you can use to pull the gems out of the bag. The weather can be more of a problem. If it's raining, you always have to have a plan B. If there is nowhere that will offer cover outside, head for the biggest window inside. You can't beat diffused window light, which it will be on a rainy day. For a Christmas wedding, be sure to capture the warmth of the interior by balancing flash carefully with the ambient light. You don't want powerful flash resulting in a black background, spoiling the atmosphere.

Wind can be worse than rain as it causes dresses and veils to fly. Old castles are terrible for that because the archways are like wind tunnels; stand the couple still for one minute and the bride is going to be wrapped in her veil or running after it. If this happens, look to the positive – it can make a great photo!

The four pictures shown here are all of the same couple, taken at very different locations in a short period of time between the ceremony and the reception. They demonstrate that you don't need to have a glamorous or beautiful background to take romantic portraits.

Mark Cleghorn

MANAGING GROUPS

When the couple require arranged and posed group shots of members of the wedding party, I will do these at the reception, after everyone has had a chance to relax with a drink and all the stragglers have arrived at the venue. The best place to set up is close to the bar, or where the main party congregates so that you can get hold of everyone easily. You certainly don't want to be a five minute walk away as it will cause delays.

The lighting and background need consideration. A simple, uncluttered background is best and if your subjects have their backs to the sun it can provide a lovely rim light, as long as it's not late in the day when the sun will shine into the camera lens. You don't want direct sunlight in their eyes, causing them to squint, or it to be uneven, with half the group in shade. I always use flash on groups, to pull up the contrast on the faces so everything is nice and bright. It wouldn't be necessary on a perfect day with the light exactly right, but we live in the real world! With small groups, I bounce flash off the catchlight card on my Speedlite flash. Bigger groups need more help with directional flash and in winter I opt for powerful units like the Quantum, or even studio flashes. One flash goes behind the camera and one to the side to give a lovely blend of light.

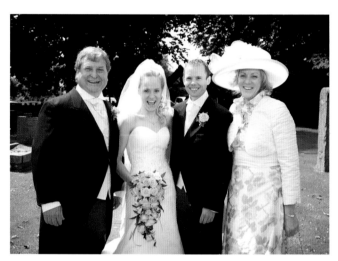

Building my group shots from the centre outwards, I start with the bride, groom and ≫ her parents. I take both three-quarter length and full-length shots. The sun behind formed a rim light and I used a Speedlite flash on the camera hot shoe, bounded off a catchlight card.
Canon EOS 5D, 24-105mm lens, 1/125 sec at f/5.6, ISO 100

≫ The groom's parents are added, along with the bridesmaids and best man. I use a Quantum flash unit for groups to add sparkle and lift shadows on the faces, which can be a particular problem when people are wearing hats.
Canon EOS 5D, 24–105mm lens, 1/125 sec at f/5.6, ISO 100

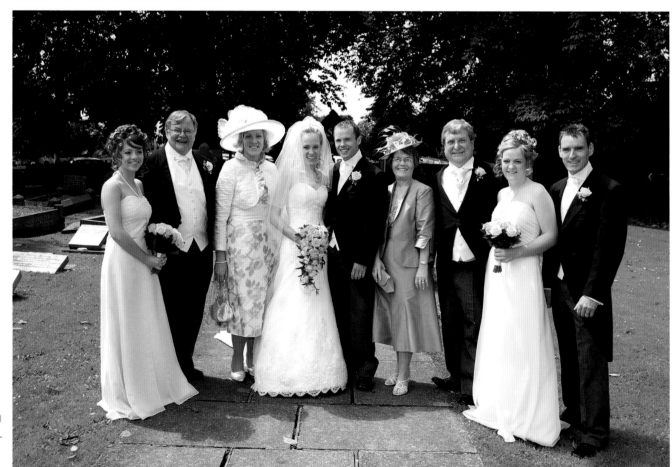

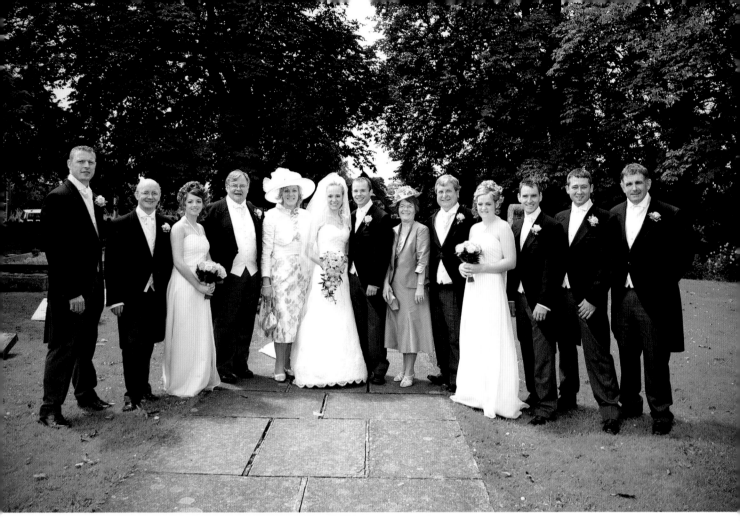

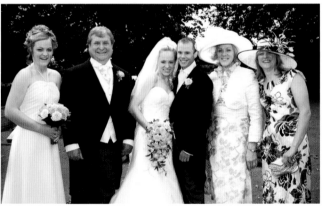

≫ Groomsmen are added to the sides of the group, coming towards the camera to form a pyramid shape. The background for group shots needs to be fairly plain and simple and also a large enough space to fit your largest group without becoming cramped or necessitating using a wide-angle lens, which may include unwanted elements in the frame. For this larger group I used the Speedlite flash on-camera in TTL metering mode, without bouncing it off a card.
Canon EOS 5D, 24–105mm lens, 1/125 sec at f/5.6, ISO 100

≪ When the bridesmaids and groomsmen are done, I start a new pyramid with the bride's parents and siblings. I then do the same thing with the groom's family.
Canon EOS 5D, 24–105mm lens, 1/125 sec at f/5.6, ISO 100

PYRAMID GROUPING

From the meeting I had with the bride and groom a month or so before the wedding, I have a list of the different groups to be photographed. These depend on the individual requirements of the couple, the age range of the wedding party and other factors such as bereavements and step-parents in the family. The most important thing is to work quickly and efficiently to avoid complaints from the guests and to allow yourself more time to move on to reportage and the relaxed and fun group shots that are more popular these days.

I base my formal groups on a pyramid shape, which I build from the centre outwards. The bride and groom are the starting point with both sets of parents added to the sides. Then come the bridesmaids and groomsmen. After that shot, I remove the middle of the pyramid, which is the parents, and move the remaining group in together from each end. With the bridesmaids and groomsmen done, I let them go and start a new pyramid with the bride's family, beginning with her parents and

the couple's own children if they have any. Then I add on her brothers, sisters, their partners and the grandparents. The next shot includes her aunts, uncles and cousins, then, if requested the bride and groom on their own with grandparents. This whole sequence is repeated for the groom's family.

The couple's friends may also play a big part in the group shots these days. Often the bride will split them into friends from school, university and work and the groom may do the same. At other times, the couple will share all the same friends so it will just be one group. There may also be special people, such as godparents, to be photographed with the couple, or perhaps all the children in the party. As I usually work without an assistant, I brief the best man and the ushers to shepherd people in for me. It's also good to get to know the bridesmaids, as they are more likely to know the bride's side of the family. The last thing I want is a mum or dad running off to find people as it can hold things up.

Mark Cleghorn

BRIDESMAIDS

As well as photographing the bridesmaids as part of the pyramid with the bride and groom, I also take some shots of them as a separate group. I start with the chief bridesmaid in the middle and then work out in size order to form a pleasing triangular shape. Once the structure is there, they can be looking towards each other slightly, looking to camera, and then gossiping with each other. This brings some informality to the basic, classical pose, which can be developed, perhaps with them linking arms, marching across the lawn or hand-in-hand looking back towards me.

If the bridesmaids and hens are a group of young women who are up for a party, you might suddenly find they have formed an impromptu can-can line. The shot you had in mind takes a completely different direction and you have to be ready for it because these kinds of informal images are really popular. So, while the shots that make them look perfect are important, get them done quickly so you can move on and relax things down.

GROOMSMEN

I tend to do most of the shots of the groomsmen at the venue before the bride arrives for the wedding but sometimes someone is running late so they have to be done later in the day. Starting with the formal shots, the posing again starts with the feet, turning in towards each other. You have to make sure the men are dressed correctly with their jackets hanging neatly. If they have hats, they can hold these in their outside hand, with the back hand out of view, hidden behind the person next to them. Ideally, the tallest person goes in the middle, going down towards the smallest at the sides. If you have a tall groom and a short best man or vice versa you have to adapt to achieve a careful balance.

These days the boys like to have a laugh and they also like to look really cool. About 18 years ago I began doing shots with a *Reservoir Dogs* feel with them wearing sunglasses and I am still asked for that today. The scrum position is also popular, or they might be running towards me. Just as with the bridesmaids, it is good to have some carefully posed shots that will ensure that they look their best and then you can start to have fun.

⌄ It was raining but I wanted shots of the groomsmen so I used the canopy of the hotel as a shelter, with them leaning against the glass. I had to bring the third man in the background forward a little or he couldn't be seen. When the light is difficult, as it was here, you can ask them to look away from the camera so that you can't see faults with the light on their faces, such as shadows in the eye sockets.
Canon EOS 5D, 12–24mm lens, 1/80 sec at f/5.6, ISO 250

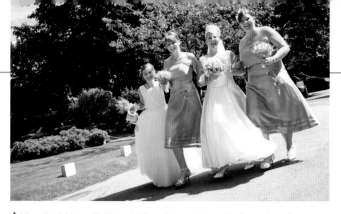

⌃ When the bride and bridesmaids have been photographed more formally, you can relax the pose down and allow for more fun, active shots that are usually much more popular. I sometimes use camera tilt to add movement to the image. Here it also allowed me to disguise vehicles and a roadway in the car park.
Canon EOS 5D, 24–105mm lens, 1/200 sec at f/4, ISO 100

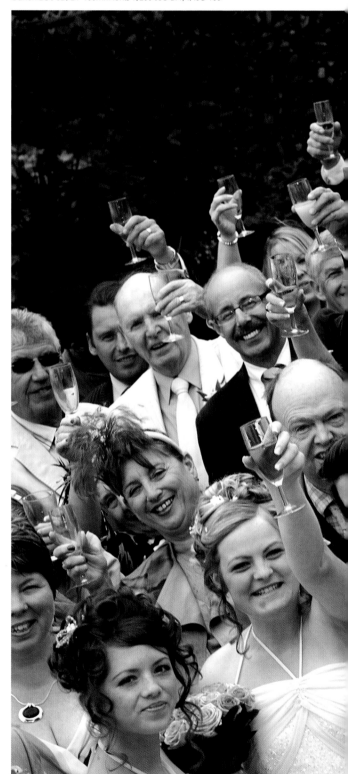

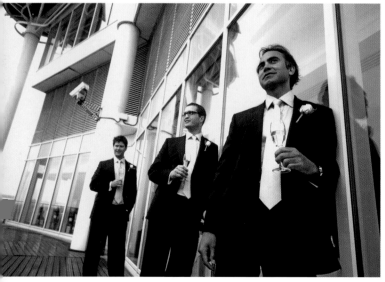

THE WHOLE WEDDING PARTY

Given the option, most couples will want a photograph of the whole wedding party but you have to think of the location to see if this is practical. You either need an upstairs window to look down on the group, or a wide set of steps for them to stand on.

The overall shape created by the group depends on its size and on how you will use the image in the album. A long, thin shape works well across a double-page spread but a smaller group taken from an upstairs window will be more of a square image. This whole group shot is the last thing to do before they go into dinner. Make it fun because it's the last thing you will be remembered for.

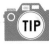

TIP

" Check you have enough shots left on the memory card before doing the final group shot. If you are photographing from an upstairs window, be sure you have everything you will need before you get up there. "

� You need a raised viewpoint to capture the whole wedding party, so look for steps or an upstairs window. Asking them to raise their glass on a count of three is a good way of attracting their attention all at once and naturally makes people smile. The quicker and more fun you can make this shot the better. The tight crop and tilt of the camera adds to the lively, party feeling here.
Canon EOS 5D, 24–105mm lens, 1/60 sec at f/11, ISO 100

CHILDREN

Some weddings will feature a lot of children so you have to be prepared for that, but a discussion with the bride and groom should alert you in advance if this is the case. It is useful to know how old they are, as they will have different energy levels and tolerances. If the service is in the afternoon, even at two or three o'clock, young children may be shattered by then, just through excitement and anticipation, especially if they are playing a role as bridesmaid or page boy.

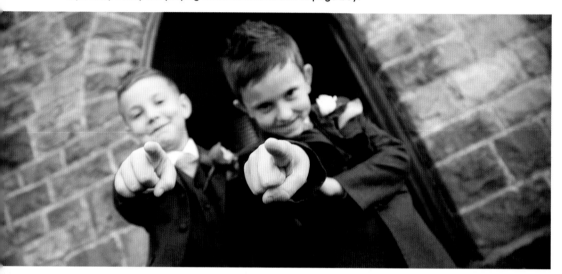

TIP

" It's common these days for the bride and groom to have children of their own, in which case they are going to feature quite heavily during the proceedings. Try to discourage them from being included in every group shot because they will soon become fed up and then you'll lose any chances of getting good pictures of them for the rest of the day. "

⌃ I like split focus as a way of drawing your eye into an image. I was having fun with these boys and one of them pointed at me. I asked them both to do it on the count of three, which made focusing on the finger difficult, as I had to do it instantly before pressing the shutter. If I had asked them to hold the pose though, I felt I would have lost their expressions.
Canon EOS 5D, 24–105mm lens, 1/60 sec at f/4, ISO 100

If I go to the bride's home and the kids are there, I make use of that time to shoot them looking their best, before they've pulled off their hair bands or flowers and taken off their suit jackets or whatever. Then, they usually arrive at the church about five minutes before the bride so I photograph the young bridesmaids and pageboys first as a group, then individually and again with the bride when she arrives. If the worst comes to the worst and they become tired or out of sorts later on, I have at least got these images in the bag.

During the rest of the day, whatever else I get is a bonus. You spot kids stealing a drink from a table, taking nibbles of food or running around the park, dragging the bride with them and these are the great candid shots that you're looking for. Sometimes you can instigate actions shots but kids usually make their own fun no matter what. If there's a group of kids they will just naturally come together and start doing their own thing, causing chaos and running around. By this time they will have stripped down and lost their fancy bits of clothing – hence the importance of the earlier shots when they looked pristine.

RAPPORT

If you build up a really good rapport with kids, you can do anything with them. It's about being cheeky and also complimenting them. Telling a little girl she looks like a princess will instantly get her on your side. Watch how kids naturally behave and interact with each other and don't force anything that seems to be uncomfortable for them. Some siblings are very close, others are quite the opposite and you can soon gauge this by watching their body language. A little boy might be horrified at the thought of being kissed by a girl, but if you tell him to cross his arms

or stick his hands in his pockets and look cool, he's going to do that instantly. Put a pair of sunglasses on him and he's on a different planet!

There's a skill in knowing when to try to manipulate kids and when not to, however. If you're too enthusiastic and you go in with great ideas early on, they will want more activity for every subsequent image. If you start with running around the place, for example, and you haven't got the classics in the bag, you're going to struggle because all they want to do is have fun now.

Some children give you the opposite problem in that they are so shy they don't want to leave mum or dad's arms or let go of their legs. I hate to come away from a wedding having got three bridesmaids and the fourth one was so tired or upset that I failed with her. It's almost a mission to get something and sometimes you feel a bit like a stalker. This is where a long lens comes in useful as you can often catch a moment when the child is relaxed with a parent without being noticed. If the parents of the bridesmaids or pageboys are there, I will try to take a photograph of them together anyway, even if it hasn't been requested.

Generally, children are best photographed at their own level. Round about the chest height is always the most complementary for anyone in portraiture because it naturally allows the head to lift a little bit. Below the chest level, people are looking down and their eyes are going to be dark and a child looking up at you can appear strange. As with all the wedding pictures, variety is important so experiment with all the different camera angles. If a child is crawling around the grass, crawl around after it!

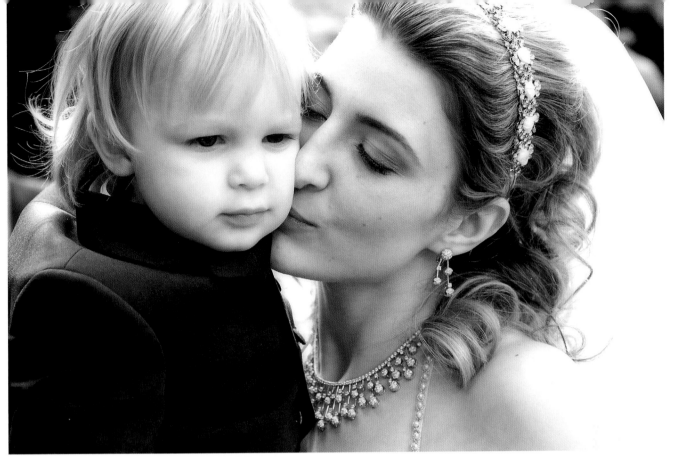

⌃ This was taken at the church as the couple were ready to leave for the reception. I could see the bride walking away from the crowds towards her son and I knew it would be a natural thing for her to give him a cuddle so I just waited for the moment. The Speedlite flash on-camera provided fill-in on the faces.
Canon EOS 5D, 24–105mm lens, 1/125 sec at f/5.6, ISO 100

⌃ These two are friends from nursery and have a lovely relationship, so I was able to say 'Can you give him a kiss?' Say that to children who don't know each other well and they're going to run a mile – meaning you've lost the chance of any image.
Canon EOS 5D, 24–105mm lens, 1/125 sec at f/4.5, ISO 100

≪ Indoors, I look for locations that I can use creatively. This was a small pub with lovely light coming in from the right of the stairs. I simply asked the girl to sit there and she posed herself. If I had used flash, the metal edging on the front of the steps would have been too bright and I would have lost the detail in the background.
Canon EOS 5D, 24–105mm lens, 1/60 sec at f/4, ISO 800

Mark Cleghorn

135

POST-PRODUCTION: ALBUM DESIGN

The creative process of designing a wedding album can be an extremely rewarding conclusion to the service you provide to your clients. During your pre-wedding meeting with them, show them some sample designs so you can get a feel for the kind of layout they like, as this will also influence the way you shoot the wedding. Many album manufacturers and printers will have their own album design software but will also accept layouts produced in Photoshop, which is my preferred method.

CREATING THE ALBUM IN PHOTOSHOP

- When you start to design a wedding album it is good to sort out the best images from the rest as this will make it simpler when deciding on page layout. You can go one step further and separate them into different folders, such as Favourites, Likes and Details.
- The first thing to do is to make a new page to the size of the album spread. This can either be done as a single page or a double-page spread, depending on the end printed result and album manufacturer.
- Set width and height of the desired page size, not forgetting the target resolution, in my case 16 x 12in at 240dpi for my album at the photo lab (picture 1).
- Drag a 5mm guide to each side and to the top and bottom of the document – the guides will appear as you drag them on to the page from the ruler (if your rulers are not visible press Command-R) – then drag a central vertical and horizontal (picture 2). This will all help with

page layout later on. Save this document as a template for later use, then save it in the album folder for this client.

- Now open one of the favourite images that will be the biggest on the page, crop it to the desired size, in this case 12 x 6in at 240dpi, then drag it on to the document. Align the image in the centre. The smart guides will help you as they snap to centre (picture 3).
- Add a keyline around the image layer (Edit>Stroke) then select a colour by clicking the colour box and choosing a tone. Select the inside position and a width of 5px (picture 4).
- Select the other images for the page layout and crop them to fit, in this case 5 x 3in at 240dpi. Drag each on to the page layout using the Move tool. Then apply a keyline around each (picture 5). The quickest way to do this is to make up an Action, which is a macro that records a screen activity. The Action can then be saved to an F Key on the keyboard, which will then play the keyline stroke command when pressed.

ONE

TWO

THREE

FOUR

- Now align the layers: first drag the middle layer to be centred on the centre guide, then move the other images to each side and align them to the top edge of the middle layer using the smart guide feature that automatically appears when images are close to each other. Finally distribute the centres of the three layers using the Auto Select option (when using the Move tool, this is found at the top of the Options bar). Now Alt-click the layers to align them, then click on the Distribute Centre icon at the top of the tool palette (picture 6).
- If you want a coloured background, click on Make New Adjustment Layer on the Layers palette and choose Solid Color; select your

colour and you get instant page colour (picture 7). If you did not have the background layer selected initially the colour may be affecting the image layers, so make sure it is positioned above the background layer. If you want a wash effect instead of a solid colour, change the opacity of the adjustment layer using the Opacity slider on the Layers palette.
- Instead of a colour as a background, try using another image (picture 8). This, too, can have a colour tone applied as before, and/or an opacity change.

FIVE

SIX

SEVEN

EIGHT

ALBUM DESIGN TIPS
- Keep it simple.
- Make Actions to save time.
- Boost colour and contrast for more impact.
- On a page with lots of colour images, use one mono image amongst them and vice versa. High-contrast black and whites with soft-focus colour images is a good blend.
- Image tone, like blue or sepia, adds a design theme.
- When changing location, start a new double-page spread like a new chapter in the story.
- Storytelling: images in sequence tell a better story.
- Image washes for backgrounds add an extra depth to the album design.

- Details, grouped together on a page, help set the scene.
- With a background image with a low opacity, try vignetting the image to allow it to fade into the background.
- Less is more: fewer images over a double-page spread will increase the album size.
- Watch the crease – where the album folds be careful not to have a face in the crease.
- One big image and one small image over a double-page spread gives good impact.
- Remember that trimming will be applied to the sides of the album. Speak to the lab or album company to find out their safe zones.
- On the back cover of the album, make sure to put your logo and website address.

Mark Cleghorn

INDEX

AUTHOR BIOGRAPHIES

MARK CLEGHORN

Mark Cleghorn's distinctive images have won hundreds of awards since he started professionally in 1983, including the Kodak European Gold Award 17 times, as well as being awarded four Fellowships for his outstanding images. In 2009 Mark launched PhotoTraining4U.com, an online training resource for photographers using streaming video in its knowledge bank to show photographers not only him at work but a vast selection of teaching and technical films.

Mark was one of the first in his field to fully embrace digital technology in the late 1990s and has not shot film since 2001. His digital workflow methods have helped to get photographers back behind the camera instead of sitting at a computer.

Mark has written books on lighting, portraiture and wedding photography as well as Photoshop. He has judged photographer's work in print competitions all over the world and is considered to be one of the major influences of style and technique in the wedding and portrait industry today.

For more information visit **www.markcleghorn.com** and **www.PhotoTraining4U.com**

MATT HOYLE

Based in New York City but originally from Los Angeles, Matt Hoyle spent his 20s as an advertising creative director in Australia. He then left the industry to pursue photography and was soon awarded Canon Australian Professional Photographer of the Year. With his photographs appearing in Luerzer's Archive, Communication Arts, Cannes and D&AD, Matt was soon back in America and shooting full-time with clients like Saatchi's, *Rolling Stone* magazine and *New York* magazine.

Matt's work is known for its richness in colour and character as well as for his unique post-production technique. His first book, *Encounters*, was released in 2007 to great reviews. In Matt's personal projects he loves documenting people and their stories.

Commercially, Matt shoots for some of the most respected agencies and magazines both in America and abroad. His fine art exhibits regularly and has been hung in galleries in New York, Los Angeles, London, Dubai, Australia and Paris.

For more information visit **www.matthoyle.com**

EAMONN McCABE

Eamonn McCabe started photographing rock music while travelling in the USA in 1969. He attended film school in San Francisco and on returning to Britain was desperate to get in the movie industry, but sadly, Wardour Street was in decline.

He then got into stills photography, first working at Imperial College and then for a rock and pop agency in central London. After a year or so he turned his attention to sport. He worked for *The Observer* newspaper for 12 years as a sports photographer, winning the title of Sports Photographer of the Year a record four times. In 1988 he was appointed Picture Editor of *The Guardian* newspaper. He left the picture desk in 2001 to specialize in photographing people, mainly from the arts world.

Eamonn is a Fellow of The Royal Photographic Society. He has an Honorary Doctorate from the University of East Anglia, where he lives. He has had several books published and appears regularly on radio and television, talking about photography.

For more information visit **www.eamonnmccabe.co.uk**

STEVE SHIPMAN

Steve Shipman's photographic life started at the London College of Printing (1978–80) where he earned a BA (Hons) in Visual Communications, specializing in stills photography. After graduating he assisted top advertising photographer Graham Hughes for two years and then established himself as a portrait photographer in 1982.

Steve's relaxed style and ability to bring out the best in people has lead to a wide range of editorial clients, including the *Sunday Times Magazine*, *Radio Times*, *The Guardian*, *GQ*, *BBC Homes and Antiques*, *FHM*, *Real Homes* and *Top Gear Magazine*. Personalities who have been in front of Steve's camera include Paul McCartney, David Attenborough, Tony Blair, French and Saunders, John Malkovich and Jonathon Ross. Steve also photographs special weddings and family portraits.

Steve has exhibited at the Photographers Association Gallery in London, and at the National Portrait Gallery. He enjoys photographing politicians, actors, writers and people in all walks of life and in all sorts of situations.

For more information visit **www.steveshipman.com**

BJORN THOMASSEN

Bjorn Thomassen, was born in England to an English mother and Norwegian father. Bjorn's father was a merchant navy captain and Bjorn followed in his footsteps and spent a short period on the high seas, eventually working as a harbour master's assistant. For ten years he was a crew member and helmsman of the Royal National Life Boat Institute where he was awarded a Velum for his contribution to saving life at sea.

Bjorn gained his first professional photographic qualification in 1994. Since then he has won many prestigious awards through various professional bodies, including the British Institute of Professional Photography and the Society of Wedding and Portrait Photographers. They include Fellowship in Illustrative Photography, International Fine Art Photographer of the Year (Western region) and Portrait Photographer of the Year (Western region).

While Bjorn's experiences have encompassed a variety of photographic fields, his passion and specialization is commercial and social aspects of people photography.

For more information visit **www.bjornthomassen.co.uk**

ACKNOWLEDGMENTS

MARK CLEGHORN
PhotoTraining4U.com, Lastolite, Canon Cameras, Loxley Colour Labs, Sekonic, Adobe.

MATT HOYLE
My creativity is wholeheartedly inspired and nurtured by my loving wife Anthea and in no small way dedicated to her as thanks for being so vital in my journey.

EAMONN McCABE
Thanks to fellow photographers whose workshops I attended, Raymond Moore and Peter Goldfield (now both sadly passed away), for their friendship and inspiration.

STEVE SHIPMAN
I would just like to say thank you to my wife, Amanda, for her limitless support and encouragement since the moment I decided to be a photographer.

BJORN THOMASSEN
Thanks to Canon, Elinchrom and California Sunbounce for their gracious support. I am indebted to them to own, use and test the world's best photographic equipment.